Painting
Miniatures

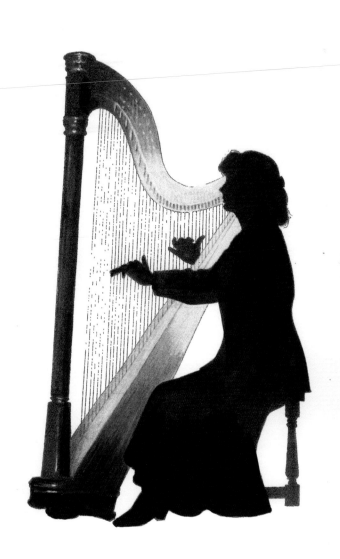

Painting Miniatures

Pauline Denyer-Baker DES RCA

THE CROWOOD PRESS

First published in 2014 by
The Crowood Press Ltd
Ramsbury, Marlborough
Wiltshire SN8 2HR

www.crowood.com

British Library Cataloguing-in-Publication Data
A catalogue record for this book is available from the British Library.

ISBN 978 1 84797 840 0

Frontispiece: *Lady with a Harp* by Michael Pierce

Acknowledgement and Dedication
First of all I have to thank my son Rupert (who is also a portrait painter), without whose help I could not have organized this book on my computer, and my husband Brian for his design of the covers, his input on perspective, and his patience, as I worked slowly through it all. Also my eldest son Brendan for his patience too, and for explaining to my grandchildren how busy Grandma was!

I have written it for all the good friends I have made whilst teaching Miniature Painting, some of whom helped me on my way, and are no longer here.

Finally I dedicate this book to Molly Lefebure Gerrish, and her husband John, who encouraged Brian and myself as we pursued our artistic careers in the early days, and helped to make us succeed. Molly, who was a well known writer herself, would have been so pleased to know I had written this book, but they both missed the news by just a few weeks. I am indebted to them both for the inspiration they provided to me and my family.

Typeset by Jean Cussons Typesetting, Diss, Norfolk

Printed and bound in Malaysia by Times Offset (M) Sdn Bhd

CONTENTS

Introduction 6

INTRODUCTION

It is commonly misunderstood that any painting is a miniature if it is small or very small; however, this is not true. A miniature work is quite different for several reasons. It is important to understand this, because if you really want to learn how to paint in miniature, it is probably surprising to find out how the techniques and methods of painting miniatures differ from the traditional methods of landscape, portrait and still life painting.

Societies of miniature painters do have certain rules and regulations, and broadly speaking, the subjects have to be $\frac{1}{6}$ life size. This makes painting insects or small flowers and birds difficult, so most of these societies will look at the subject and, if painted in exquisite detail and with great care, they will accept these works for their exhibitions, as long as they adhere to the overall size of 6.5 inches × 4.5 inches including frame and mount.

Reduced photocopies of larger works may not be submitted, as each work has to be painted completely by hand. Small etchings are also allowed, but each one must be printed by the artist himself. This means that no one can churn out 'miniatures' quickly! But if like me, you love to paint in detail, in a small format, with colour and precision, then the miniature technique will appeal to you.

Although I had a formal Art School training, and learnt to draw and paint with various media and objects, I have always been fascinated by the fine details of the subjects I was trying to represent. I was taught life, costume life drawing, anatomy, classical architecture and studied paintings and the History of Art.

During the first two years I studied Fine Art (under the late Charles Knight RWS, who passed on so much of his knowledge to his students in an unselfish and enthusiastic manner), and this basic training was invaluable in my career as a designer and latterly as a portrait miniaturist. It was very important when I became a visiting art tutor at further education colleges in southeast England.

Eventually, but only after spending some more time studying portraiture, and miniatures in particular, I began to teach both of these disciplines to adults on leisure courses.

After having taught portraiture and miniature painting over the past twenty years I realized that there was a great need for a more comprehensive book on the techniques and all aspects of painting miniatures for the twenty first century. It became an ambition of mine to write this book, in order to pass on some of the knowledge that was once given so generously to me.

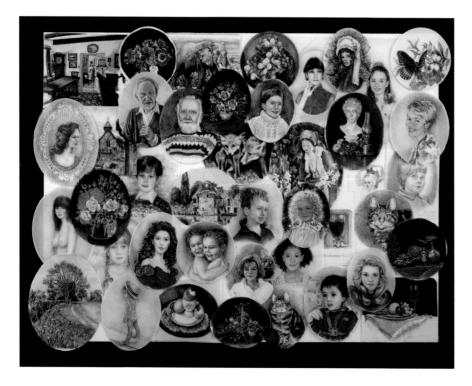

I put this collage of my work together, forty-two pieces in all, because I wanted to enter them for the RA summer exhibition 2006 called Rejects *and – they were of course.*

Looking and perceiving

I was taught to perceive: not to just look, but to look twice and draw once! Please think hard about this concept, and make sure you understand the difference between looking and perceiving. Looking at a subject, such as a landscape, you appreciate it for its beauty, but if you are perceiving it, you are taking it into your brain, with the intention of painting or drawing the atmosphere, colour and life of what is before you.

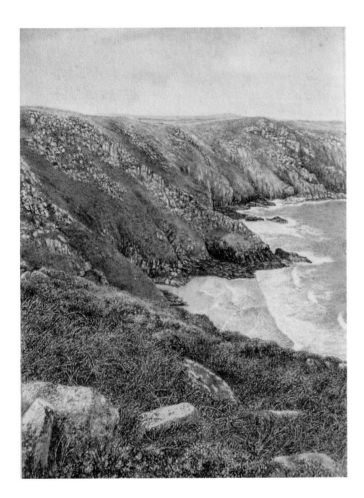

This painting by Roz Peirson, who uses watercolour on paper, is of the Cornish coast at Zennor, for which she was awarded the Gold Bowl at the RMS exhibition in London 2012.

Drawing

It cannot be stressed too much how important it is to be able to draw, a skill that can be learned if the student is prepared to study and practise. Unfortunately, learning how to draw in the art schools these days is not a top priority, and because it has not been considered necessary for such a long time, it is probable that some of the tutors do not have the drawing skills to pass on the new students. Those students who succeed are those have a natural talent for drawing, or those who are prepared to work at it and study the basic principles of it such as anatomy, perspective architecture and landscape.

Sketchbooks

It is very important to keep a sketchbook in which to jot down ideas and make sketches regularly; it soon becomes second nature to try to get down the essentials of the subject. You will get used to looking carefully at your subjects (perceiving), in an effort to represent them accurately in your sketches, and ultimately in your artworks.

Especially where portraits are concerned, studies of faces, made in pencil or with colour, seem to help imprint the image in the mind, so that when it comes to getting a likeness, the

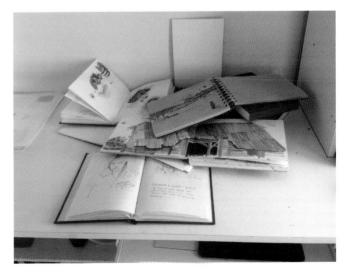

A small selection of my sketchbooks, in which I work out my miniatures in advance beforehand, which I consider a vital part of the success of my paintings.

brain is able to recall the personal characteristics. A sketchbook is also a place where you can make mistakes, and try things out, without any restrictions or criticism from outside influences. For learning portraiture, it is very useful to work from facial expressions in magazines, because the features are very clear. It is useful to keep them for reference, so that when you have to draw a particular expression in a portrait, you will have some something similar with which to compare your drawing.

Reference files

It is useful to keep a scrapbook of ideas. If a pattern or shape or colour appeals, cut it out and keep it; it may well come in useful on a later project. Keep a box file for these, as your collection will grow as you become more observant. The patterns and shadows are usually exaggerated in photographs, but this makes you aware of them and helps you to understand how important shadows are in getting form and distance into your works.

Likenesses, colours and compositions

In order to learn about likenesses, colours and composition, it helps to look at books on art, studying in particular those artists who were expert in a particular subject. It is not necessary to look just at portrait miniatures; look at the work of all portrait painters, in various media. There is a lot to be learned by studying the works of those who have a broader approach, like Frans Hals, Vermeer, Winterhalter, John Singer Sargent, Gwen John, Allan Ramsay, Harold Nicholson – the list is endless. Although the miniature painting technique is so specific, one can learn a great deal about the form of the face, shadows and features from all artists who were portraitists. In fact you may well find certain techniques and shortcuts they made, which could also be applied to portraits in miniature.

Still life

For more inspiration there are all the artists who painted still life, such as William Nicholson and those who painted trompe l'oeil, such as Cornelius Gijsbrechts, a Flemish artist around 1670, who painted the most detailed and lifelike paintings of letter boards, pinned with all sorts of ephemera. My paintings of Pinboards,

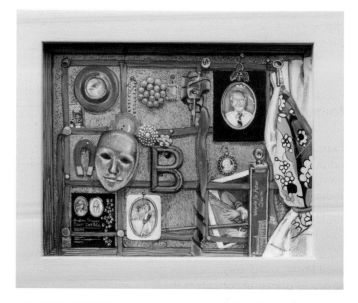

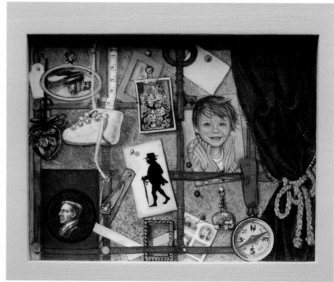

These trompe l'oeil miniatures, called Family Pinboards, *were all painted directly from life, in watercolour and gouache. They were inspired by paintings by the artist Cornelius Gijsbrechts, whose paintings really did deceive the eye!*

which include tiny portraits and silhouettes, were all inspired by these Gijsbrechts paintings. There was an exhibition of his paintings called 'Painted Illusions' at the National Gallery in 2000. If you look at his work, you will see how the details are so fine that they really do deceive the eye. One painting shows the back of a work, leaning against a wall, and it really tempts you to try and turn it over to see what is on the other side.

As they were painted in order to deceive the viewer, the detail is amazing. By observing these paintings, you can see how the

artist worked out and simplified the details in paint, but was still able to represent them accurately.

Holbein

There is a parallel here with Holbein, who painted miniatures and portraits for the Tudor court. Before he came to England, Holbein was still painting portraits for the important clients in Flanders, and so that his clients would remember him on his return, he painted a fly on the cheek of a portrait, so that the sitter, in attempting to brush it aside, would be reminded how very good Holbein's work could be, in case he returned. Holbein found favour with Henry VIII, as he had hoped, and he became the official painter of portraits to the King, and the Tudor Court. However, it is said that Holbein had learned how to paint miniatures from Lucas Horenbout in Flanders.

Although the earliest miniatures were probably painted by Flemish artists such as Teerlinc and Horenbout (who worked upright at an easel, and wore spectacles even in those early times), the tradition of miniature painting became particular to England and artists through the years. The painting of Lucas Horenbout at his easel, as well as the works of the early miniaturists, can be seen in great detail in the book *The Portrait Miniature in England* by Katherine Coombs.

Holbein had no difficulty in applying his skills to portrait miniatures. One of which, a miniature of Mrs Small (previously called Mrs Pemberton), was said to be so fine that if Holbein had never painted anything else he would be famous for this miniature alone. Mrs Jane Small is set in a very unusual decorative frame, and can be seen at the V&A Museum in London (the frame is not original, and is believed to be of Spanish origin). The portrait was painted in gouache on vellum, stretched over a playing card, which can be seen clearly on the reverse. Holbein's style influenced other artists when came to to the Court, and the art of portrait miniatures was embraced by more artists in England.

Some of the most beautiful and elaborate miniature portraits

My sketches of the backs of paintings by Holbein, showing what he and his contemporaries used to reinforce the vellum they painted on, because it was the only card they had at that time.

can be seen in the work of Nicholas Hilliard, who was also a silversmith, who made these frames for his miniatures. Hilliard also applied silver and tiny jewels to his portraits to make them look lavish, and also to illustrate the jewellery and pearls worn by Elizabeth I and the ladies of her court. He was followed by Isaac Oliver and his son Peter Oliver. The development of the art of the portrait miniature, and the artists through the centuries, follows in Chapter 2.

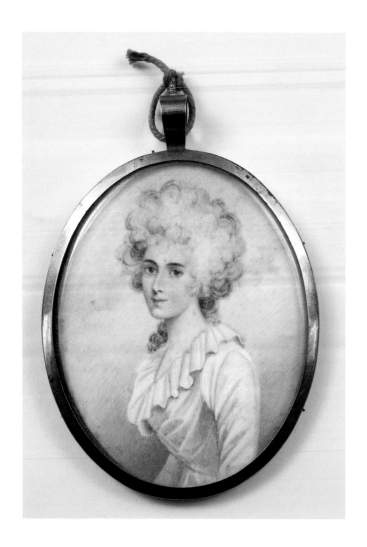

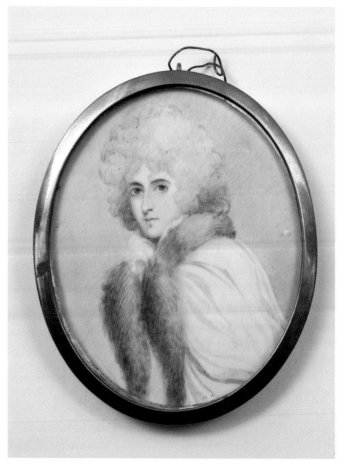

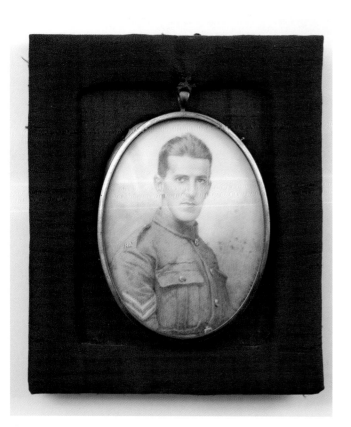

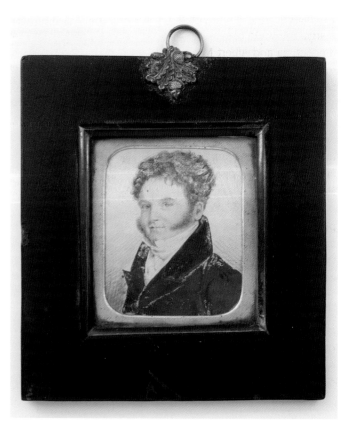

MINIATURES EXPLAINED

As stated previously, it is generally misunderstood that any small painting, in any medium, is a miniature. The word 'miniature' is in fact, derived from the word 'minium'. This was the name for the red lead that was used to illuminate the capital letters in manuscripts, on vellum. These were usually written by monks, who were known as 'scribes', able to write at a time when many people could not.

Even monarchs were sometimes unable to sign their name on letters written by scribes, so a small circular portrait was painted in place of the signature, so that the person to whom the letter was addressed would recognize the sender. Eventually, these portraits were cut off and framed, and became keepsakes from loved ones, in the same way as we keep photographs of our families and friends. (They were not always a very good likeness, however.)

King Henry VIII commissioned Holbein, arguably the best portrait painter of the period, and an excellent miniaturist, to paint a miniature portrait of Anne of Cleves, whom Henry wished to marry. The portrait, which is now very famous, can be seen at the Victoria and Albert Museum in London. It is circular, as all miniatures were at that time, and framed in an unusual and beautifully carved white ivory round box. This was cut from a whole piece of ivory, so that the lid fitted perfectly, and the painting, protected by crystal, is the pleasant face of a young woman, Anne of Cleves. The King was taken by it and travelled to Flanders to meet his bride. Sadly, when he met her face to face, he was most disappointed, and unkindly called her 'The Flanders Mare'!

Holbein must have decided to paint her sympathetically, to please the King. A later miniaturist, Samuel Cooper, whose miniature portraits were more lifelike, was commissioned to paint Oliver Cromwell, who commanded that he should be painted exactly as he was, 'warts and all' – and this is where the saying comes from. Another saying comes from the history of mini-

ature painting, a little later, when there was a fashion for painting the eye alone, very small, which was then framed in a locket or brooch. It would be given to the loved one to wear during their separation, and from this came the phrase, 'keeping my eye on you'.

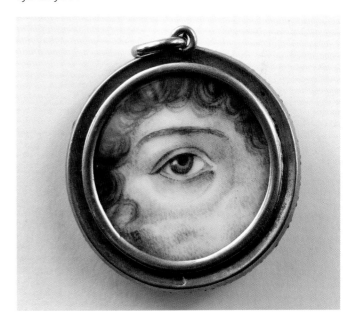

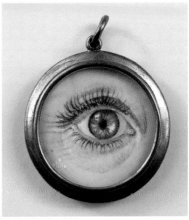

These are two of my small eye miniatures, from which come the phrase, 'I have got my eye on you', when the loved ones were parted. The smaller of these, my own eye, drawn from life and surrounded by a strand of hair, was exhibited at the RA Summer Exhibition 1993. The other is a copy of an original eye painting. Both are about 1inch in diameter, painted on ivorine in watercolour.

OPPOSITE: *These are examples of some old miniatures that I have collected. The two ladies are actually the same person, painted at different stages in her life. All are approximately 3 × 2.5in pained on ivory.*

So it can be understood why miniatures were always small, sometimes extremely so, and in the earliest times they were nearly always portraits. These were circular, and cut from the vellum manuscripts. As the genre developed the circle format became elongated into an oval, which also changed in shape as different artists moved on to other sizes. Later miniature works were slightly larger, but still a maximum of 8 × 10 inches, and painted using the same technique as portraits. They were called 'cabinet miniatures', simply because they were not carried on the person, like the eye, but put on display in rooms called 'cabinets', where they could be viewed in special cases. It is believed that this is the derivation of the word Cabinet, used in modern Government.

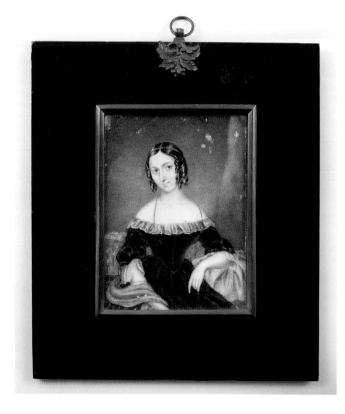

This larger painting, using the miniature technique of stippling and hatching, is a so-called Cabinet Miniature, which is showing the signs of wear and tear, due to its age.

Supports used by early miniaturists
Vellum

By far the most important reason for miniatures being singled out as special and different from traditional painting, was not the size, but the support upon which they were painted. Hol-

bein and Hilliard would paint on card, and, as suggested earlier it was usually a playing card. This was then covered with a skin, which sometimes came from a chicken, but the finest of all came from an aborted calf, where the skin was smooth and fine, and unblemished by hair growth. Whichever type of skin was used, it was stretched over a circle or oval cut out of the card, and held in place by a type of gesso paste laid evenly on the top. This was called a 'carnation', and was burnished when it dried, which made the surface very smooth. The artist would have several of these prepared and coloured in various skin tones which were then matched to the sitter's colouring. Nowadays we call this type of skin Kelmscott vellum, which is usually goat or calf skin (not aborted) filled with gesso, and smoothed and polished, which makes a really lovely surface to paint on. The gesso was made from plaster of Paris; today there are different types, but they are usually made from acrylic media, as they dry quickly. (Kelmscott takes its name from the area it is made, in Oxford, and it is where the artist and designer William Morris lived.)

Ivory

It was not until the eighteenth century that miniatures were painted on ivory. An Italian lady miniaturist named Rosalba Carreira, from Venice, first used it, and so it is to her that its discovery is attributed. It quickly became the most popular support for miniaturists to use. Portrait miniaturists liked the translucency it gave to the portraits painted on it. A very thin sliver would be cut from the elephant tusk, which was polished until it was very smooth, to remove any natural grooves from the surface. This made the ivory highly resistant to the watercolour paint applied to it, and so a special technique was devised to make the paint stay in place, called stippling, or hatching.

Miniaturists copied these techniques used by etchers, who were often craftsmen as well as artists. The most notable were Dürer and Rembrandt, who drew straight on to metal plates, which had been cut to the desired size of the work. Historically these plates were usually made of copper, but contemporary etchers use zinc, as copper nowadays is very expensive. Nevertheless, even today copper is still the preference of most skilled modern etchers.

Etching

The etching process is begun by the artist transferring a specially prepared, carefully drawn and researched image, directly on to

achieve all of the different tones and textures which make up the etching.

In order to create these forms, shadows and tones, the etcher uses a special technique with his stylus, making tiny strokes or lines ('hatching'), and tiny dots ('stippling'). In areas of shadow, the strokes are cross-hatched, to create depth of tone. The dots are close and dense, or well spaced, to create areas of light or dark.

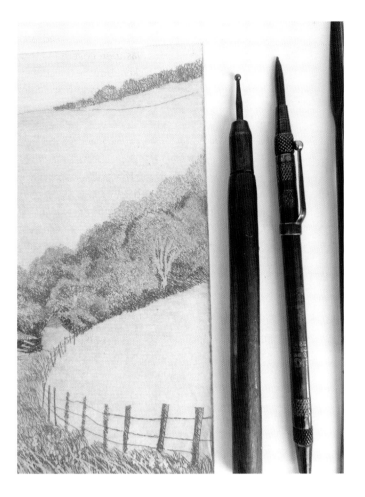

A proof of an etching, hand printed and coloured with ink, by Brian Denyer Baker, to show the strokes, hatches and stipples which are made on the plate by the tools illustrated. This technique builds up tone and texture, and was used by the earliest miniature painters.

The zinc plates used for printing etchings show more clearly how the etcher has to draw his subject matter in fine detail, using different strokes, like stipples and hatches, with the stylus or needle. It has to be worked on in reverse, so all readable parts will print the correct way round.

the surface of the metal plate. To do this they use a fine stylus or even a needle. This is also called engraving, and for etching, it is always done by hand.

The artists have to be very skilled in their draughtsmanship, because any mistakes made on the plate are impossible to correct; the drawing has to be absolutely accurate, not only in composition, but in tone as well. A lot of preparatory sketches of the shapes of objects, patterns and the different areas of tone are made. This is the reference the artist has to follow as he transfers the composition directly on to the plate.

The lightest parts of the plates are then sealed with a barrier of soot or wax, to protect the metal underneath it, so that when the plate is immersed in acid, the unsealed parts are eaten away by the acid. This is done several times, before printing, to

It is all worked up very gradually until the desired overall effect is achieved to the satisfaction of the artist. Several prints are made, or proofs (so called because they can still be altered), by inking up the plate, with the ink worked onto a special gela-

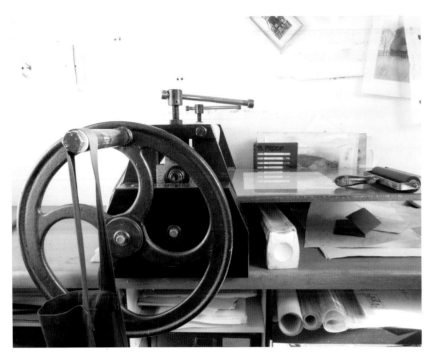

When inked up by hand using a method called 'à la poupée' (described in Chapter 5), the plate is laid on the bed of a press like the one shown here, ink side down on a sheet of damp paper protected by a blanket. Then rollers are passed across it by winding the handle through the press so that the ink is forced into the paper, and a print is made. Each one is printed separately.

tine roller, then rolled very evenly on to the metal. The plate is placed, ink side down, on a sheet of damp paper, on the flat bed of an etching press. The heavy rollers on the press are run over the plate (which is covered by a special woollen blanket, to soften and even out the pressing) by winding a handle, forcing the ink and the drawing into the paper.

This process is repeated several times, on new sheets of paper, until the printmaker is satisfied with the result. These initial proofs 'artist's proofs', which are often different from the finished work, are unique. When satisfied with the print, at the final stage the artist will sometimes hand colour parts of the plate with coloured inks, using the poupée (see Chapter 5). In this way some of the prints (of which only a limited number are made) are different from the prints that are printed in a monotone. These are quite sought after by collectors. The metal plates can only be used for a limited number of etchings, as they wear out eventually, and have to be destroyed. Each limited edition print is signed and numbered by the artist, which are sold both framed and unframed.

Painting miniatures

The miniaturists copied from the etchers the techniques of stippling and hatching, but instead of a needle they used a loaded paintbrush, like a pen or pencil, to paint the portrait, and build up the colours in layers, separately, by putting one colour alongside another – thus mixing the colours in the eye, rather than on the palette.

In the dark areas, the colour has to be built up in many pale layers. Each layer has to be pale and dry; if the layers are too wet they mix together, instead of remaining separate, and the luminous effect will be lost. The technique ensures that the paint stays on the non-absorbent surface. If dark colours are painted on too wet and thickly in watercolour, they can flake off when dry.

This method of working is the key difference between miniature painters and artists who paint larger works of art. In order to make sure the darker layers of paint are applied evenly, it is best to finish the whole area with one colour before changing to another. An almost foolproof method, which I have worked out, is to hatch with one colour, and then cross-hatch with the same, all over the dark area. Let it dry, and then stipple the second colour in the holes of the trellis-like pattern between the cross-hatched strokes. This creates an even key, so the paint cannot flake off, because it has been applied with several layers.

Polymin and ivorine (see Chapter 3) have an eggshell-like, non-absorbent surface, but if the artist is using Kelmscott vellum, the watercolour can be painted in darker layers (and fewer of them) to get the deepest areas of colour, still making sure the paint is not too wet. Because the gesso on the skin is absorbent, in spite of being smooth it will come off on the brush if the paint is too wet. Works painted on vellum are sharper because of this absorbency, but the paintings lack some of the translucency of polymin or ivory.

Georges Seurat, the French Impressionist, painted with the stippling technique, but on a much larger scale of course. It was called pointillism; the effect was achieved by putting blue oil paint dots next to yellow, for example, and so creating the green of grass. However, when this technique is used on ivory

The stippling and hatching technique, shown here on polymin (an ivory substitute, made from petro chemicals) in two colours only, light red and viridian, which are applied separately and not mixed together, so the colours mix in the eye of the observer.

substitutes, by painting tiny watercolour stipples and hatches on an almost transparent surface, a glow is created which is quite unique to miniature portraits.

Sadly, these days it is no longer possible to find authentically sourced ivory to paint on; due to concerns about animal cruelty and a rapid decline in elephant populations, it is not acceptable to paint on elephant ivory. Old ivory is therefore very scarce but painting on it is really satisfying, and the results are very beautiful. However, quite recently mammoth ivory has become available, sourced from Russia, where tusks have been buried for centuries in the frozen ground. It is quite fragile, and tends to craze and break up if cut by an amateur, which is probably the result of having been frozen for so long. It can be purchased ready-cut in standard sized ovals and rectangles. If it is handled carefully and framed securely, any work painted on it will last as

If paint is applied too thickly when stippling, it will flake off when dry, as it has done on the is old miniature portrait. I have restored it, which takes a long time because the colours must match exactly.

long as any other support. Like ivory it is a lovely surface to paint on, and has all of the special qualities of elephant ivory.

Supports used by miniaturists today
Ivorine

Another product was used by modern miniaturists from the beginning of the twentieth century called ivorine, or xylonite. This was made from cotton fibres dissolved in nitric acid, called nitrocellulose. It was also transparent and was a very good substitute for ivory. Before the use of the by-products of petrochemicals (i.e. plastics like polymin) ivorine was used to make all sorts of household items, from combs and buckets to plant labels and latterly ping-pong balls.

Until fairly recent times it was still available for use, made and imported from Italy, and sold by miniature art suppliers. It cannot now be obtained in the UK, but it is still available in America. Ivorine will deteriorate if not stored carefully, and is particularly sensitive to light and heat (it is also highly flammable). It will warp and twist and eventually curl beyond use, if not stored away from ultra violet light, and wrapped carefully to prevent it from drying out. Ivory too, will warp and eventually crack, unless it is kept flat in a frame. It can be repaired if the break is flat, but it spoils the look of the painting unless it is repaired by a skilled restorer, and if the break is across the face within the portrait it devalues the painting quite considerably, in spite of the reputation of the artist who painted the work.

Polymin

All the information given in this book about painting on polymin also applies to ivorine. However, as with every support

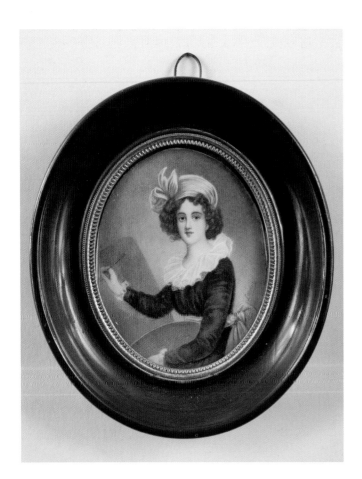

Ivory, which is what most old miniatures are painted on, will crack if it is not kept carefully, because it curves back to the shape of the tusk. This miniature has a crack across the top right-hand corner, which I have repaired. Repairs have to be invisible!

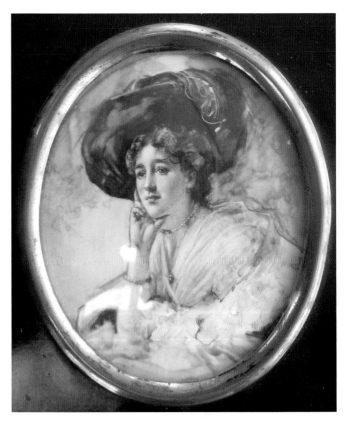

This portrait, painted about 1900, has been damaged by condensation. If ivory, ivorine or any non-absorbent surface gets damp between the glass and the painting, the watercolour will get damaged, as shown on this example. The face, in this case however, is not affected.

used by artists, from canvas and every other surface available, it must be stored carefully. No support is indestructible! Contemporary miniaturists prefer to use polymin or vellum, whilst some use smooth paper or special board. Recently a new paper called Yupo or sometimes Lana, has become available, which has a velvet-like surface, to which watercolour paint adheres readily. This will take thicker paint without flaking off so it is a good base upon which to paint silhouettes. So is Kelmscott vellum, but the best way to look after miniatures painted on any support is to make sure they are framed as soon as they are totally dry and complete, so the work is held securely in place.

Those painted on ivory substitutes should be protected with a wax coating before framing, and then they should always be hung in areas away from excessive heat, bright sunlight or damp conditions. The convex glass traditionally used to cover miniatures is to prevent any moisture that might form inside the glass from dropping onto the painted surface, and spoiling it. If condensation does form on the inside of the convex glass it will be able to roll down inside the curve of the glass, and away from the picture. In spite of this, damp can still cause damage to the work, if the moisture forms and reforms too much.

It is really down to common sense to care for precious paintings sensibly. Then they should last as long as any of the miniature works of Holbein, Hilliard, Cooper, Smart, Cosway and Engleheart have done.

Old miniatures

A great number of old portrait miniatures sold today are titled 'portrait of an unknown gentleman' (or 'lady'), in the auction house catalogues. A piece of paper containing all this information, written by the artist, was placed between the painting and the back of the frame.

The artists did not sign the back of the painting as it would have shown through the ivory. Over time, the backs of the frames were taken off to find all the details about the work, and

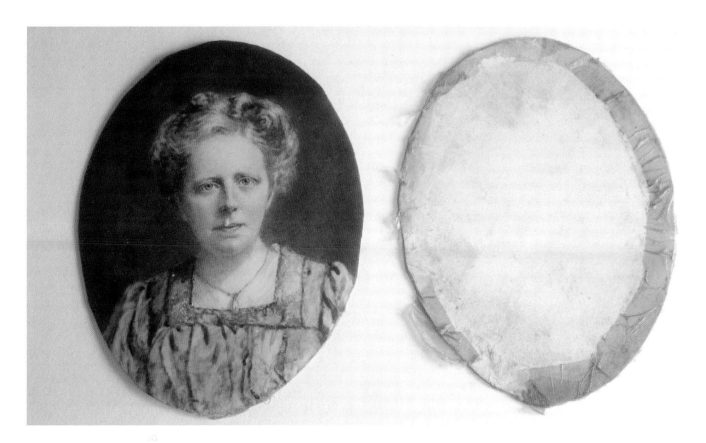

To prevent damp and dust getting in and on to the painting, earlier miniatures were sealed to the backing paper by a special tape, much like the stamp hinges used by stamp collectors in the early twentieth century. It was dampened and bent over the two edges to make a dust and water tight seal.

the information was very often lost for ever. Artists did sign their works, however, usually with a specially designed monogram, which was discreetly placed near the bottom of the picture.

If you take the time to study old portrait miniatures, and maybe copy one or two to learn about the technique, you will soon begin to recognize the style in which they were painted, as each artist had his own distinctive way of working. The portraits of Holbein for instance, were simply but beautifully drawn, delicately painted, and very lifelike; he only painted on vellum. The works of John Smart, in constrast, were always painted on ivory, and he had a distinctive way of painting the eyes of his subjects, which are always recognizable on his miniatures.

Later artists like Andrew Plimer, although very skilled, had a much more stylized technique; some other portrait miniaturist styles were very naïve, simple, and quaint. The portrait miniatures painted by Richard Cosway were painted in a more sketchy style, with very little colour on them, but he was able to get very good likenesses. His portrait of George IV is gives an insight into the king's character and lifestyle.

Painting a miniature portrait, by Bill Mundy

Prior to painting the miniature I usually make a detailed sketch of the subject, together with a photographic session. Most people are not prepared to sit for over the 40–50 hours it takes me to paint a miniature portrait, so photographic reference becomes a very useful tool.

Having made a basic colour sketch of the sitter it is then reduced in size to fit the dimensions of the (normally oval) gold-plated frame. It is important to draw the portrait within the oval to ensure that it sits nicely, leaving enough space above the head, and incorporates a slightly larger amount of body when compared to the head length.

I then draw an exact outline of the painting with a 2H pencil on thin paper, which I cover the back of with soft (3B) graphite. This then is traced down onto the surface I will be using to paint the actual miniature. (My preferred surface is vellum, because of the stability and particularly in view of the fact that very sharp brushstrokes can be achieved on this material.)

After rubbing off the graphite I then, with the point of a size 00 best quality Kolinsky sable brush, lightly apply thin lines of watercolour – yellow ochre and vermilion for the face, and a variety of colours for the clothes. Quite often I commence the build-up of colours by painting the background or the clothes first. This sets the tone and depth of colour for the portrait, leaving the cream of the vellum untouched for the face. If I had started with the face it might have become too pale, and then it would have needed more colour and detail to balance properly.

Generally the colours I use for the face are Vermilion and Yellow Ochre with touches of Davy's Gray for shadows, together with Violet and warm Sepia for darker areas. When painting hair it is best to follow the shape of the hair and to paint in small, free little lines, building up the colour as you go along. I never use white on my portraits with two exceptions: gouache white for the dots of light in the eyes, and for white hair if the sitter has a white beard or moustache. I never mix gum arabic with my colours (Winsor and Newton half-pans of best quality watercolour). To attain the ultimate detail – so important to obtain a good likeness – I work through a circular magnifying glass fitted with correct bright white lights. There is nothing worse than working under normal light only to find the following day when looking at the miniature in daylight that the colours are all wrong.

This painting of Dee Alexander by Bill Mundy, in watercolour on vellum approximately 3.5 × 3 inches, is a fine modern example of all the techniques described in this chapter.

Modern miniatures

Today, one often hears comments at exhibitions of modern miniatures, about the photo-realistic quality of some portrait miniatures – such as, 'why not have a photograph?' Of course it was not an option historically, and the painted portrait was the only way to have a portable likeness of a loved one. Nowadays this photo-realism is the norm, and has become the accepted modern way of painting miniatures. Many miniaturists who exhibit in society exhibitions are very skilled at this technique. But it does take a very long time to achieve, because the end product has to look flawless. There are some modern artists who stipple all the parts of the miniature, the background, clothing and any other objects included in the painting.

If you care to make a study of the techniques of historic miniature paintings in the Print Room of the Victoria and Albert Museum, you will find that only the smoothest areas are stippled. (If you do want to look more closely at miniatures in the Print Room, ring first to make an appointment, as it is not open every day.) However, the clothing and any scene depicted behind the sitter in the background are painted in the traditional way, and jewellery can be painted in an almost impressionistic manner. If looked at closely under a strong magnifier, the minimal use of strokes to depict these details is quite accomplished.

However, there is also considerable skill employed by the artist whose miniatures still look like paintings, not photographs. It is takes just as accomplished a miniaturist to get a likeness in the small format of a miniature, but still produce a painting. The artist has to capture that elusive core quality of the person coming alive for you as you look at the portrait. If you can achieve this it is a very satisfying experience, and you may be commissioned to paint miniature portraits, which is undeniably even more encouraging.

A BRIEF HISTORY OF MINIATURE PAINTING

As we have seen in the previous chapter, miniatures in England and the rest of Europe were usually portraits that were painted in the place of a signature, and often cut out and kept as a treasured memento of a loved one. It is fascinating to discover, however, that far away in the East, especially in India and Iran, miniatures were being painted at about the same time as Holbein and others were doing so in England and other parts of Europe.

These eastern miniatures were allegorical and decorative and told stories of domestic scenes in exotic gardens, with animals, birds and flowers. Battles on land and at sea were painted very naively, but were amazingly small in size. The Moghul miniatures illustrated stories of love and courtship, some of which were erotic and intimate.

(More information on how to paint an Indian miniature, and how the students in India learned how to practise brush control, can be found later in this chapter. Instructions on how to make your own gessoed support are given in Chapter 5, and for burnishing and decorating with gold leaf – the art of *verre églomisé* – see Chapter 10.)

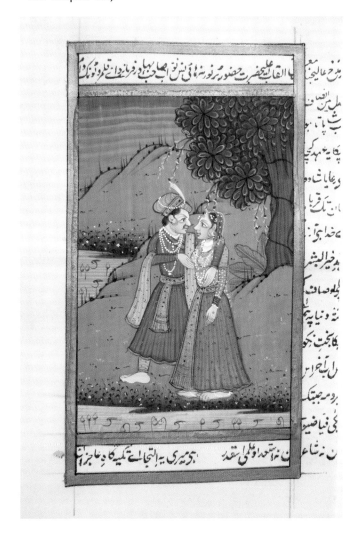

OPPOSITE: This 'Decorative Miniature' is painted on a porcelain plaque. These usually came from Europe, and were quite stylized and painted in a traditional way, but still quite small. This one of the Duchess de Parma has a lovely deep blue border with a gold pattern. This may have been made by a transfer, and was not necessarily painted by hand.

A typical Indian painting of a love scene in a garden. Although it is about 5 × 9 inches, the figures of the couple are small, and the decorative border is very detailed. Although the Indian miniatures were usually painted on vellum, this one is painted in watercolour on paper, and the techniques used to paint it are not the stipple and hatch technique used in the west. The hairs on their brushes are curved, and the artists use very fluid strokes. They have to learn how to control these special brushes to make these curved shapes from a very early age, until it becomes second nature, which makes their miniatures so distinctive.

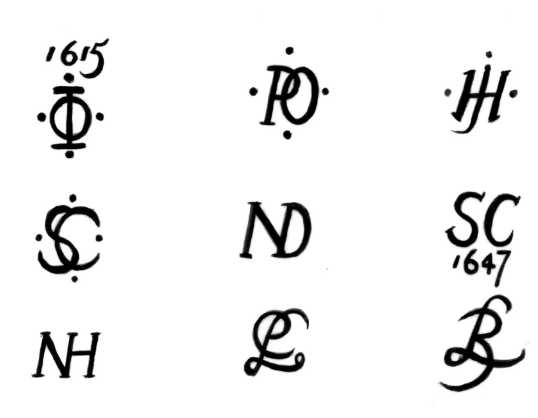

The earliest miniaturists all signed their works, with a special logo, usually comprised of their initials. These had to be very discreet, so they did not overpower the miniature. Several of the more famous ones are drawn here.

Logos of early portrait miniaturists (top row, left to right: Isaac Oliver, Peter Oliver, John Hoskins; middle row: Samuel Cooper 1, Nicholas Dixon, Samuel Cooper 2; bottom row: Nathaniel Hone, Peter Cross and Bernard Lens).

A rather poor photograph of the fifty-three miniatures selected by Sir Peter Blake for the Royal Academy Summer Exhibition in 1993. This was a rather special year for miniature painters, as we had never been so well represented before (or since). In fact some of us had all three entries selected and hung.

There have been three distinctive periods of miniature art in England, each of which has taken its inspiration from a great artist of the period. If you look carefully at these miniatures in collections and museums, you may notice that they are often signed by the artist, but rarely in full: often they are logos of their initials, painted very finely in gold, and are quite small, tucked away in the background.

The sixteenth century

These earliest miniatures were mostly two-dimensional, with very little modelling to the face. They took their inspiration from illuminated manuscripts, which were painted in gouache on vellum, in a simple style with no shadows on the faces. There is evidence that Elizabeth I did not like lines on her face in her portraits, so she insisted upon being painted in bright sunlight. This preference was then copied by the ladies of the court, and as a result the paintings were quite flat.

The period is dominated by Hans Holbein the younger; fine examples include miniature portraits of Tudor kings and queens and their court. These miniatures were frequently round, small, and always painted in gouache, on vellum or paper, mostly of men. The backgrounds were generally plain, and in a single colour, blue or red.

The seventeenth century

The second period was influenced by the genius of van Dyck during the seventeenth century and may be classed as the Stuart period. As well as circles, the short oval shape was introduced, there were shadows on the faces, and the work was generally bolder. Backgrounds were varied, and included skies and curtains. Vellum and card was used for gouache, and oils were painted on metal or slate. A large number of portraits were still of men. Samuel Cooper was considered the finest English miniature painter of the Stuart period. He worked on vellum card and paper, starting quite broadly, and continued with great attention to detail. His faces were very well drawn, with the shadows properly placed. The flat decorative style of the past was gone, and his portraits were strong and lifelike. He painted the hair better than any one before, even Holbein. Cooper's idiosyncrasy was that he often painted only the face and head, leaving the clothing and background roughly sketched.

The eighteenth and nineteenth centuries

The period marks the use of transparent watercolours, with more portraits of ladies than men. There was now a preference for the long oval shape, and miniatures of this period were influenced by the work of Sir Joshua Reynolds, which still influences the style of miniature painting today. Until this third period, artists had used gouache on paper, card or vellum; this was a time of transition from the exclusive use of gouache to aquarelle, or watercolour.

Rosalba Carriera, an Italian miniaturist, was the first to use ivory as a base for her portraits and its discovery can be attributed to her. It was the English miniaturist Richard Cosway who began to favour it over paper or card, always using it with water-

Miniatures at the Royal Academy

Miniatures were well represented at the RA Summer Exhibitions when Reynolds was President, as is illustrated in The Portrait Miniature in England by Katherine Coombes, where there is a drawing of the exhibitors gathering around a display of many miniature paintings. Miniatures have been called a 'tour de force' by the establishment, with very few being selected, and even fewer hung.

All works entered for the RA Summer Exhibition have to go through two selections in effect, because even if a work is chosen by the selection committee, it has to be selected again by the hanging committee (different from the first) according to the space available.

At the end of the twentieth century, cases were made to house the miniatures that had been selected, for security reasons; this all adds to the costs of the displays. But in 1993, when the academician Sir Peter Blake was selecting, a record number of fifty-three miniature paintings were accepted and hung that year. This was undoubtedly because of Blake's appreciation of smaller works arranged in a case, with a collage-like presentation.

Sadly, in the first decade of twenty-first century, there have been fewer and fewer miniatures hung at the Royal Academy Summer Exhibition. Nevertheless, many of the highly regarded artists illustrated in this book have had works both accepted and hung at the RA during the last twenty years.

colour. He painted elaborate miniatures, but quite quickly, and produced many of them. Unfortunately, watercolour portraits on ivory faded badly unless protected from light – this is why a lot of his work appears pale and washed out. Lovely as ivory was to paint on, a stippling technique had to be used, after the initial broad start, and gave an especially high finish to the work.

Cosway was, apparently, greatly influenced by the portraits of Sir Joshua Reynolds, the first President of the Royal Academy, and he and his wife Maria (née Hadfield) also became Royal Academicians.

Indian and Tudor miniature techniques
Indian miniatures

In the late 1980s the National Gallery hosted a course devoted entirely to the Indian miniature painting technique, run by an expert in this style of painting, Anita Chowdry. At that time the Society of Limners (an organization for miniaturists and calligraphers) was new, and a group of the members were keen to attend, including Michael Bartlett (see below).

The course included making our own support – this was basic calligraphy vellum (not Kelmscott), which had quite a lot of grain marks. Each artist was given an off-cut, which was stuck onto a card base with masking tape to hold it firmly. We were then shown how to cover it with gesso, to fill in the imperfections. Once dry, we polished it with a traditional agate burnisher, but you can use the back of a metal or ceramic spoon.

Examples of work from a two-day course on Indian Miniature painting held at the National Portrait Gallery, with Anita Chowdry. We did exercises to get the flow of our strokes loose and flowing, using the special brushes, kindly lent to us by the tutor.

In the meantime we were all lent a special brush, which is used exclusively for Indian paintings, made of squirrel hair. It appeared to be bent, but this was how it was meant to be, in order for students to practise the special scrolling and curving brushstrokes that is used for these paintings. We practised this style on paper, and discovered that it was very different from the way of working that we had become used to. Young apprentices in India have to practise these strokes for years before they become proficient enough to start painting their own works. They also learn to grind their own pigments, which they keep in mussel shells, and to make their own special brushes.

Indian miniature paintings are always drawn in black paint first, directly onto the vellum. The design will have been worked out beforehand, and then copied. We all chose from a selection of images, and settled down to work with our home-made vellum, black paint and Anita's brushes.

As you can see from the two sample works, it was a completely new technique for us all. The first one is by Michael Bartlett, who chose to paint a gentleman. You can see all his trial strokes in the top left-hand corner of his test piece; this was to keep the paint fine and dilute, before he put it to his base. I tried out a lady, as I was fascinated by the special style of the eyes, which is so typical in Indian portraits. It was not as easy as you might think, as the fine, dilute paint on the brush kept running out, as it was sucked into the gesso. This made it harder to make the flowing style of strokes required. I can remember wishing I had a sable 000 to use instead! However, it was a learning curve and I had to try it out exactly as it was traditionally done.

After every process, for instance drawing the face and hair and features, the image was allowed to dry (which did not take very long); then the whole piece was burnished again, followed by more colour and patterns of the clothing, etc. Gold paint was used to embellish the fabrics and burnished when dry, so that the whole painting had a sheen to it, and the gold was bright. By doing this often the surface was kept smooth and firm throughout the process. The experience made me appreciate and understand the style of Indian miniature painting, which I liked very much.

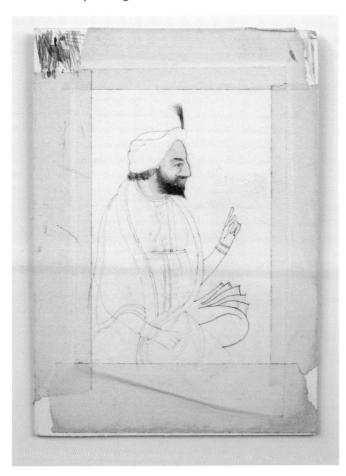

After the exercises, each of us made our own vellum. We covered pieces of goat skin with gesso in several layers, burnishing (with an agate burnisher or the back of a spoon) each layer before the next. The next day when the paint was completely dry, it was burnished again. Then we copied from real Indian paintings, as these two examples illustrate.

The image below is a tiny gold brooch (only ¾ inch in diameter) with a Maharajah, which I was lucky enough to pick up in an auction and add to my collection. Sadly, I forgot to take him off my blouse and he went in the washing machine! Though a little damaged (he has lost some of his eyelashes), he is still 'there'.

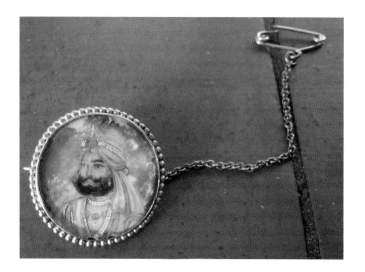

This tiny brooch contains an original Indian painting of an important gentleman, whom I call the Maharajah. He is only about one inch in diameter, and sadly is damaged due to me leaving it on my shirt and putting it in the wash!

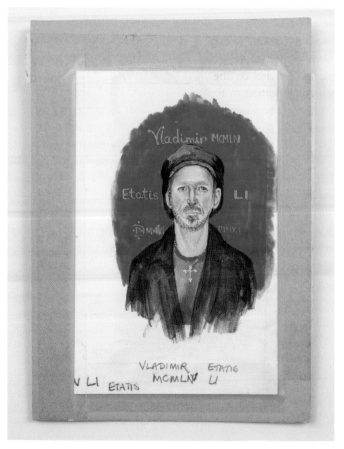

Painting in the style of Holbein

Another course coincided with an exhibition of Tudor paintings including those of Holbein, in particular his outstanding portrait miniatures such as the exquisite Mrs Jane Small.

During this course we learned how Holbein and his contemporaries used to paint. This time we had to use thick paper, not vellum (although Holbein used vellum for his portrait miniatures). This course differed from the first in that we had a live model, so we worked, as Holbein did, from life. We had to learn how to lay a thick gouache wash over the background to the painting before we started on the portrait, which was not easy.

Having drawn from the image of our choice, we mixed the paint up on a plain white tile to a creamy consistency, to fill in the background around our drawing. The paint was sucked up by the paper and the results were very patchy; we needed a lot more practice. During the first day, we had several sessions drawing our Russian model, Vladimir, at an easel, art school style. However, we did not use pencil, for the same reasons we

Work from another course, this time on Painting Miniatures in the Style of Holbein, which coincided with an exhibition of his paintings at the National Gallery. This time we only painted on paper, but tried to lay the thick gouache wash of colour on the background evenly. It was difficult, as can be seen from the first trial. But my final effort was better, and I also attempted the gold lettering which Holbein used on his works, to indicate the age of the sitter, and when it was painted.

do not use it to draw our miniatures today; instead we used thinly diluted paint, in green. No alterations could be made, so we made lots of drawings to get it right. On the final day and having decided on the pose we liked best, we proceeded to paint the portrait as the style dictated. No stippling or hatching was suggested, but the paint was still applied in layers, so that the likeness and the colours of the clothing were built up that way. It was more difficult to get the likeness right because it was not possible to 'lift off' the paint, as I was used to doing. This forced me to apply the colours and shadows on the face in very pale layers, until they were built up enough to show the details.

Traditionally, portrait miniatures of the period were embel-lished with lettering (usually in Latin) giving the date and the age of the sitter horizontally across the blue background in gold. The backgrounds were usually blue, during the Tudor period, but began to change later when Isaac and Peter Oliver were painting portrait miniatures. Sometimes the backgrounds were allegorical, and more textured, and different colours were used.

Miniature painting is, as we have seen, quite versatile, and the rules that have to be adhered to vary according to the different supports used. The finely painted details and size that dictate the miniature style, and the time it takes to paint them, are all reflected in the cost of collecting them, but they are little masterpieces after all!

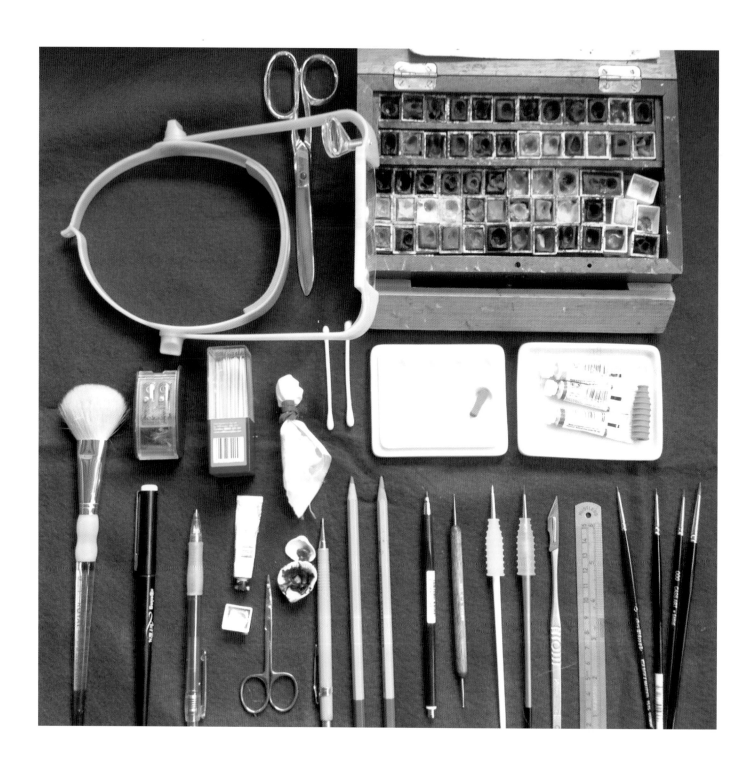

MATERIALS AND WORKSPACE

Art materials

The quality of art materials varies tremendously, and all sorts of equipment is widely available nowadays, but if you are serious about learning how to paint miniatures, which are by their very nature a Fine Art genre, it is important to know about the best materials you can buy, and the manufacturers who supply them. If you are just starting, or 'trying out' the best, at least you will be off to a good start.

If you already have some brushes and paints left over from an evening class compare them with the list below, and add to them if necessary. Brushes in particular get very worn, or damaged by the bad habit of not washing the colour out of them between each painting session, so it is advisable to buy new ones for miniature painting. There are not as many specialist art suppliers in the high street these days as there once were, and usually they stock inexpensive equipment for the newly popular craft market. They do have acrylic brushes in packets, which are useful (and can be used for mixing up later when they lose their points), and they usually keep a small selection of artists' quality watercolours. However if you want to use oils or acrylics, you will have to find a specialist

OPPOSITE: Materials used for painting miniatures.

art materials supplier, such as Cornelissen and T.N. Lawrence. These suppliers are known as 'colourmen', and can provide pure colour pigments as well as general art materials They are all available online, and produce really comprehensive catalogues, in which you will find all the top quality manufacturers listing their colour ranges and sundries, for all media.

The supports used by miniaturists, such as polymin, vellum and ivorine, are only available from specialist miniature suppliers (a full list of which can be found at the back of this book). It is important to see 'in the flesh' the colours you need and the type of brushes you wish to use – catalogues and websites are never able to show the colours realistically, however well produced they are, and as for brushes, they should be tested in water first. You run the wet tip across a fingernail and roll the hairs around to check the point of the hairs before buying, as some are not as good as others. Sables are very expensive, and one rogue hair can spoil the performance of the most expensive brush. Once you find a range that suits you, it is a good idea to stick to that manufacturer.

Watercolour paints

Old tubes and pans of paint dry up, and the pans get dirtied with other colours; if they are very old and hard they will be unusable. My personal preference is for pans, the reason being that my chosen colours are always arranged in the same order in my paintbox, so that I always know where a particular

The Heaton Cooper Studio

My very favourite art supplier is in Grasmere, in the Lake District. It is not very large – in fact the art materials part is quite small – but there is a large gallery attached with prints and sculptures of Lakeland artists, which are all very inspiring. I can never come out of there without a brush or new item, and have found a couple of things that are incredibly useful, and which I have not yet found anywhere else. They are marked with an asterisk in the 'Basic tools and extras' box.

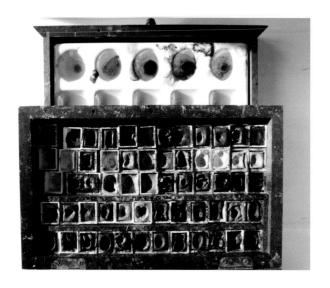

My current paint box, featuring a colour chart on the inside of the lid to remind me which is which!

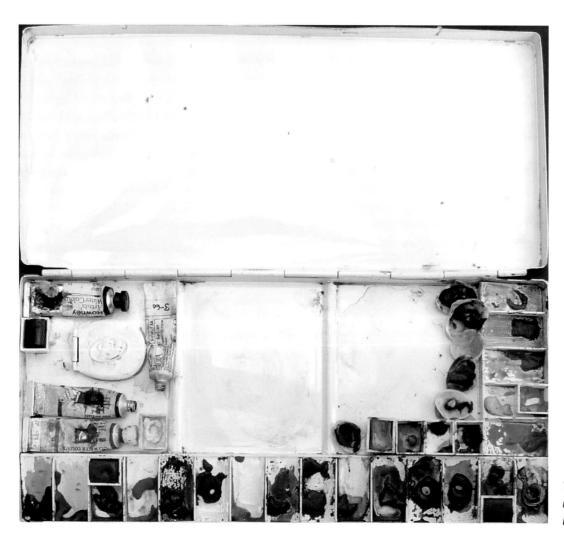

The demonstration box I use for teaching, cleaned between courses!

colour is – I do not have to find the right tube, squeeze some out and get back to work. When the pan is used up, I can then fill it from a tube. I have a list of the all the colours in the same order as the paints, with small swatches on a piece of watercolour paper, stuck inside the lid of the paintbox so it is easy to refer to. Some of the earth colours look very similar when in the pan, and the swatches remind me which is which.

When I start a new work, I mix a separate palette of colours from the main box, and then close it up; this prevents dust, and all the other colours do not then distract me. (I also have another box for use during painting demonstrations.)

If you want to get off to a good start with painting, treat yourself and buy some new equipment. You do not need to spend a fortune! But beware the lure of an art shop, and online catalogues: they can become addictive.

The basic tools and extras

Talcum powder
White tack
Cocktail sticks
Cotton buds
Tissue paper
Tracing paper
Sketchbooks
Clear acetate film
White card
Sticky tape (removable type)
Scalpel + blades
Metal ruler (small)
Stylus
Cutting mat

Scissors, curved and straight
Microfibre cloth
Pure silk square (habutai)
*Marseilles soap (olive oil soap)
*Double pencil sharpener (one hole for sharpening the wood and a second for sharpening the lead)
Magnifying glass
Headband magnifying loupe
Small water pots
Gum arabic
Graphite pencils (2H/2B/6H/9H)
Watercolour pencils: Terracotta, Olive Green, Cobalt Blue, Mauve
Conté sticks: Sanguine, Blue/Green

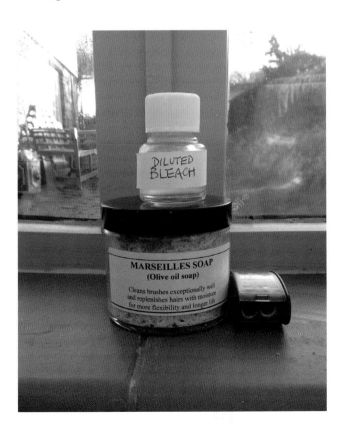

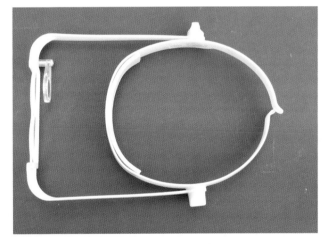

Vital things to have in your box of materials: Marseilles soap, made from olive oil, for cleaning all media from brushes; a double pencil sharpener, which sharpens the wooden part first, and then the lead to a very sharp point; diluted bleach in a glass bottle with screw top, for lifting off stubborn colours on supports; a magnifying loupe which enables miniaturists to work on detail, with individual magnification for both eyes.

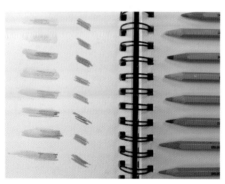

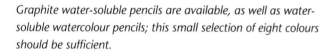

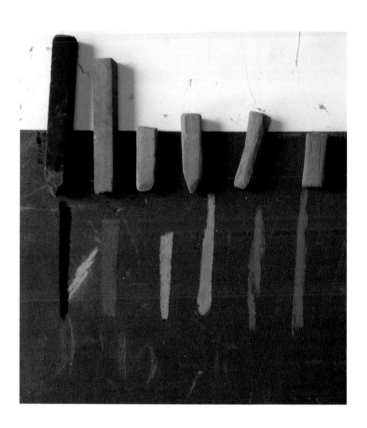

Graphite water-soluble pencils are available, as well as water-soluble watercolour pencils; this small selection of eight colours should be sufficient.

A few pieces of square Conté sticks, used for making wax free Conté carbon paper for transferring drawings (or tracings) to the support. Black, red, green, blue, and sanguine or terracotta will be useful to have in your box.

Other useful items include turpentine, rags (old T-shirts do not shed lint), a palette knife, tear-off paper palette sheets, metal dippers, old trays or lids to cover paints etc., and pliers (to remove lids on tubes of 'stubborn' oil paint).

Brushes

For watercolour

Sable brushes are the best for watercolour, especially when painting fine detail. Treat them carefully: use an old one for taking colour from the pan and mixing. The points will remain sharp and last longer if washed and dried after use. Do not leave them soaking in the water pot as the hairs will bend and remain so.

Keep the best sable you can afford for stippling or hatching. However, brushes made of synthetic fibres are much better for the technique of lifting off the paint from non-absorbent surfaces, when making corrections. When synthetic brushes are new the points appear just the same as the sable ones, but unfortunately after a while the points develop a kink. Although this does not matter so much when painting larger works, when painting miniatures it can be very frustrating.

It is not necessary to buy too many brushes at first: keep to the ones recommended here. It will soon become clear which ones you like to use best. Some experienced miniature painters just use ordinary sable brushes, and do not bother with those specially made for painting miniatures; as long as the point is sharp, they are just as good. The shorter hairs in the spotter and miniature brushes hold less paint, however, which is helpful to beginners.

Specific brushes

Spotters (all manufacturers make them, some in sable too) have a shorter hair length, so the point is quite sharp, and they are better for detail. Use a large, clean powder brush (make-up

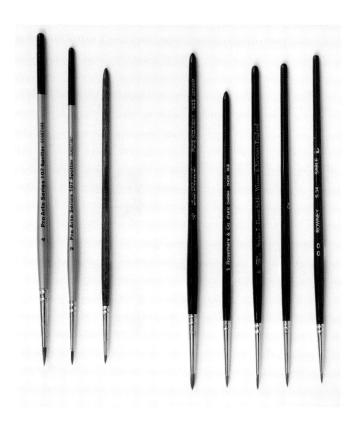

A selection of special brushes for miniature painting in watercolour. Some are sables and others synthetic. The brushes called spotters have short hairs and fine points for getting detail.

counters may be the best place to find these, as larger brushes in art shops are usually expensive) for brushing off dust and talc. Old and worn (but clean) brushes, either synthetic or sable, can be used for mixing and taking colour from the pans.

There are brushes of synthetic and pure sable hair mixed together, but it is best to use one or the other, as the synthetic fibres in the mix will still develop a kink. It is a good idea to have a separate small sable brush if you are using two or more colours, then you can be certain that the colours will remain pure; and keep one small sable for using only Titanium White.

For silhouettes

When painting silhouettes you will be using using the thicker gouache paints. This paint will get into the ferrule of your brushes, and it is impossible to remove. Keep a separate brush for blacks and golds, and any colours you need to use to embellish the silhouettes, otherwise the colours caught in the ferrule (however dilute) will dirty each other.

For oils

When using oil paints for miniature painting, you will have to have a completely separate set of brushes, paints, and palettes. Tear-off paper palettes for oils are very useful, as you can take very small amounts of oil paint from the tube with a palette knife, spread it on the papers, in the order you prefer. Then it can be thrown away at the end of the painting session, or added to the next day.

As cleaning brushes is so important, the list of tools and extras given earlier includes a very efficient brush cleaner, called Marseilles soap, which is made from olive oil. When a small teaspoon is added to some hot water, the gel that forms is the best way of cleaning and restoring the condition of all types of paintbrush. Using a hair conditioner after cleaning is also a good idea – this softens the hairs, so that they stay in shape and do not splay out.

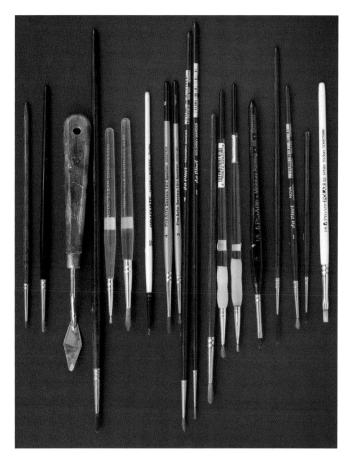

The selection of brushes I use for oil miniatures. Some well worn old ones can be used; fine sables specially made for oils get worn out very fast, so save them for really fine work. Synthetic spotters and cheap craft brushes are good substitutes for beginners.

A Royal Academician once wrote in a book on portraiture in oils, 'If you wake up in the night and realise that you have forgotten to clean your brushes, you must get up, whatever the hour, and go and do it!' This is very good advice; brushes are very expensive, and they will last longer if you care for them.

Use the same recommended brushes as for watercolours; even old ones can be used for oils. The range called Acrylix is specially made for oils, as they are stronger. Special sables are available for oils too, but most of these have very long handles, for using at a large easel. For fine details in oils the synthetic ones are best. They are available in all shapes, from fine long-haired riggers, to rounded cats' tongues.

Harmful chemicals

The following are harmful if ingested:

| Turpentine | White Spirit | Siccative (speeds the drying process of oil paint) |

Most of the harmful chemicals in modern watercolour paints have been removed, but check with manufacturer's list, and if you have some old ones, use them with care. Vermilion, which was made with mercury, is very toxic, and some foreign paints may not be as free from harmful ingredients as those from the better-known manufacturers.

Paints

Artists' quality paints are essential for miniatures. The pigment is ground more finely than the student range, and the colours are better and purer. The limited palette of watercolours listed below is recommended:

Yellow Ochre	Light Red	Perylene Maroon
Raw Umber	Ultramarine	Cadmium Red
Sepia	Cerulean Blue	Cadmium Yellow
Viridian	Permanent Rose or Rose Madder	Titanium White
Winsor Green	Genuine	

Optional additional colours include:

| Cobalt Blue | Alizarin Crimson | Davy's Gray |
| Permanent Magenta | Cadmium Orange | Indigo |

For silhouettes only:

| Lamp Black gouache | Bronze gouache | Yellow Ochre |
| Gold gouache | Silver gouache | Cerulean Blue |

For oil paintings the following palette is recommended:

Titanium White	Indigo	Davy's Gray
Yellow Ochre	Permanent Rose	Light Red
Cerulean Blue	Alizarin	Cadmium Red
Cobalt Blue	Winsor Yellow	Magenta
Raw Umber	Viridian	Burnt Sienna

As an optional extra, Cobalt Violet is expensive, but so useful it is worth it – I cannot do without it!

Water-soluble oils

There are some water-soluble oil paints available. If you are allergic to turps or white spirit, use acrylic or alkyd paints instead, and use a medium called 'Sans Odour'. Acrylics and alkyds dry very quickly, however, so the usual lifting off and correcting techniques are almost impossible to employ.

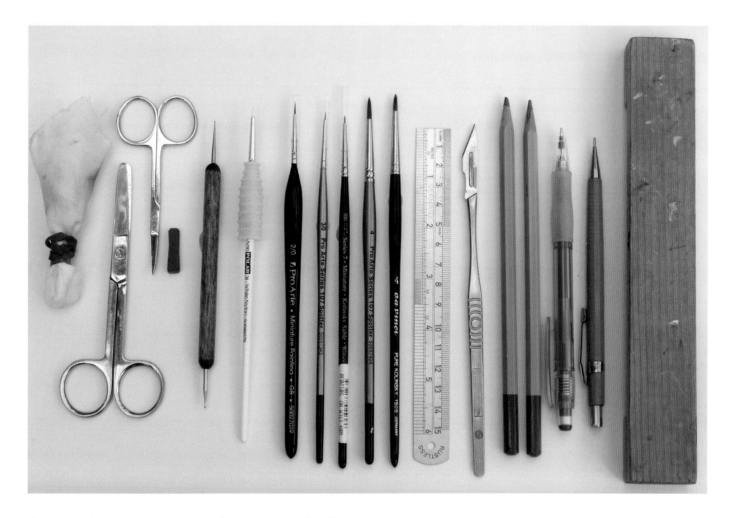

Really essential tools for miniaturists, which you cannot do without.

The essential tools of the trade are: silk poupée, straight scissors, curved scissors, Conté stick (sanguine or terracotta colour), stylus (double ended), basic synthetic brush (with yellow holder) for mixing, Pro Arte Miniature Painting Series (comfort handle) synthetic 2/0, *Pro Arte Series 107 synthetic spotter 3/0, *Winsor & Newton Series 7 (Miniature) 000 (Kolinsky Sable), Pro Arte 107 synthetic spotter 4, Da Vinci 1505 (Pure Kolinsky Sable) 4, small metal ruler (metric on one side and imperial on the other), scalpel, cutting knife, watercolour pencils (Raw Umber and Terracotta), automatic (clutch) pencil in soft blue (size 007 lead), auto-matic (clutch) pencil graphite HB (size 007 lead), wooden bridge (used for placing over work, to prevent smudging when painting).

Workspace and layout

It may not be possible for you to have a separate studio, where it doesn't matter how untidy or cluttered you are when painting. However, just because miniatures are small, this does not mean

necessarily that you need a small area in which to work. In fact, if you are going to be serious about painting and learning miniature painting in particular, it will be very important to decide right away where you will be working.

When beginning a new skill, you need your own place to work in, where you can leave your materials and projects out permanently. You can then pick up your project at any time, or just give it a glance in an odd moment, when often any improvements or corrections will occur to you, and you can jot down a note of what needs altering later on.

There is nothing more off-putting than having to get everything out before you can do any painting, and having to clear it all away every time you have finished. If you are dedicated and enthusiastic about doing something you will be much likely to succeed if you have a special place in which to work. For instance, those who love to cook need a kitchen with a sink, larder, cooker and lots of equipment and ingredients in their cupboards.

In another life as a fashion designer and dressmaker several years ago, I had to get out the sewing machine, scissors, cutting board, iron and ironing board every time I made clothes or curtains. It became more of a chore than a pleasure, and I eventually stopped doing it.

I first started painting miniatures on a course with Elizabeth Davys Wood at West Dean College, and came home determined that the sewing machine would be put away for good! But if I had not had my own space in which to pick up and put down projects when I was practising miniature techniques and experimenting with supports and colours, I should not have found out about the joy of limning – painting in miniature. Give yourself time and space to practise, and eventually submit your work for an exhibition of miniature painting. The Society of Limners (founded by Elizabeth Davys Wood) is the best one for beginners to exhibit with for the first time; they are more aware of the standard of work from first-time exhibitors, and select it accordingly. If your work is rejected they will advise what you need to improve upon, and encourage you to try again.

Your studio

The studio (as I will refer to your workspace) must have good light. The light and the direction it comes from are most important: north light is always best, because it is the most constant. The brighter light of sunshine might seem to be better, but it moves as time passes and is not constant, as it comes and goes with weather conditions. But it is not always possible to have the optimum conditions – in my studio at about 5pm in August the sunlight streams in from the west!

Light direction in the studio or room where you paint miniatures, should ideally be from the north to be constant, but this is not always possible, and mine is no exception.

It is not a good thing to rely solely on artificial light, especially in the daytime, however good the light may seem. The exception to this rule is when the light levels are low, in winter, when you will need a couple of good lamps. There are lots of lights available for craftsmen and artists nowadays but angled desk lamps are not very expensive, and if you put daylight bulbs in them, the light they give is whiter, and it is easier to see your colours and brushstrokes without straining your eyes.

Some subjects certainly benefit from being lit dramatically. A still life set up on your desk, in front or to the side of your easel, with reflective objects in the composition such as glass, brass or silver, are better painted with the aid of artificial light. Put one lamp either side of your project. (See Chapter 9 on still life set-ups, for more about this.)

You will also probably need another light over your work. I have a SAD lamp, the type made for sufferers of Seasonal Affective Disorder (those who are adversely affected by low light

levels in the winter). The light it gives is adjustable, which is very useful, because I can put it on low early on a winter's day, and as the light outside decreases I can put the light up, to compensate. As with all good equipment, it is expensive, but it is said that its light can keep the winter blues at bay.

Nevertheless, portrait miniaturists (myself included) still prefer to paint skin tones in natural light. Any work on the skin usually looks wrong the next time it is observed in natural light. So when the natural light hours are so short in winter, and when it can be too dark to paint skin tones at 3pm, with the aid of the SAD lamp I can work on other areas within the portrait, such as the clothing and backgrounds. If possible though, position your table near a good source of constant light. If you are left-handed, that light should come over your right shoulder, and vice versa, otherwise your hand will cast a shadow over your painting.

Basic essentials

You will of course need something to work on and storage space for your materials:

- A table, ideally one with adjustable height, e.g. a trestle table with a top resting on two A-frame legs with adjustable pegs, so that the top can be raised up if necessary.
- A table easel. If you are working quite close to your painting, it is better to have your back and neck straight, and not bent over all the time. (See the section on Alexander Technique by Korina Biggs later in this chapter.)
- Another table and easel to display work you have started, which should be easily visible, and some box files for photographs, reference material and ideas.
- A lamp with daylight bulb.
- A chair that is comfortable and the correct size for you. It is really very important to get a chair that is the right height, as you will be sitting in it for long periods of time. Dentists and beauticians use saddle chairs, which are excellent for your hip joints. If you can afford it, you could get an office type swivel chair, made to measure for your frame with a specially adjustable lumbar support built in. Physiotherapists will usually be able to advise you on this. It will be worth investing in the best chair for you, in terms of comfort alone.
- A plan chest of large, shallow drawers for files of work in progress, paper, mount board frames and mounts, and a smaller chest of drawers to keep painting equipment and sundries in, near to your table.
- Shelves, for reference books and other pieces of equipment you do not use so often – but do not put them out of sight,

otherwise you will waste time searching for them. Collections of items for still life compositions may also be stored here.
- Small cupboard for paint, turps and such flammable items for oil painting.
- Pin board on which to pin current ideas and reminders about exhibitions and appointments.
- Large waste bin, or a plastic sack.
- A display cabinet in which to hang completed works, or a specimen cabinet with shallow drawers. The type that insect collectors traditionally used is just right for storing framed and unframed miniatures, out of ultraviolet light (which fades watercolours) and in a regular temperature. They can sometimes be found in junk shops. Alternatively a metal filing cabinet with narrow drawers will do.
- Battens on a wall with hooks to hang your best works from (for any visitors with commissions in mind to see).

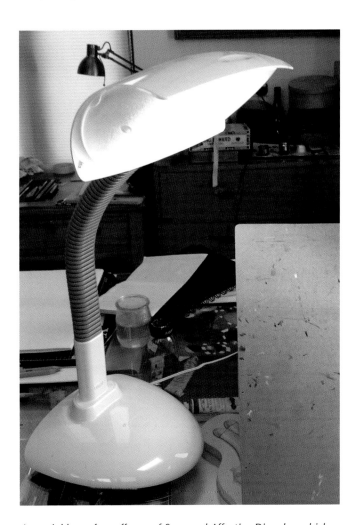

A special lamp for sufferers of Seasonal Affective Disorder, which I find very useful for winter painting, as it has varying degrees of brightness.

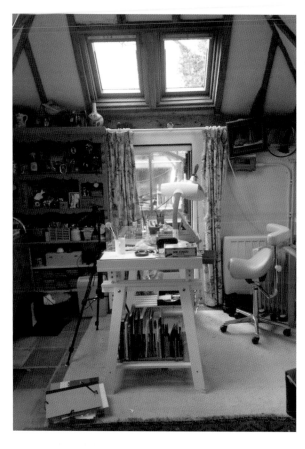

LEFT: An adjustable A-frame table is a good investment, as you can alter the height to your requirements. A saddle chair is very good for those with arthritic hips, like me.

RIGHT: To paint at a table easel is much better for everyone, and the type illustrated here has storage, adjustable rake levels, and a ledge to stabilize it against the table you are working on.

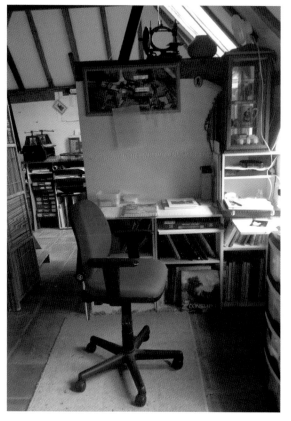

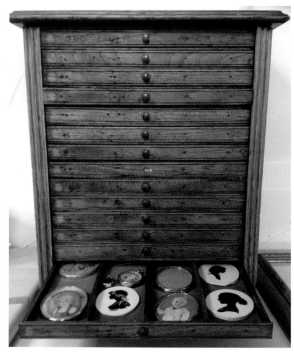

LEFT: A chair like this can be made-to-measure if you need lumbar support in your back.

RIGHT: A specimen chest like this one, once used by an insect collector, is excellent for storing miniatures whether framed or unframed, it keeps them dry, and away from ultra violet light. It is also good for filing them.

The following perspective, by Korina Biggs, is informed by the Alexander Technique. F.M. Alexander was an actor who developed the practice because he originally had problems with his voice and discovered that they were a result of how he habitually used his entire body and mind. Now there are many teachers of the Alexander Technique who work with a wide range of people seeking lessons for a variety of reasons. It is highly recommended that if you want help to address your individual needs, with gentle, skilful hands-on guidance, you find yourself a teacher from the directory of the Society of Teachers of the Alexander Technique (STAT).

The Alexander Technique, by Korina Biggs Bsc Econ MA MSTAT

Paint with poise

There is more to being a painter than skill or talent. How many of you find that when you paint, especially for long periods of time, that you become stiff or suffer niggling aches and pains? Even if you are lucky enough not to suffer it still helps to be able to paint in a way that feels free and effortless even when it is such detailed work on a small scale. It will enable you to carry on enjoying painting for as many years as you want.

Postural considerations

As you read this, bring your attention to your body. What is the shape of your spine? Have you got tension in your neck? Are your legs and arms free and easy? How much effort are you using in your hands to hold the book?

Our habitual nature means that most people are not aware of what they are doing to themselves as they go about an activity, though this is often a recipe for postural pain and related problems. The following are a few helpful aspects to consider when sitting and painting.

The head/neck/back relationship

Your head is very heavy and often it causes extra strain for the neck if you let it drop down or jut forward. It is also a source of compression for the neck if you tend to pull your head back into your shoulders. Try putting your fingertips just behind your earlobes and nodding gently. This is the level of the top of your spine. It can help if, in your mind, you ask the muscles of your neck to release so that your head can freely balance on top of the spine. As the head is able to float up without effort it creates less downward pressure on the spine.

You can keep your spine healthy and working to support you in a springy way by not slumping and not over-arching. Try allowing your spine to have space so that it can be at its natural length along its curvature rather than shortened or squashed.

The eyes

The way in which we look will affect the head/neck/back relationship. If we are straining to see, albeit subtly, then it will put strain on the deep muscles of the neck. This also applies if we are staring or fixing our eyes. Make sure you have adequate magnification and be aware that using bifocals may be detrimentally squashing the back of your neck if you have to pull your head in a particular direction to be able to focus. As often as you can, look at something further away (preferably out of a window) and remember to blink! It is also helpful to use an easel that is at a position that means that you do not have to distort your core coordination in order to paint. Ideally the set-up of your 'painting station' should support a sense of ease, poise and expansion, rather than you having to distort yourself to adapt to it.

The sitting bones and hips

It helps to sit on your sitting bones! These are the curved bones in the middle of your buttocks. Most people slump, rolling back off them or roll too far forward on them as they arch. If, however, you can balance evenly upon them, your spine is more likely to naturally lengthen up.

It is also beneficial to have free hip joints. Locate these when you are standing by lifting a leg with the knee bent and see where it bends. Having free hips when sitting means that you are able to rock forward towards your easel without hunching.

It is really important to have a chair that is firm enough for you to sense your sitting bones, and It should be flat or tilting slightly forwards. Saddle chairs also work well. What is particularly bad for our postural alignment is a chair with a seat that slopes backwards.

The legs and feet

Try to let your feet be supported by the floor and relax the muscles of the feet. The legs need to be as free as possible in sitting, and it certainly helps overall alignment and circulation if you do not cross your legs. Our body is a continuous network of muscle and connective tissue and how much tension we have in our legs and feet affects the rest of the body and vice versa.

The arms and hands

Our arms and hands have many demands on them throughout our everyday lives and yet we often bring about extra tension through using too much effort. For example, next time you brush your teeth or write, ask yourself: 'Do I need to be using this much effort in holding the toothbrush/pen?' Not only that, from a physiological perspective the shoulders and arms and hands will only perform freely when the core coordination of your head, neck and back is well organized. A useful practice is to take a moment before picking up your paintbrush to check that you are:

- supported by your feet on the floor with your sitting bones on the seat;
- allowing your neck to be free and your head to freely release up off the top of your spine;
- allowing your spine to be at its full length between tailbone and head.

Then, with your palms resting on your lap, allow your:

- shoulders to widen away from each other;
- arms to release into their full length;
- wrists to open;
- fingers and thumbs to gradually soften and ease out to their natural length (no need to stretch – just give it a little time).

You can then attempt to keep this going in your awareness as you start to paint. Force of habit will inevitably kick in, however, and so it will help hugely if you can stop and repeat this procedure for a minute or so at regular intervals. It is also vital to get up and move around, letting the arms naturally release with gravity and motion.

The whole psychophysical self

What we are thinking and feeling has ongoing expression in the physical body. Notice what happens when you feel under pressure to get something finished, or are worried about the quality of your work. Luckily the effect is circular, so by allowing your body to become better coordinated in a freer, easier way, it can affect how we're feeling and how effective we are. Furthermore it can free up our creative flow.

Magnification and miniature painting

When demonstrating miniature painting, I am always asked whether I am straining my eyes. I did consult an ophthalmologist about this as I was concerned too, when I started. I was politely told that painting detail was no different from the intricate operations on eyes that the consultant had to perform, which was undoubtedly true. However, he then advised me that I should work using binocular magnification (two lens) in the form of a magnifying loupe.

This really means that working with a magnifying glass (single lens) for long periods is not a good idea. It distorts the images you see anyway. For instance, if you are taking a picture of a face for painting purposes, and you get in too close with your camera, your sitter's nose will appear bigger than it is. This will happen too if you get too close to your reference, with a single-lens magnifying glass.

Both your eyes need separate magnification to work through. Then there will be no distortion, and no eye strain either! So you will need to invest in some sort of binocular magnification to wear, with or without glasses. There are several headband magnifiers available, as jewellers and watchmakers use them too, not to mention surgeons.

Another idea is to wear two pairs of glasses, one over the other, both single vision lenses. A student of mine used this way of seeing her work all the time! Do not wear bifocals or varilux

glasses, or you will get a crick in your neck by subconsciously tilting your head to see properly. Try several different strengths (as everybody's vision is different of course), until you have found one that is the right type for you, and then you will be able to work comfortably for long periods, without tiring your eyes.

Of course you may not need to wear glasses or use magnification at all when painting, or just rely on the loupe alone. But eventually age catches up with us, and it is best to be aware of the aids available to help to magnify your works.

Whatever magnification aids you are using, it is good practice to stand up, walk around and stretch your legs, and rest your eyes by looking across the studio, and out of the window from time to time.

Leaving your work, and having a break, is also very helpful if you are having trouble getting something right. When you return to your work, you will soon see what is wrong and what needs correcting, because you are looking at it with fresh eyes. If you are getting tired and there is something that looks odd in a painting, but you cannot quite work out what it is, leave it until tomorrow. If you are up against a deadline, take a photo of it, or scan it onto the computer. You can be sure you will then see the mistake very clearly.

Quite often, thinking I have finished a portrait, I take a photograph of it, or scan it, so that the next day I can polish it and frame it up. As soon as it comes up on the screen, any mistakes jump out, and it's back to the drawing board! So an important tip is never to frame a work at the end of a working day, but wait and look at it again the next day, until you are sure that you are completely satisfied with it. If you do not, every time you look at the work, that mistake will always make you wish you had taken the time to get it right.

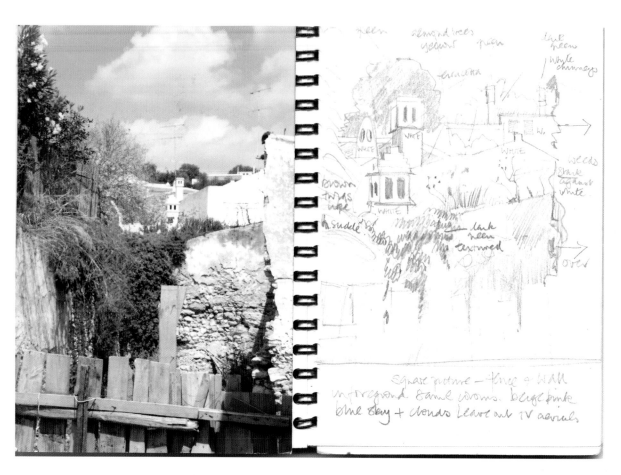

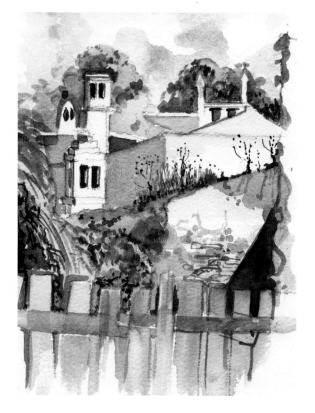

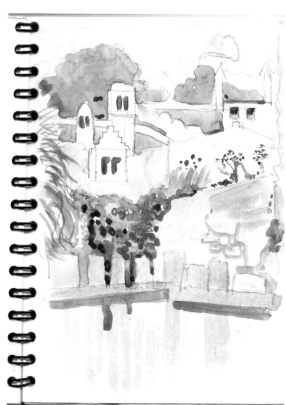

SUBJECTS AND SKETCHBOOKS

Sketchbooks

The importance of having a sketchbook cannot be overstated. But sheets of stark white paper can be intimidating to someone using a sketchbook for the first time, so buy one that has not too many pages, and perhaps one with coloured paper. Choose a neutral colour (not lots of different coloured pages) and a small-ish size, no larger than A5.

Get yourself a mechanical pencil, 0.7mm with a B lead, then you will not need to keep sharpening it. Try not to use an eraser, although these pencils do have a small one at the end. You will learn much more from looking at any mistakes you make, than from rubbing them out.

It's nice to use pastel pencils in a limited way. Black, white, and sanguine for chalk sketches on coloured paper sometimes

Fruit Bowl on a Checked Cloth: *a preliminary watercolour sketch.*

OPPOSITE: *Photo reference for a studio painting, Portuguese Villas, comprising drawing, tonal painting and watercolour sketch plus notes.*

give you encouraging results, if you find ordinary pencil difficult at first. A small selection of water-soluble coloured pencils can be useful too, if working in colour outside. You can make the drawing with them, and then blend the colours with a special watercolour brush, with a reservoir of water in the handle.

Colour range of watercolour pencils.

Try to get used to doing something in your sketchbook every day, to 'get your eye in', so to speak. You do not need to go outside or into a studio to set up something to draw. It should be fairly spontaneous, even drawing something from memory, or jotting down a few notes about a colour you have noticed. For instance, on observing the intense yellow of the fields of oil seed rape in late May, a note could be 'unbelievably bright, but will try lemon or cadmium yellow, see if they work.' Later you can make some watercolour strokes of those yellows to see if they are like the colour of the rape flowers that you saw.

But even sketching a tea mug or a sugar bowl after breakfast will start you off looking, or more importantly, perceiving the shapes, lines and shadows of objects in front of you, and then you will get used to drawing from life.

It is likely that when painting miniatures, especially portraits, you will be working from photographic reference, which is acceptable, but only if you are able to draw from life as well. To draw and paint from a two-dimensional image all the time would make it really hard for you to make any work look three-dimensional. The habit of using a sketchbook regularly will be enormously helpful in developing your drawing skills, and making your works look lifelike and real. It is useful to have a book to jot down ideas as and when they come into your head, and then follow them up, later in the studio, when you are working. Like the mobile phone, keep it with you all the time.

Students at art schools always have to keep a sketchbook, as it is an important record of their progress. Sketchbooks say a lot about how they interpret the basics of what they are learning. Tutors are able to see how they are progressing and what really interests each individual. But as you are learning by yourself, no-one but you will see your sketchbook. And knowing this, you will use it in a more relaxed and experimental way. It will bring a sense of achievement too, when you finish the first one: looking back at its contents is rewarding, and you may surprise yourself.

This is the point at which to get another one, maybe with white paper this time. If you are going to paint in it, make sure it is made up of heavy paper, which will take the watercolour without cockling, and pen and ink too.

Sometimes you may be stuck for subject matter, which does happen to us all. That is when leafing through your sketchbook can spark an idea, and off you go. In it, all the notes and drawings, ideas and workings out of your projects and little aides-memoires of scenes, inspirations, and colour notes, may help you decide what to try next.

You might include photos of landscapes, beach scenes of figures, flowers, still life, interesting faces etc. Then you can work on a composition for a painting, sketching the best bits, deciding how things catch the light, and making the most ordinary scenes and subjects into a work of art. Scrapbooks are a useful tool as well.

It may take some time for you to get used to using a sketchbook, but once you start, you will see how useful they are. As for looking through them all, which I have done recently, for examples to put in this book, they bring back memories of when and where the sketch was done, drawings of people I had completely forgotten about, the detail of the which sometimes surprises me, which even I find encouraging.

If I have been commissioned to paint a portrait, I always start with a pencil sketch (from life, if possible) and by doing this, I get to know the face quite well; I can make a ' road map' diagram of the features so that particular characteristics come to the fore early on. Then I like to make a watercolour sketch, very loosely, deciding the strength of the hair colour, and the depth of the shadows on the face, under the chin and down the nose, and mixing the colours I shall probably use on the clothing and the background. If it doesn't work, and the likeness is wrong, it really doesn't matter, as no-one else is going to see it anyway.

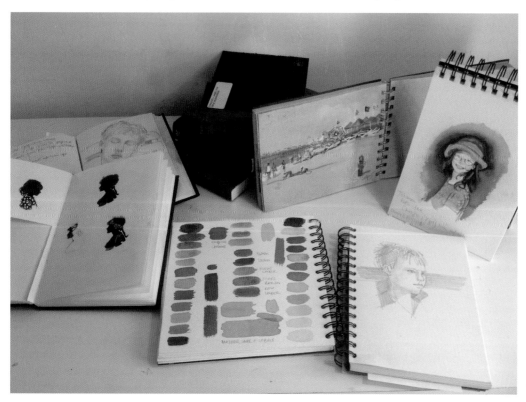

The importance of sketchbooks.

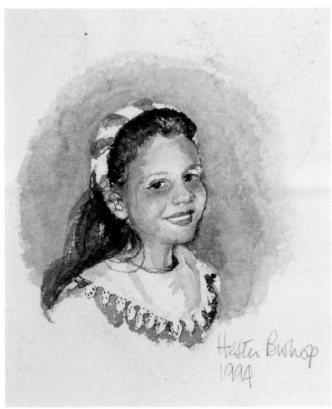
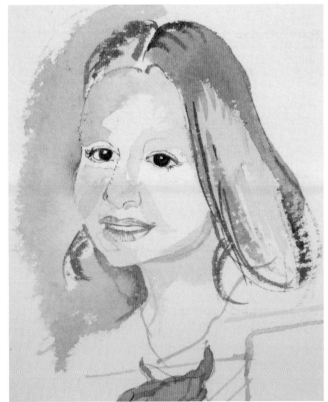

Hannah and Hester Bishop: pre-commission sketches.

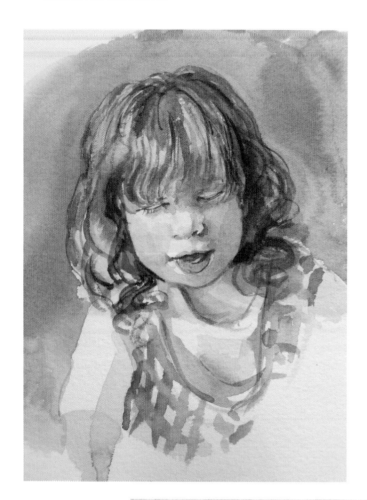

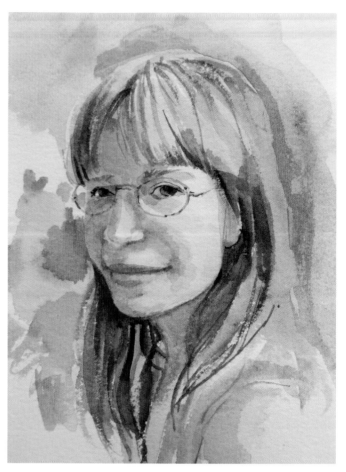

Becky in the Garden *and her sister: watercolour sketches and triptych pre-commission sketches.*

Studies of Sophie, *and her final portrait.*

It is the same working on a still life, set up on your table in front of you. Sketch the shapes first, to check your composition. Even do a quick small painting to get the colours right. I use mine to work out important details, to practise drawing the patterns of, say, a piece of lace, then maybe to work out the folds and highlights on a piece of velvet.

If for instance you are painting a collection of blue and white china on a lace tablecloth (in a landscape format), draw the shapes of each piece, and rearrange the composition if necessary. Follow this by a watercolour sketch, having noted and mixed up the different shades of blue in the collection. To make the tonal work come alive, put in another item in a colour complementary to the basic blue.

In the illustration of a work like this I did sometime ago, when painting collections of ceramics, I found a small orange lustre jug, and put it at the front. Because orange is opposite blue on the colour wheel, and therefore its complementary colour, the addition of the jug brings the painting to life.

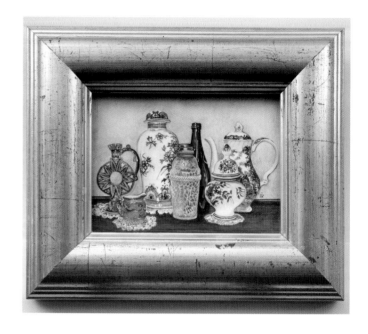

Blue China and Orange Jug, *watercolour on vellum, using the miniature technique. Cabinet miniature size.*

a

b

Exercises of assorted faces: (a) Kyla 1; (b) Kyla 2; (c) Child; (d) Timoko; (e) Timoko, watercolour on ivorine, 3 × 2.5 inches.

c

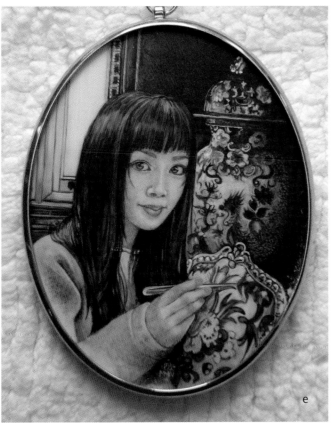

e

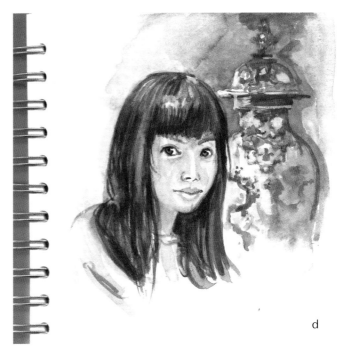

d

Copying

During the process of learning how to draw and paint, art students copy works of other artists, Old Masters and classical sculpture. (Constable's sketchbooks are tiny, and absolutely fascinating. To see how such an accomplished artist worked out his compositions on the pages is like looking over his shoulder as he worked.)

In their endeavours to draw and paint in the same style, artists learnt much by the process of copying. These copyists were often employed by the Old Masters, to paint different areas in their works, so the Master could paint the portrait, or the parts of the painting where he was most competent. Historical paintings labelled 'school of' mean that they have probably been worked on mainly by the students still learning from the Masters by copying their style. Larger works were often copied by miniaturists for clients, so they were more portable, rather like having a photograph, to wear in a jewel or to carry around.

So it will help you to copy the miniatures of famous portraitists and limners. If you are going to paint portraits, copy some drawings of heads by Holbein and Ingres. Their drawings are full of fine details, just composed of lines and shadows. They have picked out the important parts to get the likeness, and by copying you will pick up lots of ideas. Then you may even go on to study drawing the human head from a sculpture. From this you will understand the added dimensions of perspective and foreshortening. (There are further details about this in Chapter 9, Portraiture.)

Inspired by Vermeer.

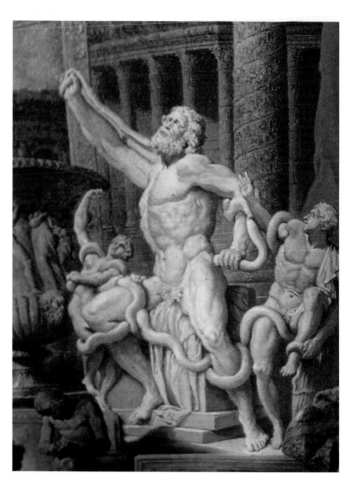

Statues, used historically in Art Schools for students to study and draw the form of the human figure.

As an example, during their Foundation courses at Art School, students spend many sessions drawing from plaster casts of sculptures of the human body. Initially these are drawn in monotone, either charcoal or pencil on paper. These are not quick studies; it is only by spending many hours perceiving the different areas of light and dark that they learn about the shapes and shadows that go into the drawing and make the image on the paper appear three-dimensional.

At a contemporary art school based in Florence, pupils learn to draw portraits in charcoal only. It takes about six weeks to build up the drawing just in one tone. However, as a result of such in-depth drawing many of them become really competent draughtsmen. Students also draw from the nude figure (from life), and the clothed figure (costume life).

So how can students use the copying process to their advantage? Some studies of the skull would be a good starting point. If you understand the bone structure of the human skull, it will make drawing a portrait easier. For instance, the shapes of the female and male skulls have subtle differences. To have studied those subtle differences, before you begin, will prove to be very useful when making drawings of male and female faces.

It is very important to learn the basics so that when you start to work on a portrait, you will understand subconsciously the points you will need to look for in order to make a portrait look real, lifelike and three-dimensional. This basic understanding will ensure that you feel encouraged by your first attempts, rather than feeling that you are struggling with your work.

In order to learn from the Old Masters you should invest in some books for reference (or go to the library) from which to make a drawing. Start with Holbein, who was, as mentioned before, an expert at portraiture – full-sized as well as in miniature. Find a book on his work and copy some of the images in pencil or chalks in your sketchbook. These reference books can be looked at when working out poses too. You may notice how familiar the faces seem, in spite of the passing of time since they were drawn.

Michael Bartlett, who was often commissioned by collectors of valuable portrait miniatures to copy them, was once heard

The subtle differences between the male and female skulls.

MALE

MALE FEMALE

FEMALE

to have said, 'You can often see an Engleheart or Cosway sitting opposite you on the Tube' – further illustrating the point that although the centuries change and people too, the faces of them do not.

A excellent source of reference books, with examples of particular artists' works, are Dover Publications (all of the images in them are copyright-free). Their book of Holbein's portraits is excellent, as is another with drawings by Ingres. Explore their book lists for other titles on anatomy and drawing hands.

Anatomy

During my years at art school, I studied anatomy. I learned all about the positions of the bones in the body by drawing the human skeleton from a life-sized one. I also became aware of the proportions of the human figure at this early stage, which saved me a lot of alterations in my drawings later on. Then by a further process of drawing the muscles and tendons, on tracing paper, I drew each muscle that lies over the bones, until I had built up the flesh of the human body on the skeleton. By drawing every

muscle I learned how they were placed over or alongside one another and so on, until the whole body was built up from the skeleton to a recognizable figure. As a result of making these studies, I was able to understand the shapes under the skin, made by the muscles I observed when starting to draw from life. I could also see how the shape of the muscles changed when they were used in movements such as gripping or walking. I studied the human head in just as much detail. During the same process I discovered how muscles move to make the smile on the face, and why for instance the eyes narrow when the face is smiling.

I suggest that studying anatomy for a while would help any student intent on learning how to paint a portrait.

Costume life classes then followed and were also important. Having learnt how to draw the body unclothed, I understood what the shapes were underneath the clothing and why the folds and drapes in the fabrics fell in the way they did.

If you attempt to learn any new skill, time spent practising the important elements and principles of that discipline will enable you to master the techniques, and produce successful work. Practise, practise. Think of musicians, who learn from the work of other artists, incorporating the most important elements into their own performances.

I have been commissioned by several clients to copy the work of other artists, one of which was an oil painting by the Dutch artist Willem van Mieris. In this work, which is executed in an allegorical manner, the artist's father Frans Van Mieris (nicknamed 'The Prince of the Leyden Fine Painters') was also a publican in this old university town, illustrated by the pewter tankard on the right of the composition. The allegory represents the near-end of his colourful life – the red velvet drape picturing his inevitable death. The empty glass directs us to the end of his undertakings; the hand on the tummy tells us he lived a full life. The feathered hat depicts his acceptance amongst the 'gentry' of the town. The sword on the table suggests that his 'battles are over', the smartly positioned weapon creating depth and three-dimensionality in this picture, typical of the Dutch seventeenth-century Masters.

My client wanted the painting to last as the original had done, so the support had to be very durable. I used a special board covered with gesso, from Italy. The smooth, absorbent surface made it much easier to represent the fine details in oil paint. My client wanted the whole picture to be as similar to the original as possible; nevertheless, so that it could never be confused with

the original, the owner asked me to put two extra items in my painting. (If you look at both the paintings you may notice the extra wine bottle and rummer.) As the original painting (an Old Master) was so often on loan to galleries in Europe, the owner wanted to have his own copy with him when the real one was being exhibited.

It was an exercise I enjoyed very much, and was sorry when I had finished. I had absorbed so much knowledge from copying the picture; it certainly was time well spent, in terms of learning more about oils than I knew before. Similarly, if you copy some miniatures of famous limners you will absorb (perhaps without realizing) a lot of things from the copies you make, until you start to paint your own miniatures, and that knowledge will be in your head already to help you interpret your own paintings.

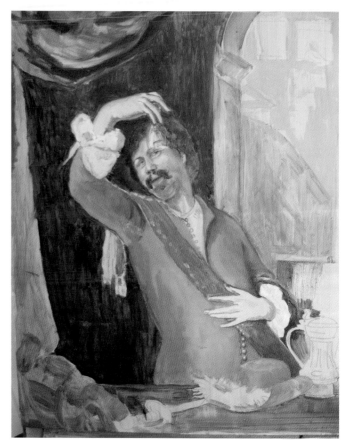

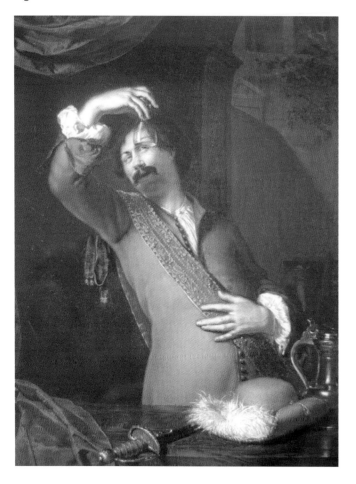

The original painting by the Dutch painter van Mieris the Elder is a self-portrait, an allegorical work in oil on board approx 14 × 16 inches. My copy is in below right and my initial under painting is top right. Making a copy from a fine work like this is an invaluable exercise. Note the extra glass and bottle, which have been put in deliberately so it cannot be mistaken for the original.

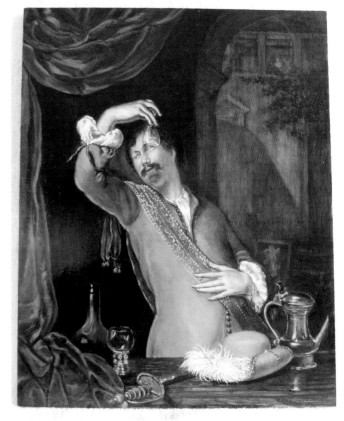

Subjects

Autumn watercolour on paper by Roz Peirson approximately 3.50 × 4.75 inches.

Two watercolour sketches of the same view, not necessarily for a later work, but for the sheer enjoyment of painting alla prima *in the open air.*

Pencil sketches made of sitters for commissions.

Landscapes

I really admire artists who paint landscape miniatures, because I find them very difficult. With all those greens I prefer to stick to loose and wet watercolour sketches of landscapes In my sketchbooks, which give me a great deal of pleasure when on holiday. (I cannot go for very long without painting or drawing something, and usually return from the break, with renewed enthusiasm for miniature painting.)

Jenny Brooks

The traditional approach to working in miniature is important to me, as I need to develop the structure of tonal shapes by building up continuous layers of hatching in small diagonal strokes, in brushwork for painting and pencil in drawing. The need to gradually 'work up' a drawing so that every area of detail is resolved, becomes totally absorbing. It is hard work, demanding deep concentration, and it can take up to forty hours of work to finish one drawing.

I am a purist and perfectionist; I need a quiet atmosphere to work in, and I am very organized in setting out equipment and materials before starting work.

For my portrait drawings I work on paper, on a sloping surface, mainly from photographs, but I like to see my subjects to clarify in my own mind the character of that person. I use best quality handmade very smooth HP (hot pressed) paper with just a little texture to it. This gives just the right 'tooth' for my pencils. Those I use range from 9H to B. I have to keep the points sharp, and I often shorten the pencil to half its length, as I find this easier to hold for the long periods of time required.

Using a light box, I trace off the main shapes from the photograph onto paper, with a 6H pencil. Then I rub most of the lines away, leaving faint marks. Then I gradually build up the layers of the shapes of different tones starting with a 9H pencil, so that the tonal structure of the work is built up, with every area 'resolved'.

Working on drawing is painstakingly slow, as I work on one area at a time, gradually moving across the picture so that all the tonal values are the same. This is repeated, using softer pencils to gradually produce the darker tones. The actual strokes I make are short, diagonal hatches from right to left, which are visible under a magnifying glass, until I am satisfied that the work is complete.

Pencil portraits on paper by Jenny Brooks.

The mythological and allegorical

Lists of entries to Miniature Society Exhibitions are usually divided into groups; these are quite specific, but cover a broad range of genres. One which covers a wide range of imaginative and decorative paintings is that of the mythological, such as fairies and historical scenes, seen here in works by Linda Orams and Janet Howard. Roundels often contained allegorical paintings that depicted a story (this has always been so in Fine Art painting, as described earlier in the painting of Van Mieris the Elder). These subjects allow artists to express their imagination to the full, and so by the use of colour, pattern and detail, much skill can be found in their work.

Janet Howard

I have always been a dreamer and so it was the Victorian and Edwardian fairy painters and illustrators that inspired me to choose the subject of fairies. My love of flowers and life drawing was a good combination to fulfil this theme in my paintings. The colour combinations used are mainly determined by the flowers I have chosen to feature. I love the technique of stippling which lends itself to the blending of colours in order that I can, hopefully, produce an ethereal and mystical quality to the miniature.

The Fairy and the Frog *by Janet Howard, watercolour on ivorine, 3 × 2.5 inches.*

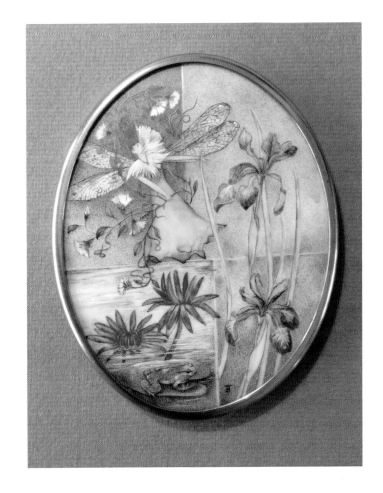

Linda Orams

I have always loved the jewel-like colours and quirky figures of medieval illuminations and completed a specialized study course on the subject at the V&A in London. Painting in miniature provides the perfect technique and medium to re-create the medieval style, and I gain inspiration from my many books on the subject. I use watercolour on ivorine and this enables me to achieve the translucent look of the original illuminations.

Roundel *by Linda Orams, 2.5 inches diameter.*

Caroline Hayes

I came to miniature painting through a brief study of calligraphy. This course included a session on illumination and I was so charmed by this that I dropped calligraphy and took up miniature painting instead. I was lucky enough to discover Pauline [Denyer Baker] giving classes just down the road. I did about a year with her and have never looked back.

I would say my work has been influenced (or I would like it to be influenced) by several different cultures. I have always loved Indian miniature art for its delicacy and beautiful colouring. I admire the early hand-drawn Disney full-length cartoons for their humour, colour and draftsmanship. Lastly I love and admire the Russian lacquer miniature tradition and have been lucky enough to attend courses in three of the four villages that produce this work. I am also fortunate to live in the same city as the great twelfth-century Winchester Bible.

My method is to draw my picture at about A4 size. When I am happy with it I reduce it down on the computer to the size I want to use, usually about 2 × 3 inches. I then put it on a light box under a piece of polymin and paint through. I love vibrant colours and gold leaf. I have absolutely no skill in laying gold leaf, in spite of instruction in Russia and at the Prince's School of Traditional Arts in London. I shall keep trying and be thankful that I have to cover only a few millimetres of surface.

Sad *and* The Walrus and the Carpenter *by Caroline Hayes, both approximately 3 × 2 inches.*

Animals

Of all the subjects that artists love to paint, especially in miniature, animals are amongst the most popular. This is not surprising, as they are much loved as pets, as companions for the disabled, and as the essential working partners of human endeavours. Their portrayal in advertising demonstrates the important role they play in product promotion. Think of the Meerkats, for example, and the Metro Goldwyn Mayer Lion.

However, in art, their popularity as subjects can help their conservation, because paintings, prints and photographs can raise funds for their protection. Admittedly they are possibly sometimes portrayed in what is called a 'chocolate box' way, but art is commercial as well as aesthetic, and artists have to earn a living, so they paint what their collectors want to buy. Even the traditional portrait miniature can be painted to flatter and look beguiling.

Miniatures of animals are very well represented by artists, not only in Britain, but also in the USA, so a book on miniatures would not be complete without many of them. Many a would-be miniaturist has started out by painting animals, birds and insects; the ubiquitous kingfisher and blue tit have been painted many times on my courses. Fur and feather are particularly useful to paint when learning the stippling and hatching techniques as the textures have to be shown, and it is a step on the way to perfect strokes.

Amanda Laman

I like to paint animals and most recently I have started to paint composite pictures with two or more animals interacting to make a 'story', just as a still life is more interesting if there is a scenario such as opera glasses, a fan and a sheet of music. This takes the viewer to a place, which would not happen if the picture just depicted a pretty fan and unrelated items. I have undertaken commissions for family pets and just painted them straight, as in this example, but I do favour a more humorous approach where the cat could be looking at a mouse or a bird, which could explain the uncertainty on the face.

I build up the fur in soft layers of different colours – as in nature an animal's coat is made up of varying shades. (With human portraits it is the eyes that are the key.) The background should enhance either by echoing colours in the fur or a simple setting such as a sofa, cushion or even a garden. It should not overwhelm the subject, however, and occasionally I will play around with the background on a clear plastic sheet overlaying the picture until I get it right. The frame (and mount if indicated) is always chosen at the planning stage and constantly put back over the picture to check everything is in proportion. I tend to do several sketches to get to know the subject well before embarking on the final picture. I never trace as I feel you lose the essence of the picture and become just a slave to lines.

Heather Catchpole

Heather is very versatile, and her choice of subjects is wide. However, when painting dogs, her obvious love for them is apparent, when she seems to capture their personalities. Her portraits, too, are very accomplished and she paints distinctive profiles, unusually *en grisaille*, a way of painting in monochrome, which she has made her own.

Handsome Cat *by Amanda Laman.*

Cosy Dogs *by Heather Catchpole, watercolour on ivorine.*

Jennifer Fry

Jennifer has travelled widely, and her knowledge of animals in the wild, such as lions and leopards etc, is apparent in her detailed paintings. This is also reflected in her work of domestic animals as well.

Leopard in a Tree *and* Lioness and Cub, *watercolour on ivorine.*

BELOW: Castle and the Garden *by Stephen Overy, watercolour on ivorine, 3 × 2.5 inches.*

Janet Kay

Janet spent many years painting animals in poses that fitted the shapes of the small pebbles she painted them on, using acrylic paints. She quickly took up a suggestion I made to her about venturing into miniatures, and now she has become very successful with her framed miniature paintings of all sorts of wild and domestic animals and birds.

Architecture

Stephen D. Overy

Stephen specializes in architectural subjects, in watercolour, based on either a specific building or style of architecture. He takes photographs and sketches to cover the whole aspect as well as key details. From these he experiments with compositional sketches to work out a final composition, paying particular attention to perspective and opportunities for light and shade to define the building and its surroundings. All drawing is done based on the expected final picture size. Sketches are then reworked using a light box into a final drawing from which the main elements are traced on to Arches

Flora, watercolour on ivorine by Janet Kay, 3 × 2.5 inches.

Aquarelle HP watercolour paper (140lb). Additional drawing is then done on the painting surface using a 2H pencil. Any excess pencil marks are removed using a Staedtler Mars eraser.

Stephen secures his paper to a 10 × 8-inch sheet of MDF using quality masking tape. This allows him to rotate the work during painting, which is particularly useful when painting straight lines. He uses a wide ruler as both a brush guide and hand support. He finds using a daylight lamp invaluable and uses this even when painting during the day as it provides a level of consistency. For the finest detail he uses a binocular clip-on magnifier secured to his glasses (2.5× magnification).

Stephen uses Winsor & Newton Series 7 brushes (mainly sizes 000, 0 and 1). He always has more than one '000' brush on the go at once as he finds the points improve with use and hates the need to 'work in' a new brush when doing the finest detail on a picture.

His palette is made up of Winsor & Newton artists' quality paints and he recommends experimenting to find a range of colours to suit an individual artist's style. He finds always adding other colours to basic greens a great help. Colours are mixed on white plates, allowing him to move the paint around to thicken it before application; he also rolls the brush between his fingers to bring it to the best possible point before use. He always attaches a piece of the painting paper to his board to allow the paint colour and consistency to be tested before use. This also proves useful if there is a need to match an earlier colour.

Stephen always starts with the sky, using a wet-in-wet technique after initially covering the sky area in a thin layer of water. If the sky does not work he will start a new painting. He then paints the windows, protecting the surrounding area with a thin line of blue masking fluid (Pébéo Drawing Gum) applied with a mapping pen. After this is completed, he blocks in the rest of the building in light initial washes. Each area of the painting is then worked on using standard watercolour techniques. He finds the stippling technique particularly useful for trees and garden areas. Finally, the finest details are added, e.g. lamps, door bell pulls, etc., along with his initials, to complete the painting.

For Stephen, visiting exhibitions and looking at other artists' work has been of great benefit and inspiration and he recommends for example visiting the Annual Exhibition of the Royal Society of Miniature Painters, Sculptors and Gravers. Galleries specializing in miniatures also provide a great source of inspiration and encouragement: Stephen found the advice and support of the Llewellyn Alexander (Fine Paintings) Gallery invaluable.

He also believes that for him the challenge of submitting work to exhibitions, and the subsequent encouragement of artists in-

volved in selection, has been of great benefit in improving his work and enhancing the enjoyment of painting miniatures.

The best advice he was given was, 'Just have a go'.

Peter Shaw Fraser

Since his childhood Peter has always had interest in miniature painting, and he remembers a book on the Elizabethan miniatures of Nicholas Hilliard. He became even more interested when he saw some Persian miniatures in his teens, discovering that he preferred drawing on a small scale with intricate details.

Insects and Leaves, *watercolour on paper, 3×2.5 inches, and copy of painting by Rosetti, watercolour on paper, by Peter Shaw Fraser.*

Painting by Rosetti, watercolour on paper, by Peter Shaw Fraser.

When expressing his desire to become an artist at school, he was told, 'You won't make any money, but I expect you will be happy.' He studied at the well-respected Glasgow School of Art, gaining diplomas in design and illustration. He believes that drawing can be taught, but that the co-ordination of the hand and eye is a most important element to learn. His work was influenced by the stipple technique used by an illustrator called Robin Jacques.

Peter developed this further, and began to paint on small items, such as lacquered boxes, and found that stippling suited his style. It became his chosen way of applying paint to surfaces. He says: 'It is close to pointillism of the impressionists, and suits miniature painting where larger brushstrokes can be too visible.'

Ivory simulants are not to his liking, and he usually paints on a lacquered surface, which he prepares himself, using white enamel, which is abraded with fine glass paper. The surface holds the paint well, but mistakes can be lifted off with a wet brush, or cleaned with an eraser when dry.

Although a skilled portraitist (he studied anatomy at art school), his favourite subjects have always been insect and plant studies, as shown in the examples of his work. However, he also likes to copy the work of major artists, for his own enjoyment, such as Rossetti watercolours.

Decorative

Some miniatures are labelled 'decorative' – meaning that they are embellished by the addition of a flowered border, or a patterned background. It is a style of painting miniatures that I like, and I am constantly keeping an eye out for suitable designs to add to my works.

When it comes to putting a background to a miniature, usually a still life or a portrait, it can be made a part of the composition, as long as it does not overpower the subject matter – in fact an eclectic background can enhance a painting. They give the picture depth and a sense of being part of the scene. The examples below show how a well-designed and carefully thought-out pattern can make a work very attractive. The idea may originate from the works in miniature of the Moghuls, whose allegorical paintings were set in gardens, with flowers and foliage, and surrounded by patterned borders. This can be seen in illuminations on coats of arms (where the objects in them are very significant) and on calligraphy, as in George Simpson's works.

A copy of Michel Angelo's Doni Tondo, *another exercise in learning by copying, in oil on a gesso covered wooden panel, with a different background to the original.*

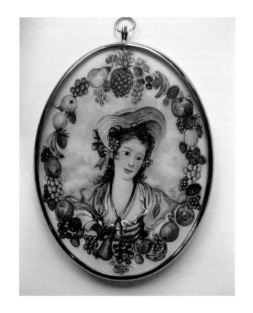

Fairy in a Garland, *with sketchbook watercolours for reference.*

In Michelangelo's *Doni Tondo*, there is a landscape behind the Holy Family, as well as several classical sculptures. I copied this beautiful painting, because when I went to see it in Florence I was impressed by Michelangelo's wonderful colours, his attention to detail, and how 'modern' it seemed. I decided it would be a very good exercise, and I chose to use oils, as in my opinion they are more difficult to use for details. It was the size of a cabinet miniature. An art collector saw it, and expressed a desire to buy it, but we decided to put a different background behind the figures, so that it was obviously a copy, and not painted to deceive. Painting it was such a good lesson.

I paint lots of flowers in my sketchbook, or fruits and berries, from life. Later, in the studio, I work out a border of them all, and paint a portrait inside, or whatever I have in mind.

Stained glass patterns look really great behind a portrait. I was first inspired to do this when taking photos for a commission in the hall of the client's house, with the stained glass door behind her – quite by accident. We were both very pleased with the result, the basic premise of which I have repeated several times.

Calligraphy in miniature

One of the best styles of miniature work can be seen in calligraphy in miniature. It is a highly skilled discipline and needs a very steady hand and deep concentration: one spelling mistake near the end of a work can be disastrous. Depending on the length of the piece it can take a long time to write, and to illuminate.

George Simpson is the foremost miniature artist of today in calligraphy, and his work is quite naturally sought after at exhibitions. He has written the following piece to explain his techniques.

George Simpson

When I am asked, 'How do you create a work of miniature calligraphy?' the simple answer is, 'do exactly you would for your "normal" size, but do it all much much smaller.' But this immediately presents a number of problems. The reduction in size demands greater precision and accuracy. The slightest variation in scale of any letter will be very evident. You must therefore be consistent in the size of every letter, the space between letters, the space between the lines, etc., etc. Any tiny variation in any of these factors will ruin the texture of the work.

The guidelines that you rule must be absolutely precise. The width of a pencil line is crucial. Use a soft (say 2B) pencil, frequently sharpened and rule the lines as lightly as possible. When it comes to writing, remember that the beauty of calligraphy depends on the correct distribution of thick and thin strokes – and the smaller you write, the more difficult it is to achieve thin strokes. Do not overfill your pen and use the lightest of touches. Choose a writing surface that is sympathetic. Vellum is desirable, but can be variable. There are many papers available, all with different properties, and you need to experiment to find those that suit you.

Of course, a steady hand and a good eye will help, but have no hesitation in using magnification if you need to. But don't try to write too small: there is no point in writing something that cannot easily be read. The 'difficulties' are well worth overcoming for the satisfaction of creating truly miniature works.

A rare piece of calligraphy in miniature, by George Simpson, in ink with gold leaf on paper, He Who... (a quotation from St Francis of Assisi).

Coryn Taylor

Coryn has embraced miniature painting in all its genres, and has been able to work in both oils and watercolours with exceptional ease. One of the tasks she decided to try was to paint the same still life in both watercolour and oils, from photographic reference. The project took her two years – partly due to the fact that at that point she had little time for painting, but also because she pays so much attention to every detail in her work.

I had difficulty in distinguishing which was which, because the paintings were so alike; I could only tell them apart by their frames, and I have never found it so difficult before.

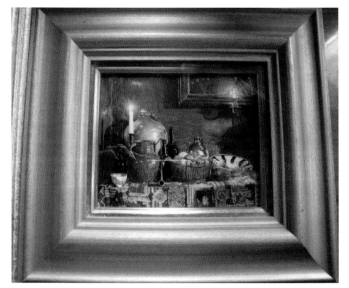

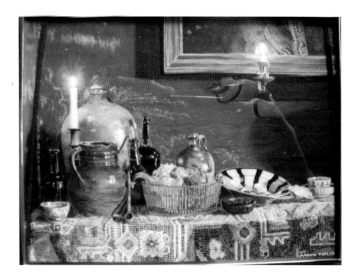

Still Life on a Piano, by Coryn Taylor, in oil on polymin (right) and in watercolour (left). Coryn liked this set-up so much that she experimented with the two media, and then decided to always paint her miniatures in oil afterwards.

Coryn Taylor's instructions for painting miniatures in oil

1. Preparation of painting surface: not as much care is needed to keep fingers off the surface due to the medium being oil-based. But keeping it dust-free is very important.

2. I normally paint on polymin, which I fix to a white acid-free card, with the matt side up so that the paint will adhere to its slightly textured surface. To check for this surface, hold it so that light is reflected off a side. The one that is slightly matt is the surface you paint on.

3. To protect your painting between sessions, a frame of cardboard is placed over the work to act as a separator, and a ridged piece of plastic fixed to it. To help prevent dust attraction an anti-static cloth can be laid over the whole. These can then be folded up or removed while painting.

4. I use a sable brush with a fatter ferrule so that there is a small reservoir of paint and a very fine tip (Winsor & Newton miniature series 7 number 1). For scumbling, an old, worn brush is fine.

5. The only medium used is white spirit (which can be obtained odour-free). This allows the paint to dry very quickly. Mixing oils and turps is not required.

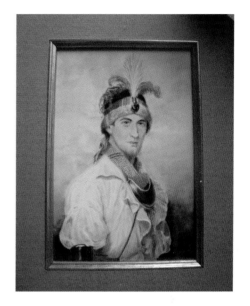

6. The initial drawing/tracing can then be carried out. Alternatively, thanks to the thinness of polymin, it is possible to work directly on a light box, using a photocopy on acetate of the work to be copied. Then no under paper is required, as the light box when turned off acts as a white background.

7. As with watercolour, you can only do one initial very thin wash of paint, of the various areas within the painting. The oil paint is thinned using only white spirit. The colour of the wash is the palest in that area. Unlike normal oil painting, you paint from the palest to the darkest, so that you get the full effect of the translucent paints (preferable to using opaque paints). When applying the 'wash' an almost dry brush is used, and the paint is scumbled on; any excess paint is then removed with a dry brush. This layer dries very quickly, and can be painted on almost immediately.

8. Each subsequent layer is built up by either stippling (small dots) or hatching (small lines). A very fine stippling effect can be gained by using a dry brush over a just-stippled area (still wet), which breaks the already stippled area into finer dots. (This does not work for hatching.)

9. If painting longer strokes in hatching, a glaze medium can be used. The brush is first moistened with white spirit, then a touch of glaze medium; the brush is then partially dried and a small amount of paint added. This allows the paint to flow more easily. If too much is used it gives a gloss to the dried paint, which in some cases can be desirable.

10. To correct mistakes: using a clean brush dipped in white spirit and then dried, lift the offending brushstroke off as if painting it, then clean the brush and repeat until the desired effect is reached. This technique can also be used to divide a too-thick line of hatching, so that you end up with two lines, or you can thin the edge to create one thin line. If the paint has dried the above method does sometimes work if you persevere and leave the moist white spirit *in situ* for a short period, and with several applications. Diluted bleach can also be used very carefully. If a complete area of work has too much paint it is possible to make it paler by tamping it. This is done using a bit of lint-free material made into a ball with one very smooth, flat area the size of that which is to be removed. This is just moistened with white spirit and then dried further on another absorbent surface until it appears dry. The pad is then evenly pressed on the area of the painting, and very carefully lifted straight up so as not to smudge the painting.

11. I prefer not to varnish my paintings, although this is an option if wished. But only use a very fine layer.

Two oil paintings by Coryn Taylor

Flowers

Myrna Francis

Myrna, who is a skilled botanical artist, took to miniature painting very easily. She has a great interest in gardens and flowers in particular; her enthusiasm shows in her work, and the colours and forms are no problem for her in her paintings. Then she found she could adapt these skills to genre paintings of many subjects, but particularly farmyard scenes with chickens and ducks etc., with reference from historical paintings of early English landscapes.

Hens by an Old Wheel, *2.5 × 3 inches, and* A Hampshire Garden, *2.5 × 2 inches, both watercolour on ivorine.*

Airbrushing

Lorena Straffi and John Dillon

The airbrush is a small pen-like instrument used to spray a fine mist of colour. It requires an air supply, usually from a compressor, and a paint that has a fine pigment to allow it to flow. It has been around since the late nineteenth century and was originally intended to spray watercolours. It was an extremely popular instrument in illustration and photo retouching, before the digital revolution. The nature of the airbrush makes it possible to achieve very fine and subtle colour graduations.

The airbrush is still popularly used in a variety of art forms. The unique feature of the airbrush as opposed to other artists' tools is that there is no physical contact with the substrate. The layering of colours is controlled by a trigger located on the top of the airbrush body. Lorena Straffi and John Dillon are two artists who specialize in miniature painting using the airbrush.

They have worked for various companies in the luxury market and for private collectors. Recipients of their artwork are presidents, state dignitaries, celebrities and sports personalities. They have exhibited and demonstrated their technique at Harrods in London, the Grand Hotel in Venice, Salzburg in Austria and at various shows throughout Italy. They also have works in the Tate Modern in London and in the Hermitage Museum in St Petersburg.

An example of airbrushing on to small objects by Lorena Straffi and John Dillon.

Mavis Gibbs

My method of painting is that I tend not to do a wash to start a miniature but stipple right from the beginning – apart from the hair, that is, which I do with long thin strokes of the brush.

Four works by Mavis Gibbs. ABOVE: The Kitchen Maid, *watercolour on ivorine, 4 × 3 inches;* CENTRE TOP: Mum, *watercolour on ivorine, 3.75 × 3.25;* CENTRE BOTTOM: Fingers in the Ice Cream, *watercolour on ivorine, 3.5 × 2inches;* FAR RIGHT: The Blacksmith, *oil on ivorine, 3.5 × 2.5 inches.*

Daphne Padden and Geoff Hunt

Daphne and Geoff were both members of the Royal Miniature Society for many years. They exhibited regularly in the later part of the twentieth century. Daphne painted on paper, in watercolour, and her style was very finely detailed, as illustrated in her painting called *Crab Apples*. The waterdrops on the skin of the apple are beautifully painted.

Commander Geoffrey Hunt shares his name with a fine marine artist; however, Geoffrey Hunt the miniaturist also painted seascapes. He often painted on antique boxes, and lacquered

Crab Apples, *watercolour on paper by Daphne Padden, 2 × 3.5 inches.*

A Sea Battle, *acrylic on an antique papier mâché box by Geoff Hunt, 4 × 3 inches.*

them in the style of Russian painters. This one, entitled *The Battle of the Nile*, is painted in acrylic. These two miniatures are part of my own collection of modern miniature paintings. by Geoff Hunt

Abstract portraits

Rosmar Booth

Rosmar Booth paints miniatures and larger paintings. Her work is often described as Expressionistic with a touch of Surrealism, but she retains her own individual style. As a base for her contemporary miniatures she uses a fine smooth card, Bristol Board, which she prefers to prime with fine gesso. Having decided on the size and shape of the miniature, the card is cut to the required size, leaving about an extra centimetre all around, and then she secures the card on a slightly larger piece of white cardboard. Rosmar works on a desk with a slightly raised wooden sur-face, and uses a large magnifier.

She begins by applying a coat of acrylic colour, just a light touch very diluted with water. When it is dry she introduces various other stronger and brighter colours; some of her favourites are turquoise and pink, or red, blue and yellow. Very carefully she outlines her ideas with a fine brush using gouache or aquarelle. When satisfied, she follows the process of painting it with more detail in acrylic, slightly thinned with water or an acrylic medium to increase flow, applying the paint on a soft mix of hatching and stippling brushstrokes to build up the picture.

She starts the composition by painting the face and then the clothing, followed by the background. Working instinctively, little by little the painting grows, generally with more faces or figures around the main portrait creating multiple images. The composition is usually busy and in such a small area and with tiny brushes it is a difficult process, because the medium of acrylic dries very rapidly (she does not use a drying retarder).

Brushes should remain clean at all times, otherwise they can become damaged very quickly. The size of the brushes ranges from 0000 to 1, the one most commonly in use being 000. When the work is nearly finished Rosmar glazes it by applying some washes of transparent colour: dark, light or fluorescent. Using a combination of pen and brush, the background is then finished with several layers of pointillism – small dots of pure colour with white ink in the upper part, and coloured acrylic ink in the lower part. Rosmar puts the painting aside for a few days, then with a fresh look she finishes the last touches with aquarelle, ink, body colour or fine pastel; the work is then mounted on an ivory-coloured acid-free mount and an appropriate frame is chosen.

Rosmar likes to play with colour. She paints from her imagination, improvisation and suggestion, combined with personal feelings and recollections, exaggerated shapes and features. Subjects for her paintings include mystical and theatrical images, also circus characters in her stylistic way. Her

A Courtier and An Actress by Rosmar Booth, , both in mixed media on paper, 1.5 × 1.5 inches approximately.

imaginative, intimate and secretive work produces images of soft and rich colour creating a fantasy of intriguing vision for art lovers looking for a message.

Wildlife

Tracy Hall

Tracy Hall works in a studio on the shores of Scapa Flow in the Orkney Islands. She is a full-time artist and illustrator, working exclusively in watercolour. For many years, she has worked with both private and commercial clients around the world, but when she discovered miniatures in 2007, a new and exciting chapter began, enabling her to 'balance commissioned work with something purely for herself.'

Like so many of us, she has become completely hooked and now is keen to promote miniature art whenever possible, serving on the councils of the Hilliard Society and the Royal Miniature Society. Tracy shows regularly in exhibitions in the UK and abroad and at selected galleries throughout the year.

Swallows *and* The Thinker*, both watercolour on paper, by Tracy Hall.*

Barbara Valentine

Barbara is best known for her beautiful flower and still life paintings in the style of Dutch seventeenth century works. Oil on ivorine is her chosen medium and sometimes she will paint on gessoed board or vellum.

Barbara uses oil paint very like watercolour, by using a thinner, and builds the colours of her flowers and vases by working in many layers of transparent glazes. Her miniatures can be made up of six to fifteen thin layers of colour, and can take up to two weeks to complete. However, she works on two or three paintings at the same time, so that they can dry in between. This takes about twenty-four hours.

Wet oil colour can be wiped off easily, leaving previous layers intact. Using many layers of paint creates an intensity of colour, as if light is trapped between the layers, and painting a dark background for still life adds contrast and dramatic effect to her paintings. The subjects she paints sometimes include objects with symbolic meanings, e.g. a key represents the innermost self, while a parrot is a special person, or an aspect of a relationship.

Barbara's miniature marine paintings are based on those of her late husband, Louis Dodds, which she paints on tiny boxes. Always versatile, Barbara also paints portraits and architecture.

We shared the same teacher, the late Elizabeth Davys Wood who founded the Society of Limners in 1986, before joining other Miniature Art Societies in England and worldwide.

Still Life *by Barbara Valentine.*

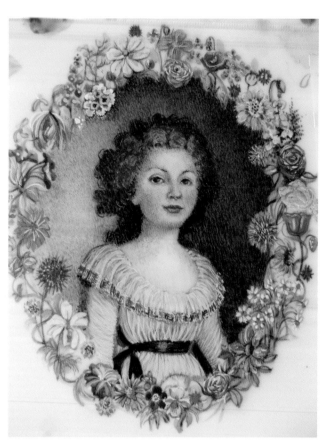

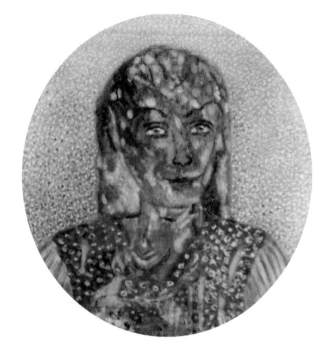

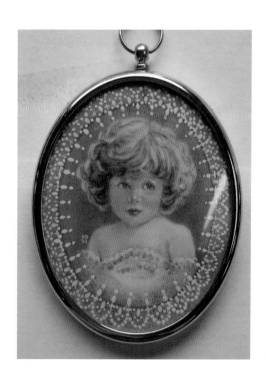

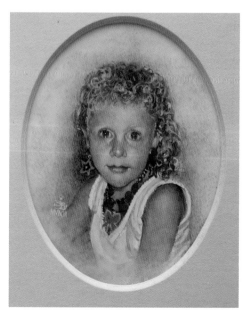

TECHNIQUES AND EXERCISES

The Egg Exercise

To help students understand how to stipple and hatch success-fully, I have devised an exercise using two colours only – light red and viridian – painting an egg shape, and stippling the colours in alternate layers. I call it the Egg Exercise.

One of the miniatures I was able to buy at an auction of was what I call *A Lady in a Black Hat*. I guess she was painted around the 1900s and she is very much in the style of John Singer Sergeant. I was able to buy her, as nobody else made a bid when the auctioneer asked, 'What about fifty pounds?' – up went my paddle and she was mine.

I took her apart, of course, and decided she was painted on ivorine, which was interesting as that convinced me that ivorine had been made and used for around a hundred years. But what was most interesting of all was the fact that the artist had used such a limited palette: only viridian and light red, with perhaps a little indigo or ultramarine, nothing else at all! There was great deal of water damage too, where condensation had run off the glass and onto the picture, but only at the edges, because the detail in the centre was unaffected.

If you look at her face, neck, hand and arm, they are all stip-pled using just light red and viridian, and where there are dark shadows the two are built up in depth, but look quite right, as you no longer identify them as 'colours' but as the natural flawless skin tone of a lady of that period. As far as the rest of the painting is concerned, you can see (in spite of the water damage) that it is painted very much more broadly. The hat is especially so, washed in deep indigo, with the shine of the fabric, made by lifting off the area, and then painted in viridian. There is a little bit of scratching out too, on the feather which is hanging over the brim. It really stands up to close scrutiny, and it seems to me as though it was never finished, but was probably a very good likeness, and so was framed anyway.

I made a copy as an exercise purely for my own interest. Later, I led a course at West Dean, based on her, which was called 'Painting Miniature Portraits from Life'.

It was a short weekend – Friday to Sunday – but the model sat for four sessions. She wore a black hat, and ordinary cloth-

OPPOSITE: Top: Lady in a Garland of Flowers, 3 × 2.5 inches, watercolour on ivorine; Absorbed in Reverie, mixed media on Bristol board, 1.5 inches diameter, by Rosmar Booth. Centre: Egg exercise on vellum in light red and viridian oil colour. Bottom: Lacie, watercolour on ivorine, 3 × 2.5 inches; Egg exercise on ivorine in light red and viridian watercolour; Francesca Resta, watercolour on ivorine, 2.5 × 2 inches.

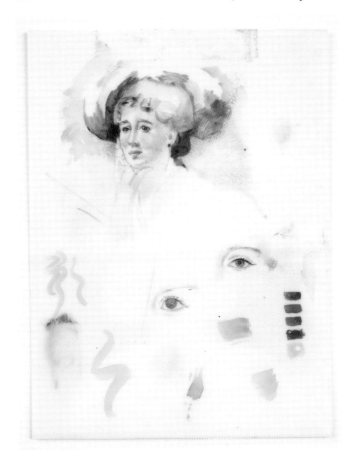

The origin of the egg exercise, my trial piece in light red and viridian.

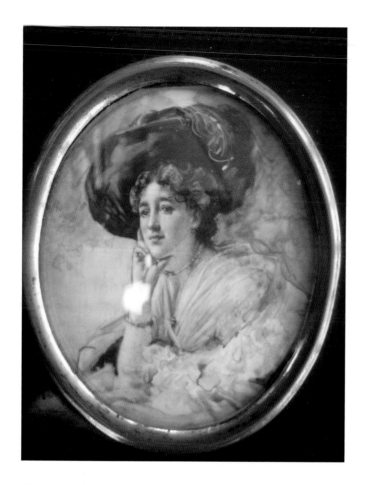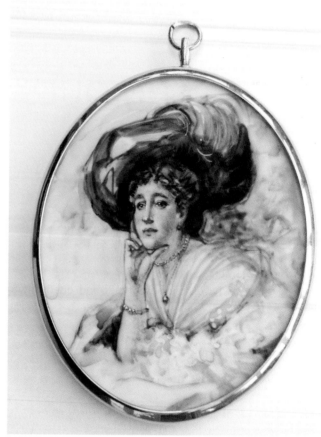

My copy of the original, called The Lady in a Black Hat; *the original painting of* The Lady in a Black Hat.

ing. The students who came were all relatively experienced and not complete beginners; it was a very small group, so everyone could see the model very well and was able to sit quite close to the dais she was sitting on. Preparatory sketches were made and the poses from where they were sitting worked out before they started their miniature works. I suggested they all use the limited palette of two colours only: red and green. To my surprise they all tried, some with more success than others, and they all found it very difficult.

But if you understand the ways the Old Masters worked in oils when painting nudes, their under-paintings were always made using these two colours. This created luminosity in the skin colour, as the skin of these women was never sun tanned, but naturally pale and delicate. It was a very specialized course and more akin to studies of Fine Art. But I know some of the students learnt a great deal from it.

It was as direct result of *The Lady in a Black Hat*, and the course, that I worked out the Egg Exercise, which I recommend everyone tries out at least once. So much can be gained by anyone trying to learn how to stipple and hatch successfully. Please try it out: it does actually work!

Preparing supports

Miniatures, as already explained, are usually painted on special non- or semi-absorbent surfaces. These supports are thicker than paper, and have to be cut by hand in a specific way. Ordinary scissors will not cut them cleanly or straight.

The surfaces commonly used are polymin, ivorine and Kelmscott vellum. Polymin and ivorine are of a consistent thickness; if you think of softened fingernails, that is what these two products resemble. Polymin is a by-product of petrochemicals, and is the most flexible. Ivorine is made from cotton fibres dissolved in acid, and has been used for making ping pong

Curved scissors are sometimes used for trimming polymin or ivorine, before the miniature is put into the frame. Thin slivers are pared off to make the painting fit accurately. If old ivory can be found, it must be cut to fit by an expert.

balls, as well as household items, since the nineteenth century. But vellum is a natural product, made from the cured skin from a goat, sheep or calf. So it is not surprising that the thickness can vary from piece to piece. Vellum that is untreated, and used in calligraphy, is sometimes called parchment, but Kelmscott vellum has been coated with gesso, and then polished in order to create a very smooth writing or painting surface. It is more absorbent (due to the gesso) than the others.

Some miniaturists prefer to use a paper that is very smooth, with no texture at all, called hot pressed paper. Bristol board, also known as Ivorex, is another popular choice of miniaturists who prefer to work on paper.

Lana paper (also called Yupo) is a new synthetic product that has an eggshell, paper-like surface. It is more akin to paper than the other non-absorbent surfaces.

All these supports have their advantages and disadvantages. Paper will absorb the paint, so the process of painting will be quicker, but corrections cannot be so easily made as when using polymin or vellum. Grease on both of these will stop the paint from staying put on the surface, so they have to be handled carefully, cleaned with soap and water, or lighter fuel, and rubbed lightly with talcum powder, to absorb any grease before taking on the paint. Polymin and vellum can also be cleaned and used again, but paper will stain, and cannot be re-used.

Kelmscott vellum should only be cleaned with lighter fuel because soap and water will ruin the gessoed surface; the paint can also removed by rubbing with very fine flour paper, so the piece can be used again.

To cut these different bases, you will need a self-healing cutting mat with grid lines printed on it, which can be found in craft shops as well as online suppliers of art materials.

Polymin, vellum and ivorine come in assorted sizes, but they are usually not much larger than A5, so it is not too difficult to cut them into halves and quarters. For example, an 8 × 6-inch sheet of vellum can be cut into four. Do not cut any supports into ovals before painting; keep the rectangular format, so that there is a margin for error. The painting can be adjusted to fit the frame when completed.

Cutting supports

You will need a metal ruler and a very sharp scalpel with a new blade.

1. Take the sheet of vellum, and lay it on your cutting mat, lining up the straight edges with the guide lines on the mat.

Cutting vellum on a self-healing mat with a scalpel and a metal ruler.

Cutting polymin or ivorine as vellum but using less pressure on the blade.

2. Measure the sheet exactly in half vertically, and put the metal ruler against the line and draw a line from the top to the bottom, using a coloured pencil. Do the same thing horizontally.

3. The metal ruler must be longer than the sheet of vellum, so that you can pull the knife in one move down the line. Moving the ruler half-way is not advisable!

4. Now holding the metal ruler very firmly right on that line, score down once with a scalpel or craft knife (with a new blade). You may have cut through, but it usually needs a second score in order to make a clean cut. It is best to press quite hard, in order to get this right. It may help you to practise on a piece of thick paper first.

5. Polymin can be cut with a guillotine, but not vellum or ivorine. You could damage the guillotine by cutting such thick items (I have personal experience of forcing the blade off the rollers on a guillotine, when trying to cut two sheets of ivorine at a time – not a good idea!).

6. If you are ever lucky enough to have some old ivory that needs cutting to shape, it will have to be cut with a saw, by an expert. Mammoth ivory can be trimmed with curved scissors, but with great care, because it tends to flake. It is sold ready cut to size, and it is advisable to choose the frame to fit.

7. If you are cutting a rectangular painting, cut it the same way as you cut the sheets up. It will sit more easily in a square or rectangular frame if you snip a little triangle off each corner.

Stippling and hatching

Before making a start on a miniature work on ivorine, it is best to learn how to use the stippling and hatching techniques. As we have seen, they were worked out by miniaturists who began to work on smooth, slightly polished supports such as polymin, mammoth ivory, and ivorine. Rosalba Carrera, the Italian artist credited with using these techniques for the first time, presumably discovered when stippling the paint onto her portraits, that by building up her colours in a key of tiny dots, they adhered to the ivory surface more easily. In addition to this she would have discovered that by using the technique of laying the colours adjacent to each other – by mixing the colours in the observer's eye, rather than on the palette – a luminosity and glow would be imparted in the finished work. Strong shadows could be painted on the reverse of the work, and would show through on the other side, without a build-up of thick paint. Because of the chemicals used in the make-up of watercolour (gum arabic and glycerine), if it is laid

too thickly onto a shiny surface, when dried out it will flake and come off.

Stippling

Stippled and hatched painted eggs, in red and green bottom right.

As with every new skill that you learn, it is necessary to practise by doing some exercises. If you are learning music, scales teach you manual dexterity, and the stippling technique in painting will teach you how to create form and dimension.

Method

Use a clean sheet of white card. Even if the card is slightly off-white, it will change the colours applied to it, just as it will 'grin' through the transparent polymin or ivorine. Do a little test and slide a bit of coloured paper under the polymin, and you will see

Palette

Use a clean palette with small wells. See the list of suppliers at the back of the book for stockists. Avoid the plastic ones; try to use china or white enamelled metal ones. The paint does not mix well on plastic, and forms big blobs. The wells help you to keep your colours separate from each other. As you are going to learn how to put the colours on side by side in layers, it is most important that each colour is kept pure, and not dirtied by the other colour you are using. Have a brush for each colour to start with. Two clean white saucers or plates will do, if you have not got a palette.

for yourself how the polymin changes. In order to maintain the clarity of the colours, make sure the card underneath is white.

Off-cuts of supports are very useful for practising on; alternatively, cut new pieces into 3 × 2.5-inch rectangles and stick them down onto the white card base.

Take pieces of vellum and paper too, and tape them to the same piece of card, so that when you have practised on each type of support you can easily compare the results.

The purpose of this exercise is to paint an egg shape, by stippling two colours one at a time, inside the oval, from light to

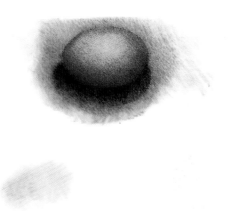

Egg exercise in light red and viridian on ivorine.

Photo reference – egg on green fabric.

dark, to make the 'egg' look smooth and round. To paint this from life is best, for the first time, so you can refer to the shadows as they are in situ.

Put an ordinary brown hen's egg on a darker green coloured base. Select a big enough piece of green material to have it tucked over a piece of card behind (fabric or paper will do, but a bit of green velvet is even better). Place in an elevated position – on top of a box, for example – opposite your easel in good light. It is important to have the egg surrounded by the green material.

Clean the polymin (or ivorine) with talcum powder to remove any grease left from your fingers when you cut it to size. Vellum can be wiped with lighter fuel, not water; too much water will spoil the polished gesso surface. All supports can then be wiped over with a clean piece of habutai silk. This will remove any hairs or gritty particles that may have been left behind.

Have two clean water pots, one for moistening the paint, and one for washing the brush between each colour. Now mix up some paint.

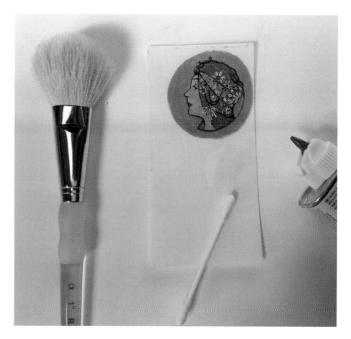

Cleaning vellum before starting a work, using lighter fuel and a cotton bud.

Common colour combinations

Pairs of colours you will be using (separately in layers) quite frequently will be:

- Light Red/Viridian: tanned skin, particularly European tans. The green is used for the dark shadows.
- Cerulean Blue/Raw Umber: backgrounds. By varying the depth of each colour, you can make several shades of these, from pale sepia to blue green and green blue. These were used by miniaturists in the seventeenth and eighteenth centuries, when miniatures were at their most popular and prolific.
- Raw Sienna/Rose Madder Genuine/Permanent Rose: skin tones of children, or pale skin for adults.
- Winsor Green/Alizarin Crimson: an excellent black or dark, when built up in layers.
- Cobalt Blue/Light Red: a useful grey. More blue makes it cool, and more red makes the grey warmer.

These combinations of colours are used for particular areas of miniature painting, and are useful to have at your fingertips.

Draw ovals or circles with a template, or freehand on your samples, evenly spaced on each type of support. They do not need to be big: ½ an inch diameter will do. Use a water-soluble pencil in blue or light red, or a brush.

Colours that I use frequently, showing how they mix together, and also how some look when stippled separately, one over the other.

Mix up each colour, by itself in a palette well, not too wet or too strong. Use an old brush for this operation.

Before the paint dries (you will use it dry later), take a size 2 brush, and load it with the light red diluted paint. Blot the brush to absorb some of the liquid paint, so it is loaded enough to complete your wash without the need for re-loading.

Blotting

Use a lint-free rag for blotting. A piece of an old well-washed cotton or linen tea towel is ideal; not kitchen paper or toilet paper, as they are meant to degrade. They will leave behind little fibres on your brushes, your paints and your work, which will become difficult to take off, and drive you mad!

Then fill the oval with a wash, starting at the top, and in one continuous stroke move from side to side and down, until you reach the bottom, lifting the brush off the support. There will be a little blob of darker paint left as you do this – this is normal – but the oval should be filled evenly with the pale paint. If you have lines showing the path of the brush, the paint was too dark. The paler it is, the better; then the wash will be even.

Try again if it is stripy, and practise till you get a fairly even wash filling the oval. It may take one or two before you get it right, but it is a skill worth mastering. It is so useful to be able to lay down an even wash, as a basis for many subjects: skies, landscapes, seascapes, fabrics, glass, and of course smooth skin. A wash is especially important when staring a miniature, because you only get one chance to use it. Any second attempts remove the first, because the wash sits on top of the polymin.

ABOVE: Four eggs and a bad stripey wash.

RIGHT: Stippling the egg exercise (and a pearl) on paper top, and vellum below.

Go on filling every oval with washes of one of each pair of colours listed above and let them dry. Your first washes should always be very pale.

By now the first paint mix you used should be dry. If not, you should wait until the diluted paint has dried sufficiently to be able to draw a fine line with it. You can tell if the paint is still too wet, because the line you draw will be broad.

The paint you take from your palette should be pale and dry, reconstituted by a damp (not wet) brush. (Remember to blot the brush before putting it to the surface of your support.) It helps to imagine the brush is more like a pencil, and then the stipples and hatches you make to fill the ovals will be fine and hair like, rather than big wet blobs.

paints luminous miniature landscapes, uses the stippling technique totally in her work, to great effect, and always paints on a white paper called Bristol Board (her work is shown elsewhere in this book and on the cover).

Try a very smooth hot pressed paper, such as Bristol Board or Ivorex, so that you can make some alterations if you need to. White paper is most artists' first choice, but do not be afraid to experiment with coloured papers too. You can create some really unusual effects by using white on darker papers, in the style of the watercolourists in the 1930s, such as John Sell Cotman.

Silhouettes are usually painted on paper; using cream paper or parchment-type papers with textures enhances the art of silhouettes.

Paper

Although it is not so necessary to stipple on paper, because the colours will stay on the surface, it is very useful to practise before you begin, and get used to the technique, as it will become necessary on occasions. Then you will be able improve your work in all sorts of ways, when painting miniatures on paper.

Consider a landscape, with many trees of different colours, in autumn for instance. The different shades of yellow, orange, red and bronze can be more easily indicated by stippling the colours separately. Painted in this way the colours will seem more powerful than if mixed up in the palette first. Roz Pierson, who

Lana and Yupo

Lana, or Yupo, an especially smooth-textured paper, is now widely available. Very sharp lines are easier to achieve than on a textured watercolour paper. However, the disadvantage is that you cannot correct mistakes very easily. But if you paint a silhouette on ivorine or polymin, it is never going to be quite as sharp as an image on paper anyway. Thick gouache paint or ink will definitely flake off in time. It is always best to use an absorbent surface for silhouettes.

There are four examples shown below of different colourways stippled on two shades of cream paper, and two white papers, available from Polymers Plus (contact details are given at the end of the book). The colours used are listed below, and no pencil is used at all.

Watercolour trials on Yupo, a new support, and tinted paper. Silhouettes in black gouache (top) eight eggs in several colour mixes; (below) six eggs stippled in various colours, on different shades of paper.

Use a size 0 brush for the wash, and size 000 (sables) for stippling.

A: Raw Umber base wash, stippled with Cerulean Blue.
B: Cobalt Blue base wash, stippled with Light Red.

C: Viridian base wash, stippled with Light Red.
D: Rose Madder base wash (pale), stippled with Raw Sienna.

E: Alizarin base wash (dark), stippled with Winsor Green.
F: Yellow Ochre base wash, stippled with Cerulean Blue.

G: Light Red base wash, stippled with Viridian.
H: Raw Sienna base wash, stippled with Permanent Rose.

There are subtle differences in how colours appear, depending upon the base colour of the paper they are painted on. Obviously the colours are brighter when painted on a white base, and more muted when painted on a cream coloured base if you are using paper or vellum or the two shades of polymin.

Frittillaria in a blue lustre vase, painted in miniature on paper, from life.

Glazing

As touched on earlier in this chapter, white may be used on tinted paper. However, there is a technique called glazing, which is sometimes used in oil and watercolour works. For example, if you are painting a woodland scene with primroses, anemones and bluebells on cream paper, vellum or polymin, the brightness of the colours will be changed by the coloured support. So all the flowers should be blocked in with Titanium White first.

When they are completely dry, they can be glazed over with Cobalt Blue + Magenta (bluebells), Lemon Yellow (primroses) while the anemones are left as they are, but may need two layers of white to stand out.

Remember if painting on non-absorbent polymin or vellum, make sure your glaze is fairly dry or the paints will mix together. The effect of the white base shining through the blue or yellow will be completely lost if the colours are too wet and mix up on your work. This is another exercise to perfect before you start.

There are also some very striking miniature flower paintings using black paper and gouache paints, which have more body and depth, so that the bright colours of the flowers stand out against the dark of the paper.

It is wise to be aware of these effects when choosing the colour of your base. For example, if painting flowers, which have bright clear colours, it would be sensible to use the brighter white paper; the same for snow scenes. Landscapes and seascapes, on the other hand, would be fine on the cream paper, as natural colours are often more muted and any bright areas can be touched in with Titanium White.

Some useful tools to make for yourself

Making a poupée

A poupée is used to clean grease off the surface of a support.

What you will need:

A square of habutai silk
Talcum powder
Strong thread or an elastic band

Shake a large teaspoonful of talc into the centre of the square of silk. Draw up the edges wonton style, and tie firmly with thread or an elastic band.

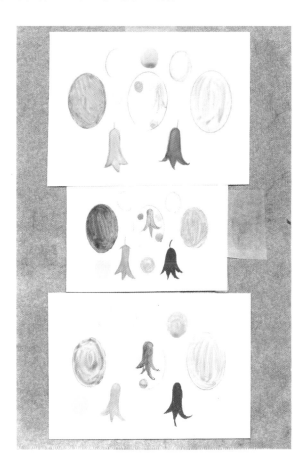

Glazing over white watercolour, on tinted paper. This practice enables the colours to stay bright on the cream coloured polymin or vellum.

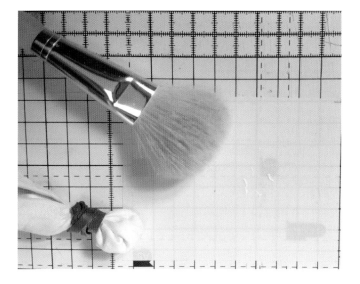

Making a poupee (dolly) from a square of pure silk, called jap or habutai, filled with talcum powder, tied at the top. This is used to clean polymin and ivorine, before starting a work.

Making wax-free carbon paper

What you will need:

Acid-free tissue paper
Scissors
Conté stick (sanguine or terra-cotta)
Craft knife
Cotton bud

Method

1. Cut a rectangle of good quality white tissue paper, the type without a shiny side.
2. Using an inch of a sanguine Conté stick and a craft knife, gently scrape some of the pigment from the Conté onto the tissue paper. Rub the colour onto the tissue with a cotton bud, and work it in well until there is an even layer all over the surface.
3. Blow off the excess, and store in an envelope, as the loosened pigment is apt to migrate.
4. If you need to clean any loose pigment off your support, use a small ball of white tack, or putty rubber.

Making wax-free carbon paper, by using powdered conte (sanguine) sprinkled on to tissue paper, and rubbed in with a cotton bud. Blow off the excess, before using.

Making a canvas for painting in oils, alkyds, acrylic or gouache

What you will need:

Washable table top
A4 sheet of mount board
Paper palette
White acid-free mount board, 2.5 × 3 inches
Habutai silk, torn into a rectangle (not cut with scissors – this keeps the fabric absolutely square), about half an inch larger all round than the white board
White gesso
Old ½-inch synthetic brush with coarse hairs
Palette knife

Take the materials you will need to a surface you can wipe down easily, away from your miniature painting area as it can be a messy process. Have an A4-sized old piece of mount board ready, and put a paper palette on top of this.

Method

1. Lay the board (the size of your painting) and the silk side by side, on top of the paper palette.
2. Take some gesso on a palette knife, and spread some on both surfaces.
3. Spread the gesso evenly over the white side of the mount board (which will be your canvas) with the bristle brush, from side to side and up and down.
4. Lay the silk on top of the gessoed board, and spread the gesso blob evenly on that too. Be careful to keep the silk weave at right angles to the card; you should have an even margin of silk all around the board.
5. Let it dry a bit, and then turn the silk-covered card over and fold over the silk margin and stick on the back of the board. It might help to cut a diagonal off each corner of the silk (making a mitre) so that the silk will lie flat when each margin is folded over. Do keep all the margins even, turn it over

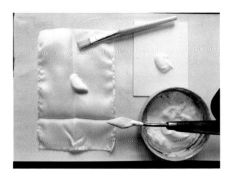

Making a fine-toothed canvas from jap silk, and gesso, on acid free board (stages 1 to 3).

Making a silk canvas with a fine tooth suitable for miniature painting, particularly oil painting (stages 4 to 6).

and make sure the silk is pulled taut on the front, and that there are no creases, air bubbles or uneven gesso anywhere on the silk paint surface.

6. Give the front another even coat of gesso from side to side and up and down, evenly.

7. Check that the side you will be painting on has an absolutely even surface; if it is uneven, lift up the silk, wash it out and start over again.

8. When you are satisfied with it, allow it to dry thoroughly, but away from direct heat, or it may warp. When it is completely dry, the surface should be even with a little tooth to it, and then it can be burnished with the back of a spoon, or a burnishing tool.

9. The surface should be similar to the surface of Kelmscott vellum.

10. Wash out the brush or discard it.

The advantage of this surface for oil paint is the fact that there will be a slight texture to it, which helps the paint to come off the brush as you work. It is also a good base for gouache or acrylic painting.

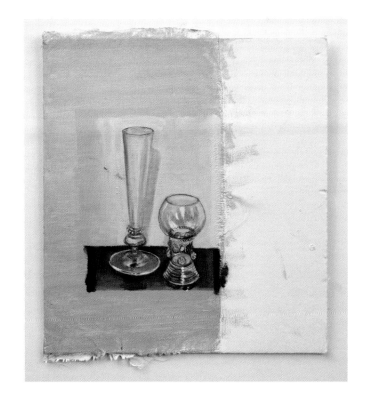

Trial painting on the silk canvas, in oil paint, in monotone, of two antique Dutch wine glasses.

Correcting and troubleshooting

If you paint on simulated ivory supports, the advantages they have outweigh any disadvantages, because you can easily correct your work. There does come a time when it is definitely best to start afresh, but if you need to alter just the pupil of an eye, for instance, it is so easy to take out the paint with a clean damp brush, wait for the area to dry, and repaint it.

Kelmscott vellum

Vellum is slightly different: too much lifting off with water will eventually create a hole in the surface, and ruin the piece, as well as all the hard work on the rest of the painting. The gesso on the surface of the skin is quite hard and polished, but gesso is water soluble, and will break down if it is too wet.

The very best way to correct a mistake, or change a colour on a piece of Kelmscott vellum, is to abrade it with the finest flour paper, *when it is completely dry*. If the area to be corrected is tiny, use an eraser template. Place the appropriate sized hole over the part to be corrected, and rub gently with a small piece of folded flour paper.

For larger areas, just rub gently with even pressure on the vellum, up and down and from side to side. You will need to use several pieces of flour paper, as the tooth of it will get filled up with gesso after a while. Keep the area abraded evenly, by not working too hard in any one area at a time.

Using this method it is possible to completely remove a painting on vellum that has not worked, or to remove parts of the painting that are too dark.

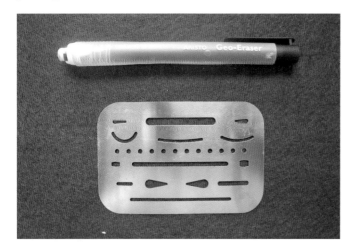

A small metal template with small cutout areas for erasing precise areas of fine work, and a pencil style eraser, to use with it.

To correct larger areas of colour on vellum, it is better to rub them off with fine flour paper, than use a wet brush. It is also possible to re-use a piece of vellum by totally removing a watercolour this way. Be sure to work evenly, all over the surface.

Blotting an area upon which the paint has been applied too thickly and too quickly is sometimes quicker than using a damp brush. Have several small squares of kitchen paper cut out ready. Using a larger brush, load it with clean water, and dampen a 2cm area on the paper square, and place it over the paint to be removed. Press down firmly with your finger, and roll your finger from side to side. Lift up the paper, and discard. Depending on how long the paint has been in place, a lot of the excess will have stuck to the paper. Move on to another area and repeat the process, using a clean square every time, until most of the over-painted area has been removed.

It is possible to take off any over-painted area, even on a portrait, in this way, allowing you to get back your basic drawing, and even out the colouring. Just keep the paper damp, not wet, and blot a new area each time, so that you are left with a paler, more even area of colour.

Then let it dry, and stipple more layers on the top of the blotted area, keeping them paler this time, and not so dense.

Backgrounds

Beginners often find larger background areas hard to get even

In order to remove heavily applied colour without losing the drawing or composition, it is possible to 'blot' the excess off with dampened (not wet) kitchen paper or thin cotton cloth. By doing this evenly across the work, or in one area at a time, you can get back to your basic, thinly washed level without losing the likeness or main outlines. Use a clean damp piece of paper, for each blot. Otherwise you will just put the excess paint back on in a new place!

Beginners will find it helpful to put colour on the back of the ivorine or vellum to create a background. The colour will show through from the right side, and that may be enough, or you can use it as the base to stipple on. Be sure not to paint over any areas that should stay light. Strong shadows on faces can be painted on the back in this way.

Using grated pastel and rubbing in on the back with a cotton bud can also be used as a shortcut to getting an even background.

and smooth with the stippling over a basic wash technique. There are two methods of overcoming this problem.

The first is by painting the wash on the back of the polymin. By putting the work face down on a light box (or holding it in place on the window) you can paint your background colour around the image which is on the front. Leave it to dry thoroughly before turning it over, and you should have an even tint of colour showing through the transparent support. You can then stipple over the tint, on the right side.

Pastel is also useful for putting on the back, and works in the same way. Grate the coloured pastel onto a palette, dip a cotton bud into the powder, and work that into the surface on the back, around the image on the front (still using a light box, or the window). An important point to make here, is about how pastel or paint colours can appear different when showing through the support. So try them out first on the back of an off-cut, to see which colour suits your work best.

The second method of getting an even background, if you cannot get an even wash, is by sponging the colour on. Cut a mask from paper to place over the portrait, or main area of the work, the same shape. Now mix up quite a lot of the back-

ground colour you want, and let it dry off a little. Take a small piece of sponge, natural or synthetic, and make it just damp. Holding the mask in place with your fingers, load the sponge with the colour mix, blot off the excess on a rag, then with a stencilling action press the sponge all over the background, firmly all over the unmasked area. Lift up the mask, and you should have a fairly even background colour for stippling upon, or you may leave it as it is.

Sometimes beginners find the first wash on a background hard to get even. It may help to cut a mask to lay over the main subject of the painting. Then use a small piece of sponge (any synthetic dense sponge will do) dipped into the main colour, ready mixed up quite strongly in a saucer but not too wet, and quickly press it all over the unmasked area. As with most techniques used in miniature painting the colour must not be too wet!

Getting stuck

At some stage all artists who have been working on a particular miniature for a long time cease to see what is wrong with it anymore. It can be very disappointing, after several hours of hard work, to find that you are not sure if the portrait is a good likeness, or to realize that the perspective in a landscape is not accurate.

Do not be tempted to start correcting, lifting off or blotting at this stage. If you alter your work prematurely, you will never know if it was perfectly all right, and you were just tired, and unable to see accurately anyway. You could end up spoiling work that was perfectly fine in the first place. I admit to having done this myself, on more than one occasion, and then regretting it the next time I looked at my work! At the very least you will have wasted a lot of precious time, and you are then faced with doing the work all over again.

There are several things you can do in this situation, if you are having trouble correcting or getting an eye or expression right, before blotting the part off or abrading the mistake.

If you have a deadline, and do not want to stop working, try looking at it in a mirror, or turning it upside down. But if you have access to a computer, scan the miniature, and look at it on the screen. This is the method which I prefer, as it always makes mistakes show up so much more clearly. As long as you have

time left to spend on correcting the mistake, go back to the drawing board, and try to sort it out.

Alternatively, start working on the background only. Or begin another project, and work something out in your sketchbook. In fact, do anything that completely absorbs you for a while, and when you return to the work, you will be able to see it with fresh eyes.

But the best course of action is to cover up the work and palettes, wash your brushes out, and take the dog out or have a cup of tea, and leave it until tomorrow.

Emergencies

Never bring the cup of tea into the studio and put it down near to the work you have been working on. I learned this the hard way, when I accidentally knocked a cup of coffee over two completed but unframed portrait commissions, which had been accepted by my client. They were carefully covered with acetate, but lying flat on my desk. The liquid seeped under this cover, so that the paintings were both stuck to it. In a bit of a panic (to say the least) I rang Michael Bartlett, and asked him what on earth I should do. He was very calm, and asked how long ago they had been done. Because it was some time since I had painted them, he suggested that I remove the acetate carefully, by lifting it up and off the surface. Then, having done this, I was to leave them alone, until they dried. It was hard not to fiddle about and blot and wipe, but I obeyed my mentor. It was the very best advice, because in spite of being covered with liquid, when the pictures dried, there was in fact very little damage, which I could repair quite easily; if I had tried to dry them any other way, I should have had to start again from scratch. So if you see a droplet of water on your work, leave it until it dries, and you may be left with a small ring around the area of the droplet, which others may not notice at all. Fiddling with a brush will result in a catastrophe, and you will have to start again.

I have since learnt that you can dry the drop a bit more quickly, by cutting a small square of kitchen paper, and putting one corner into the edge of the drop, which will act like blotting paper, and absorb most of the water.

Cleaning off stubborn grease

The smooth surfaces of polymin, ivorine and vellum pick up grease very easily from your fingers when cutting and sticking them to card, in preparation for painting.

If the paint will not stay on the surface, it is a sure sign that

Keeping your work clean: useful tips

- Although it is not necessary to wipe your palette clean after every painting session, it is a good idea to cover it, as hairs and dust in the air stick to all mediums.
- Change the water or turps frequently to keep your colours clean.
- If you can see too many 'bits' in the paint on your palette, and lots of your mixes are muddy, it is time to wipe it off and mix up new.
- If stippling is getting more difficult, check the condition of your brush. Sables wear out quite quickly, especially if you use the small ones for mixing. Keep an old synthetic brush for that, and save the best ones for fine work.

your support is greasy. So be especially diligent and clean it thoroughly before you start on a work. It can be so frustrating if you have carefully transferred your image to the polymin and you have to clean it all off because the paint will not stay in place.

To be absolutely sure it is clean, use diluted washing up liquid to wipe over the non-absorbent supports (use lighter fuel for vellum). When it has dried, polish gently with the silk poupée filled with talc, to make doubly sure the surface is pristine.

It cannot be emphasized too much how clean and dust-free your painting area should be kept. Cover up the work, and your palette, if you stop painting, even if it is only for a short while. There are plenty of environmental aggregates in the air! In his book The Arte of Limning, the goldsmith and portrait miniaturist Nicholas Hilliard warns about 'dandruff' and 'spittle', advising limners to wear a hat, smooth clothing, and not to speak too much, when working!

Care of bases (supports)

Ivorine and vellum have a tendency to warp, if they get wet or too dry. If you do get some ivorine, it is best kept in a sealed polythene bag, in a tin, because it is highly flammable, and it dries out if left open to the atmosphere.

Vellum is affected by damp and heat as well, although it is not so flammable.

So a drawer in an even temperature is the best place in which to store supports, including polymin. Cut the supports into the various sizes you prefer to work on, so that the risk of warping is kept to a minimum. During storage, sandwich these supports between two sheets of really rigid cardboard. Then put each type in its own bubble-wrap lined envelope, labelled clearly.

If you use paper, it too has to be stored carefully and kept flat, away from damp. The moisture will make it cockle, and then it's almost impossible to flatten it out again.

Watercolours

Some watercolours are 'fugitive', meaning they fade easily. The manufacturers indicate by letter or numbered coding those that are prone to fading. So keeping watercolour work away from direct sunlight is important.

Likewise, some colours 'stain' and cannot be completely lifted off, so make a note of those as well, and for miniature painting, try to avoid them. If you find a colour difficult to shift, make up a mixture of bleach in a small screw-top glass bottle – a teaspoon of bleach in two or three tablespoons of clean water – this will usually clean off or reduce the stain on the support. For instance, when working in the small area around the pupils of the eyes, correcting becomes difficult sometimes, as the white part of the eye becomes stained with the colour being used for the pupil.

It is no good trying to paint white over the stain: it will be unnatural looking, and jump out at you as being quite wrong. So this is a case for using the dilute bleach. A synthetic brush should be used, as it seems that the synthetic hairs are slightly abrasive, unlike sables. Dip the brush in the bleach, and blot off the excess on kitchen paper. You will find that the colour can be gradually removed.

Step-by-step guide to painting on polymin (or ivorine) and vellum

Choose your subject matter, and decide on the size you will be working to, and get the image made larger or smaller by using the grid method, which is explained later in this chapter. It is easier though, and not cheating, to reduce or enlarge your subject matter on a photocopier, or on a computer. A black-and-white image will suffice, because the colour will be on your original picture already. A good starting size to work on is an oval or rectangle 3 inches high × 2.5 inches wide. (This upright

format is called portrait; 2.5 inches high × 3 inches wide is called landscape.)

As a general rule, a miniature painting should be kept contained within the shape you choose. (There are also strict rules about the accepted sizes of miniature works, and the object sizes within them; these are explained fully in Chapter 11.)

Spend some time deciding upon the best format for your composition. This may mean leaving out some details in the picture. It is best to design the composition for yourself; photographs are just an aide-memoire. An artist painting *en plein air* does not necessarily put everything he sees in front of him into his painting.

Preparation of the support

Remember to clean the polymin after you have cut it to size. If you use a metal ruler and a cutting mat with lines in centimetres, it will be easy to keep it square. The slightest amount of grease from your fingers will render the surface hostile to paint, so it must be scrupulously clean. It may be helpful to draw a right angle on your white mountboard, so that everything can line up subsequently. Do not use a coloured mountboard, as the tone will show through the polymin, and you won't get

your colours right. (You will not know this until you have taken the picture off the board, to frame it – all that hard work, very frustrating!)

Cleaning

Polymin: clean the support after handling, with a silk poupée. If it is very greasy, wipe with liquid soap, run under a tap. Dry with a lint free cloth, like a microfibre lens cloth, and then finish off by using the poupée again.

Vellum: wipe over with lighter fuel on cotton wool, or cotton buds, then leave to dry. This will not take very long, as it evaporates quickly.

Ox gall can also be used for cleaning both polymin and vellum, but it has a very unpleasant smell, so it is preferable to use the other methods. Mammoth ivory can also be cleaned by all these methods, but must be handled with great care.

Re-using supports

Kelmscott vellum, which is recommended for use, can be used again, after the original work has been removed by using very fine flour paper, to abrade the surface gently and evenly until the work on the surface disappears (see page 132).

Never try to wash the paint off vellum, either under the tap or with a wet brush or cotton bud. The gesso on the surface will dissolve, leaving an uneven surface, which will warp and will be impossible to paint over evenly.

Mammoth ivory can be used again too, by wiping the paint off the surface with a cotton bud, and so can polymin, by washing the watercolour paint off with soap and water, and when dry, cleaning again with the poupée. Whenever the poupée is used, just blow or brush the excess talc from the surface, but do not touch with fingers again. Treat the supports with the same care as you would handle a DVD.

Having advised that these supports can be used again, it does depend on the state of the surface to be cleaned. Some watercolours will stain, such as Alizarin and Viridian. As discussed previously, you can use well diluted bleach to remove stubborn

These supports are laid on black card to show their translucency or opacity.

colours, or gently clean polymin, ivorine, and mammoth ivory with toothpaste. Use fine flour paper (dry) for vellum. However, if you have used oil colours and they have dried, cleaning off and flour papering will not work; however, because it is opaque, vellum can be painted on both sides.

Painting a miniature on polymin

You will need:

A4 size sheet of white mount board, with a 90-degree angle marked on it in blue pencil
A5 sheet of tracing paper
A5 graph paper with grid lines and squares (use the paper between the sheets of acetate)
Half sheet of polymin
Talc-filled poupée
Oval or rectangular template 3 inches × 2.5 inches, backed by a small sheet of acetate (clear plastic film)
Metal ruler
Cutting mat with grid lines
6H pencil
Sharp blue watercolour pencil
Rubber
Removeable sellotape
Small sharp scissors
Small square of wax-free Conté carbon paper
Sanguine Conté stick
Cotton buds
Craft knife
White tack

Image of the miniature to be painted, scaled down to fit the aperture, size 3 inches × 2.5 inches (beginners may use a photocopy); or a simple drawing of the subject, to fit the aperture

Bronwen Davies – profile reference, and sketch.

How to transfer a traced image to your support

1. Cut the support to a size slightly larger than your finished work, even if the format is oval (as described on page 71). If you need extra lines rule up the size in pencil. (*Note that this is the ONLY time a graphite pencil can be used on the support. Any pencil marks on the image area will dirty the watercolours painted on it afterwards.*)

2. Take your sheet of tracing paper and sharp blue pencil, and make a careful tracing of the image. It does not have to be very detailed: the main proportions and outlines are enough to start off with. All the details will be built up when you start the painting – this is when all the hard work will be done.

3. Tape the half sheet of polymin (cleaned with the talc-filled poupée) to the mount board, squared up with the 90-degree angle marked in blue pencil, along the top and down the side.

4. Take your wax-free carbon tissue (having blown any excess pigment off the surface) and tape it, carbon side down, to the tape holding the polymin in position.

Precise preparation

It is important at this stage to have everything squared up. It will save a great deal of time from being wasted on getting everything straight later on. It is a very good habit to get into, as miniature painting is quite precise. Time spent on careful preparation is invaluable. It is even a good idea to do it at leisure, and start the real work of painting the next day. You will then not be tempted to rush the important stages of preparation, and make mistakes

Lindsay – *the transfer of drawing to the support from a photocopy (or drawing) by stages: tracing; laying carbon conte on support, with tracing on top sticking it down, so it does not move; tracing over the image again, in a different colour so as not to miss any lines out; the red conte image should be clear on the polymin (if there are any smudges, they can be removed with a ball of white tack).*

5. Now take your tracing, lay it over the carbon, and tape it to the top again. (Because of the graph paper and the angle you have drawn on the mount board, everything should line up.)

6. Sharpen your 6H pencil to a fine point, and trace the image carefully but firmly, so that the image will show up on the polymin, or you can use a rollerball pen, as long as you can use a different colour, so that you can see clearly that you have traced over the all the blue pencil lines of your original tracing.

7. Lift up the tracing and remove the wax-free carbon paper, and you should have an image of your subject in pale sanguine Conté on your polymin. (If you have not, you have probably traced it on to back of your tracing! It has happened many times, so always check first.)

8. Some of the Conté pigment may have discoloured the polymin, and this is easily removed with a ball of white tack to blot off the excess. Keep rolling the tack to keep the white surface clean for each blot, or you will put it back on!

9. If you are satisfied with the image, remove the carbon now.

10. Now take your acetate-backed template and stick that over your polymin with the image on it. This acts as a dust cover when you are painting, which enables you to see your work even when you are not working at it, and stops dust particles from settling on top of your work. Use it every time you leave your easel, as bits of hair and fibres are so difficult to remove when stuck to your painting.

Checklist of layout

1. White mount board
2. Squared paper
3. Polymin/vellum/paper (your chosen support)
4. Conté carbon paper, face side down
5. Tracing of image
6. Aperture
7. Acetate dust cover

You will have made a 'sandwich' of card, graph paper, reduced image, tracing paper, polymin and aperture.

Using a light box

Some miniaturists find that drawing directly onto the support is not to their liking. They prefer to use a light box, which is an alternative method of transferring your image to your support. Having traced the image, tape the tracing on the top of the light box, and place the cleaned polymin over the tracing. if they have been cut accurately they should line up.

Turn on the light, so the image is visible beneath the polymin, and then trace the image with blue watercolour, with very dry and yet strong enough paint to see when you turn the light box off. If you are not quite familiar drawing with a brush, you can use a very sharp watercolour pencil instead. Lift up the tracing to check if the image is complete. Remove it and turn off the light box. Try not to handle the painting surface of your support, or the paint will not stay on. Now go back to your easel and tape the polymin (which now has a clearly visible blue image) to your card base, and cover with the aperture first and then with the piece of acetate.

Now you are ready to start working on your first painting!

The mask for the next image on a light box (top off, below on). This shows show how the use of the light box makes it easier to see the shapes.

Watercolour pencils used to draw directly on to the support or in sketches, and the use of white watercolour pencils on tinted paper.

Checklist of layout using a light box

1. Lightbox
2. Tracing of image, stuck down, so that the image is in the centre of your support
3. Polymin or other, stuck down with tape, with the painting surface uppermost

Painting miniatures in oils

Oil paints when used in painting miniatures have some advantages and some disadvantages. It is a traditional medium, and historically many portrait miniaturists used it for their works.

Oil colours do fade, as watercolours do, but usually not beyond the point of restoration. The varnish used to protect them darkens and so the colours lose their vibrancy, which returns when the painting is cleaned by a restorer.

Some of the pigments in watercolours just fade away, and cannot be restored. They are particularly susceptible to ultra-violet light, and if hung in bright sunshine, will deteriorate very

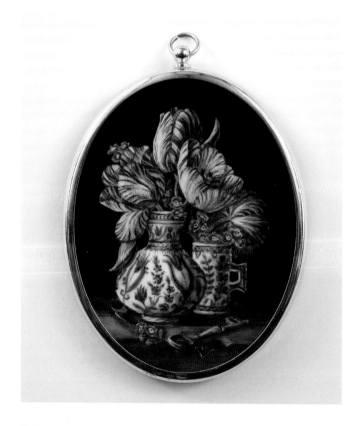

Tulips by Barbara Valentine, oil on ivorine, 3 × 2.5 inches.

rapidly. This is why in most museums the display cases of very old miniatures are protected by heavy leather covers. Those in the V&A are shown in very low light conditions, with additional low lighting for viewing, which does not stay on for very long, in order to preserve them.

The main advantage of painting in oil is the use of white paint. It is much easier, for instance, to paint highlights on glass and silver, or in the pupil of an eye, with touches of Titanium White. However, when using oils for painting on the small scale required for miniatures, it is necessary to dilute the oil paint quite considerably, as by its very nature and composition, oil paint is thicker and more viscous than transparent watercolour.

So there are several media used by artists to thin oil paint, so it can be used finely.

There is also a method of painting glazes over oils when they are dry, to create depth of colour, rather like the effects of stained glass.

Barbara Valentine, who paints many of her miniature works in oils, uses glazes to maintain the vibrancy of colour in her flower paintings to great effect.

It is a technique that cannot be used on watercolour works so easily, especially if they are painted on a non-absorbent surface such as polymin. The painting would be lifted off in the process. However, if the watercolour is on vellum, it is possible to glaze, to a certain degree, over the work, but it has to be completely dry, having not been worked on for several weeks.

The palette of oil colours is suggested in the chapter on Materials.

Making a start on an oil miniature

Set aside a whole morning (or even a day) session for your first attempt at painting an oil miniature. If you are not familiar with the medium, it would be a good exercise to put some paint out on a palette, and some thinners (turps or white spirit) into two dippers: one in which to rinse your brush, and the other for diluting the paint. This practice of having two pots is important when you paint with oil. The paint pigment is so much more dense, as you will discover when rinsing the brush, and the turps will get dirty very quickly. Use kitchen paper to squeeze the dirty turps out of the bristles, and rinse again until it is clean.

The same selection of oil colours as for watercolours is recommended.

- Take an off-cut of any support, vellum or polymin, and stick them down on white card (then you will see how each works with oils).

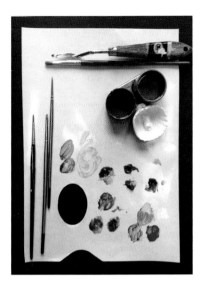

Oil paper palette on card. Dippers for turps (mixing medium) and siccative (drying medium). Clean shell for white oil only, and brushes. Palette knife for taking small amounts from the tubes. Range of tubes, small ones!

- You can draw some shapes on the support with a coloured pencil (not graphite, as it makes oils dirty too).
- With the palette knife, take a little Viridian, Light Red, Permanent Rose and Cobalt Blue from your tubes, and spread onto the paper palette. Squeeze out some Titanium White in a separate container.
- Now the fun starts! Use any small brush, old sable or synthetic, and dip it in the clean turps, and then into the Cobalt Blue, and mix it around a little.
- Now take (with a clean brush) some Permanent Rose, and put it by the side of the blue and, using the brush for White, add a bit of that next to the other two.
- Now try mixing the blue and the pink together, and then mix them into the white.
- Wash the brushes and then mix some light red into the blue, and you will get a warm or cool grey.
- Now add some white to that and make it paler.

- Add more blue, to make the grey cooler.
- Add more red, to make the grey warmer.
- These greys are so useful in all types of miniature painting, from seascapes, snow scenes and portraits.
- If you are only used to watercolour, you should notice the difference in the colour of oil: it is so much brighter and does not dull off when dry.

Egg exercise in oil paint

Have the same egg and velvet front of you, which you used for the watercolour exercise, or the photograph of it. Draw the egg shape in red or green paint or coloured pencil, on the support. Make it quite small, so that you can try again on the same support, if you want to.

First clean your brushes. Now use the Viridian and Red, mix together and try the Egg Exercise described earlier in this chapter.

Egg in oil, Viridian and Light red.

If you use a little siccative to mix into the paint to thin it down, the paint will dry more quickly, and you will be able to work at the exercise a little longer. Another useful tip to help the drying process is to use lighter fuel instead of turps. However, it is very volatile, flammable, and it evaporates, so use it with caution.

Using these methods to thin the paint when carrying out an exercise such as this is very useful, but you will soon discover that oil paint can only be worked on for a limited time, otherwise you will end up with mud.

Most miniaturists who paint mostly in oils have more than

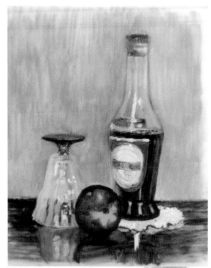

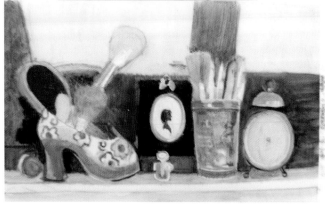

Two oil miniature paintings at the under painting stage.

one painting to work on at a time – several in fact! Then they move from one to the next, ensuring that they will be working on an oil that is dry.

Still life in oil

By now you may feel enthusiastic enough to try a still life, from a set up or using some reference, to make a start on the real thing. Sketch the composition onto whichever support you prefer, and then paint it in lightly, with broad strokes in watercolour.

This is what is called the 'under painting'. If this first layer of paint was oil, you would have to wait a couple of days for it to dry before you could work on it again, so it is advisable to use a different, quicker drying medium for this under painting. Acrylic paint could also be used.

After working over the under painting, the next layer of oil paint can be thinned using siccative, and the painting will be dry in about twenty-four hours.

It is really satisfying to work over the layers beneath, with glazes and white, and if you are careful with your detail, you may complete an oil miniature more quickly than a water-colour.

Remember to blot the brush, and keep rolling the tip, to keep the point fine. As you work, the paint may get too thick or 'gloopy'. So take a clean dry brush, and lift off the excess, wiping the brush dry as you go. Or this can be a great opportunity to blend the colours too, if you want to smooth them out. Depending on how much you lift off, the brush will get dirty fairly quickly, so have several old ones to hand to complete the operation.

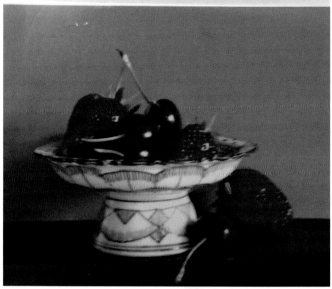

Watercolour under painting for Strawberries *(for speed of drying to get on more quickly). Photo reference for the painting, as the strawberries will lose the shine and colour before the painting is completed.*

Tonking

Another way to remove excess paint is to lay a piece of newspaper over the whole painting and rub over the top firmly but not too heavily, or you will smudge your work. Lift up the newspaper, and you will have blotted off the excess on your painting. This practice was devised by Professor Tonkin at the RA Schools, and is therefore called 'Tonking'. It is used by many artists, usually at the end of a painting session, so that the painting will dry more quickly, and the layers will be more even.

Strawberries *(stage 2).*

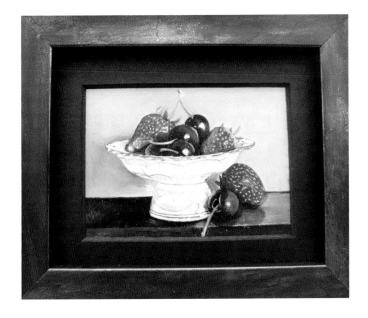

Strawberries *(finished painting).*

Elizabeth Meek MBE

Elizabeth works exclusively in oils, usually painting portraits. Her use of the medium is very fine indeed, and it is not always easy to tell that oil paint has been used. Her work is much sought after and collected.

Masai Woman *and* Anthony Lester: *oil portraits by Elizabeth Meek MBE, both on ivorine, 4×3 inches approximately.*

91

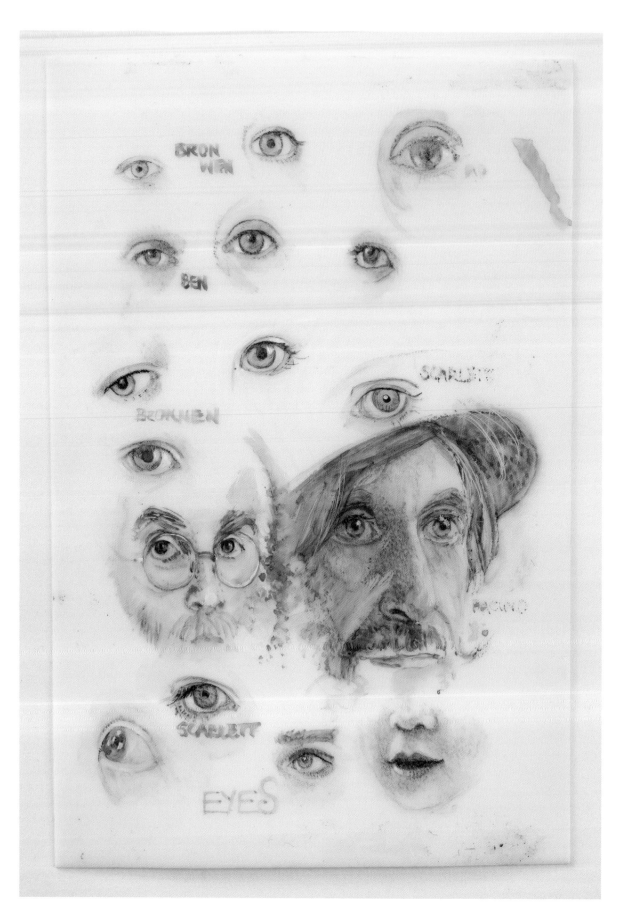

GETTING STARTED

It is essential to choose a subject that you want to paint and will enjoy working on – then your motivation will be high. I have always loved painting portraits, but they are a little more difficult, because of the element of capturing a likeness. Other subjects may seem easier to start with, but in my experience of teaching miniature painting, every student wants to try to paint a portrait.

It is a very good idea that for your first attempt at portrait miniature you paint someone you do not know. Then, without the added complication of having to make the portrait really look like your granddaughter or your friend, you can concentrate on getting the features down and the proportions correct, and learn more that way.

It is not necessary to take photographs of your own to practise on, as there are plenty to be found in magazines and newspapers; in fact the images and features are often sharper, and always larger. But commercial images should only be used for practising – copying from other photographers' images is purely for learning purposes. You cannot exhibit them without asking permission of the person who took the picture, and you are never allowed to exhibit portraits of Royalty, unless you have been officially commissioned.

In an ideal world the sitter would remain in the studio, for the duration of the painting of the portrait. Unfortunately, this is never the case, as miniature portraits take so long, but if you can meet the sitter and have short sittings during the process of painting, that will be a great help.

If you have seen famous portraits by the Old Masters, you will understand what special extra element of their personality, or presence, the artist has captured in the painting. Consider the joyous ebullience of *The Laughing Cavalier*, for example, or the impressive stance of Holbein's *Henry VIII*, not to mention the gaze of the *Mona Lisa* whose eyes are said to follow you around the gallery.

At the first sitting with your subject, you should make notes of skin tone, eye colour, hair, and then make sketches of them for reference, to help you remember the characteristics that are particular to their face. During the process you will become aware of certain attitudes they have, which are part of their personality, and can never be captured in a photograph. So you must meet them, in order to feel and see the essence of the person that they are, and in doing so, the portrait you paint will express something more than an 'image of their face'. You must try to capture that elusive part of their personality, which is theirs alone, and will make your painting of them especially personal and unique.

You should always take your own photographs to work from. The images you will then use as reference are your own visual perceptions of them. The digital camera has made this process so much easier: take several pictures in different poses, from various angles with different light conditions. Then you can show your sitter the pictures and discuss with them which one you will use, and if you are painting a child (who cannot be expected to sit still for very long), give them absorbing toys to play with, whilst you are sketching. Playing a game with them, maybe even drawing together, will help them to feel at ease with being the centre of attention. As a result the subsequent sketches and photos you take will be more natural

Using reference material for portrait painting

The larger your reference, the easier it will be to see all the shadows and shapes that make up the face, and this helps to get a more accurate likeness. This reference material (even when black and white) is really useful for learning about facial features. For example, you can make studies of just the eyes or lips, to understand their different shapes.

OPPOSITE: *Ways and means: exercises of eyes and faces on ivorine.*

and relaxed. Later on those images can be shared with their family and the most appropriate pose and expression that you will use can be discussed together. Ultimately the image you will paint must be your own perception of the child. As a portrait artist this is vital, as the photograph is only taken to remind you of the child's skin tones, proportions, clothing and backgrounds.

The particular characteristics and what to look for (and how to get them right) are outlined in further detail in Chapter 9.

Unfortunately there will be times when you have to work from someone else's images; when the portrait is posthumous, for example. It is advisable to be cautious before accepting the commission, if you have to do this. Ask to see the photo first. It is not unreasonable to explain that you do need a reference of a good size in order to get a good likeness. It is amazing how small and indistinct some of the photos you get can be, and usually they cannot be enlarged successfully. Sadly, some clients can expect you to know the person from the smallest image, and perform miracles.

Be aware that photographs are very deceptive: eye colour, skin tone, and shadows can be completely different from the actual colours in life, and even the most sophisticated cameras cannot capture some colours accurately. For instance, the elusive colour of bluebells is never quite the same in a photograph; it is always much better to paint them from life anyway. The camera can help you with your endeavours to get a likeness, but the colours of your sitter's complexion, eyes and hair can only be accurately interpreted from your own sketches and colour notes, taken from sittings with your subject.

Landscapes

I do not advise painting a miniature landscape *en plein air*. It is much better to sketch in the field and do colour washes to remind you, and perhaps take photos, for later work in the comfort of your studio. However, there is nothing better than taking your inspiration for landscapes in the countryside, and making up your compositions later. The light on water, and the clouds in the skies of winter, spring, summer and autumn, have to be observed and experienced before they can be realistically reproduced in any painting, as well as in miniature, as illustrated in this lovely picture of an English spring woodland by Roz Pierson.

Demonstration 1: Portrait profile in watercolour

This photograph of a little boy called Mackenzie is a good one to choose for a demonstration of how to start painting a

Spring by Roz Pierson, watercolour on paper, 4 ×5 inches.

The photo reference for Mac's profile demonstration.

miniature. He is enjoying playing with some clay and the photograph is taken in profile. Notice all the contrasts in the photo: the bright light on his hair against the dark shadows behind. These contrasts between dark and light make it easier for you to see his profile clearly, and the light on his hair adds to the strength of the composition.

The photograph is taken exactly level with his profile in the viewfinder, so there is little or no perspective to think about (this aspect will be covered later on in Chapter 9). This is a very good pose for a beginner, as you only get one of everything – eye, ear, nose mouth – all on the same plane. This means that they are exactly level to your eye, and not distorted by him looking up or down, or looking round too far away from you. (The concept of 'planes' is explained in more detail in the chapter on portraiture.)

Mac is relaxed and animated. This is important when taking photos for reference if painting a portrait, as you need your sitters to become as relaxed and as natural as possible; posed set ups will never look realistic. The digital camera is invaluable for this purpose because you can take as many photos as you like, all in different poses, and from different angles. Choose the most natural ones, and any that have got the colours right, and discard the rest.

Setting up

Before you start, have everything you will need set up and ready. If you have got everything ready beforehand, you will not need to break your concentration when looking for your favourite brush, or have to get some clean water in the middle of a tricky bit of stippling. Decide on which colours you will need for the portrait, and mix them up, in a weak dilution, on a palette you will only use for this work.

When working from a photo it is best to use a table easel; working upright it is better for your back, neck and eyesight, as pointed out earlier. Even if you are working from life, it is much easier to look at the set up at your eye level, and move your eyes, rather than your head. If you work flat you will be looking up and down all the time, and you will soon notice the strain.

In this demonstration I have used the following colours, and used them on both supports. You can see the little squares of colour, painted on the support out of the picture, to remind me of my basic palette.

- Skin tones: Rose Madder Genuine, Raw Sienna, Light Red
- Hair: Yellow Ochre, Raw Umber, Cobalt Blue, Sepia, Titanium White

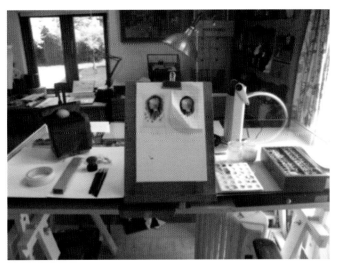

TABLE PLAN

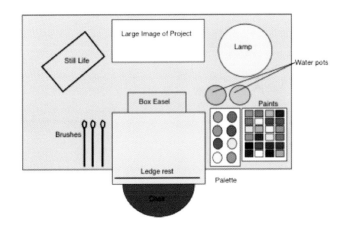

A good table layout. Have all you need to hand nearby in a chosen order, then you can really concentrate.

- T-shirt: Alizarin, Winsor Green
- Background: Cobalt Blue, Indigo, Magenta

Keep the colours separate in each well. The reason for this is partly cleanliness, and to keep the colours pure. The dilution of each pigment with water enables the paint to dry to the right strength to use when stippling. If the paint is too thick or too wet, it makes the whole process get off to a bad start. By keeping every stroke pale, but sharp (as the paint is drier), it means that the colours can be built up slowly, layering one colour over another.

It is tempting to use the paint darker and thicker, and build it up more quickly, but you will surely have to lift most of it off later. If you rush ahead and the paint is too thick, when it is completely dry on a non-absorbent support it will inevitably

The palette of colours used for Mac's profiles.

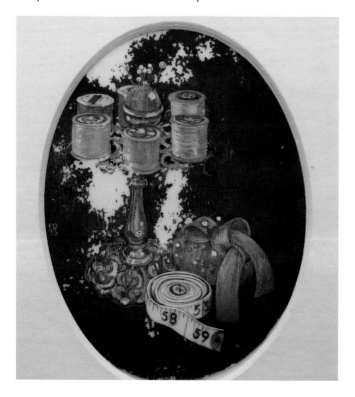

A painting of mine, showing what happens if the background paint is laid on ivorine or polymin too thickly.

flake off. (Most beginners discover this the hard way, including the author.)

If you have not worked on the egg exercises in this book I suggest that you spend a couple of hours practising them before you start. However, if you have done them already you will understand that instead of mixing paints together before applying them, when painting a miniature, they are sometimes applied separately. This technique, when used on skin, gives a special glow, and luminosity. But the technique is just as effective in other subjects: landscape, seascape, flowers and still life. The colours do not lose any of their purity, and the results are brighter. Cleanliness of palettes, brushes and water pots is paramount in getting this clarity of colour.

Method

This demonstration shows how to work on two supports, polymin and Kelmscott vellum. Polymin (non-absorbent) has a right side, which is the least shiny. Vellum (absorbent) can be used on both sides. They are stuck on to a piece of clean white card with removable sticky tape. (Do not use masking tape, as it is so difficult to remove; even after a short time, you have to apply lots of lighter fuel to shift the glue.)

Notice the two palettes I use. Having chosen the basic colours, I usually paint diluted blobs of them on a palette or on a separate piece of the same support I am using, near to my work. Here I have put them directly on the supports, next to the work, for the purposes of illustrating them next to the actual miniature. I can reconstitute them from the polymin and I do not use them until they are really dry. They are cut off when the portrait

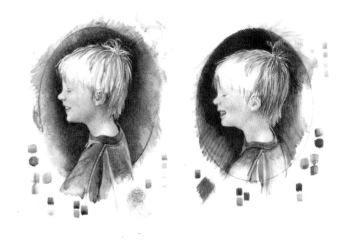

Mac's profiles on polymin (left) and vellum (right). Note the colour swatches of paint outside the picture.

is framed. The swatches on the vellum are for you to see how they appear on this support.

I have made a simple tracing of Mackenzie, using a very hard pencil (6H) on a good quality tracing paper. Poor quality tracing papers are thinner and more opaque, which makes it more difficult, as you cannot see the image so clearly. Put a piece of Conté carbon paper over your pre-prepared support (thoroughly cleaned, with a layer of talc to make absolutely sure).

Use sticky tape to hold the carbon in place, and another piece to hold the tracing firmly over the top. Using the hard pencil again, trace over the first image, so that the carbon will transfer this simple image to your support.

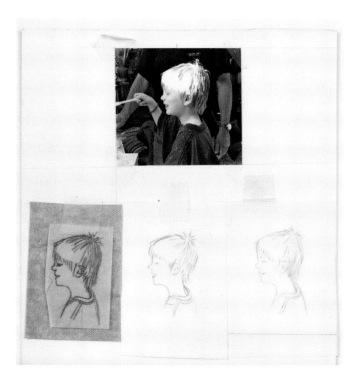

The process of getting the image traced and transferred to the polymin. Clockwise from the top: photo; tracing in pencil and blue; final conte image on the polymin; tracing placed over carbon on top of the support.

By now your diluted palette will have dried thoroughly. (Even though you are using watercolour, you may forget all the wet on wet techniques you may have used before.) The reason for mixing the palette of colours before starting to work is because of the fine technique required for painting miniatures. Once mixed up and allowed to dry, it is easy to reconstitute the paints with a clean damp brush, and stipple the colours side by side on the support, to preserve their luminosity and clarity. Working this

way is more akin to drawing, but with a paintbrush, using the paint really quite dry. This is one of the ways in which miniatures differ from small watercolours.

Using a size 0 sable brush, take up some water and wipe the brush. It must not be too wet or have a drip on the ferrule. Then reconstitute the skin tone colour with the brush, and place it onto the face under the hair. By moving the brush from side to side in the face and neck area, pull the paint down to meet the line of the T-shirt. Try to keep this first wash in one continuous stroke, not lifting the brush up until you have covered the whole area of the face and neck.

It is the only time a wash is used. A second wash would only remove the first and you would have to start all over again. All further colour is stippled or hatched onto the work.

Use the same method to colour the hair, but leave out the light area of the hair, apart from a few hatches on the diagonal hairline from the forehead down to the ear.

Wash the background in with cobalt blue, carefully around the profile and down the sides of the T-shirt. It does not matter if it is streaky, as it will be stippled and hatched over later.

Wash the T-shirt area with charcoal grey, and sketch with the brush the folds and ribbing on the neckline.

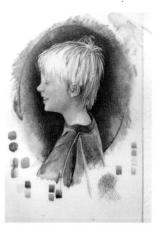

Mac's profile demonstration: stages 1, 2, 3 and 4.

Keep colours pale and dry

If you can remember to do this, you will be halfway there. If this is difficult at first, blot the brush after re-charging it on the palette, *every time* before you go back to the painting. Getting into this habit of blotting will help you keep the colours pale, and your work will dry more easily. Rolling the hairs on the brush as you re-charge it will help to keep the point, which helps the process of stippling and hatching.

Now the absorbing technique of building up the layers of colour begins. Mackenzie's complexion is very soft and smooth, so your stipples must be almost invisible. In contrast, the background is a much stronger colour, and will take more layers, so you can hatch, cross hatch and stipple in the spaces between. Darker colours are much easier to build up on vellum than polymin, as you will find if you are trying out both supports. It is easy to see this on the two finished portraits.

When painting hair, make your strokes follow the growth of the hair, as if you were brushing it, and this will help you to paint it more realistically. Start with the mid-tone, and work up to the darker ones. The highlights can be lifted off with a clean damp brush, or scratched with a craft knife. The very fine bright hairs can be put in with a little white at the very end.

If the hair in your portrait is very curly or frizzy, dry the brush and work the paint into lots of tiny circles, and keep the edges soft and pale by using dry brush technique.

Mac's profiles completed polymin top vellum below. Note the subtle difference of the colours. A patch of blue on the vellum has been left unfinished to illustrate this.

Molly's curly hair was painted using dry brushwork (scumbling) with circular strokes.

Now there should be a pale colour wash over the whole surface of your work, within the desired shape you have chosen. Keep within the oval; stippling is exacting work, and if you cover a larger area, it will be cut off later, wasting valuable time and effort. However, one way of making sure the brush is not too wet is to start the stippling just outside the oval perimeter, background or edges. Start so that by the time your brushstrokes reach the main area of colour, they will have been worked to the right consistency and tone. Loading the brush too often tends to make your strokes too broad. The amount of colour on your brush can be worked with far longer than you may realize. During my demonstrations of stippling in lessons, students would often notice this, go back to their project and find stippling a bit easier after that.

Remember to try and relax a bit every now and then, as you can find yourself tensing up if things are not going well.

To illustrate how much stronger the dark colours can be on vellum, I have not filled in all of the background on the portrait shown.

Demonstration 2: Mac in a Pink Hat

This portrait demonstration is of a full face view of Mackenzie again but this time wearing a pink hat. This time there are two eyes, a mouth, a nose and an ear to paint, as well as the challenge of painting a hat that does look as if it is actually on the sitter's head. Sometimes students paint hats, hair or head-dresses as if they are only balancing on the head.

The photograph is always used for reference, but it has een transferred to the polymin base in two ways. One will suit the beginner, and two will be used by more experienced artists.

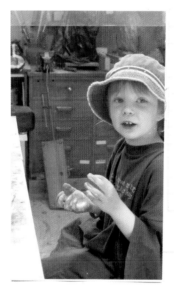

Drawing from the photo freehand, using a grid. This has been drawn in pencil directly on to the support, so it can be seen clearly.

For beginners

Trace the image, then reduce it to fit your chosen size – in this instance the oval measures 3 × 2.5 inches. Follow the instructions for transferring and then trace the image on to the support surface, using the Conté carbon. Make sure the support is free from grease.

Mac in a Pink Hat *demonstration photo.*

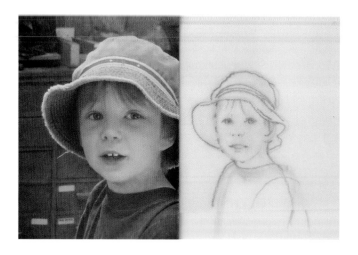

Working from your own drawing, transfer it to the support as before.

For improvers and experienced artists

The other image shows how to draw freehand the image from the sitter or a photograph, and how to position it within the oval aperture.

The portrait outline can also be traced in paint directly from a sketch or tracing using the lightbox. Stick the image to the centre of the light box, and place the translucent support over the tracing, and stick that down firmly so neither can move.

Keep your image close by, so that you can refer to it, if some points are indistinct, but it is not necessary to put in every line and shadow. This process is only a short cut to getting the proportions correct, not to help you to get a likeness, although accuracy at this stage is very important.

If you feel confident in your drawing abilities, you may by-pass both processes described above, and draw directly onto the support from a watercolour sketch you have made from life, or from the photograph you have taken. It suits some artists to have no carbon or even a watercolour outline on the base, when starting a portrait. It does help to have done plenty of sketches of your sitter first, however.

The palette

Take a clean palette, a brush and two water pots. Now jot down the colours you will need for this work and mix them up in the wells. Make sure you dilute quite a good amount in each one, and let them dry. Nine colours have been used and white.

The ovals in between the main colours are mixes, some of which which will still be applied separately, but are to show he colour strength to aim for, and what they look like when mixed.

Keep the oval palette just to take the colours from, as if it were a paintbox. Use another clean palette when you need to mix colours.

Watercolour list:

* First column from top: Cerulean Blue, Raw Umber, Light Red, Cobalt Blue, Raw Sienna

Stages of getting the drawing right. Clockwise from top left: drawing using horizontals, diagonals and vertical lines to position the head correctly within the oval template; checking with a grid; how this drawing appears on a lightbox; finally with the support over the top of the tracing, you can see the outlines and paint in blue over them, directly on to the support.

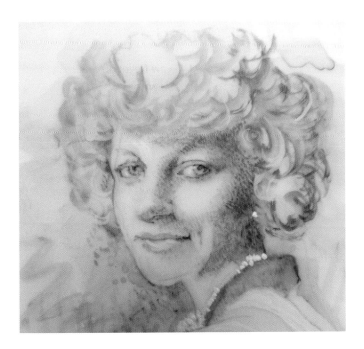
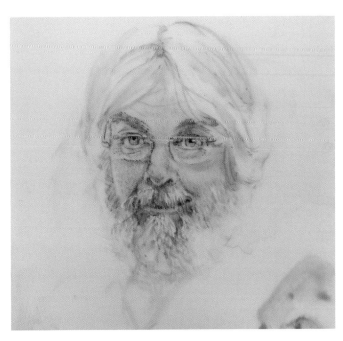

These two paintings (enlarged of course) were painted without any tracing aids. Some artists may feel confident enough to start a miniature this way.

The palette of colours used for Mac in a Pink Hat.

- Second column from top (these are mixes): Cerulean Blue/ Raw Umber, *Rose Madder Genuine/Light Red
- Third column from top: Permanent Rose, Rose Madder Genuine, Cadmium Red, Sepia, Titanium White
- Fourth column (mix): Rose Madder Genuine/Raw Sienna

*The mix of Rose Madder Genuine and Light Red is used for lips, between teeth, ears, and shadows on hands. I call it 'Mucous Membrane' colour!

Starting to paint (beginners and improvers)

Remove the tracing and start to paint the first wash on the hat, face and T-shirt with the appropriate colours. Now put in the eyes, as they are the focal point of a portrait. There are different opinions on this practice, and everyone has their own way of working on a portrait. I believe that if you have put the eyes in (very pale), they hold the portrait together.

Work around the portrait, and do not work up one area too much, so that you keep the layers of paint even. Try to get some of each colour painted in, so that you can see how they work together; you can change them at this stage without too much trouble.

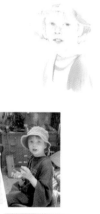

The first washes must be very pale.

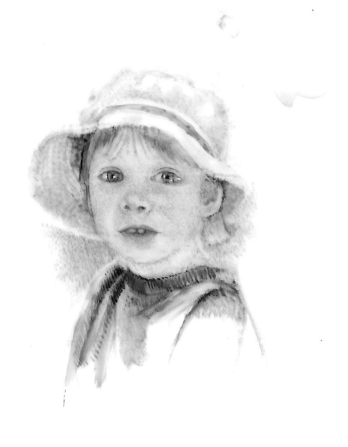

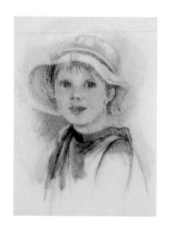

Building the colours up slowly but evenly. Getting the tonal values right is a great help at this stage.

Drawing freehand (improvers)

To draw freehand it is best to practise first and to keep your sketches simple, within the size you have decided upon.

Having practised drawing Mac freehand, with his image nearby (small and large) draw an oval on paper. Divide the oval with horizontal and vertical lines. Draw another line $^3/_8$ of an inch above the central line. Then draw diagonals that cross where they meet on the line you have just drawn.

The painting at the top is from a traced image, and the one below, freehand.

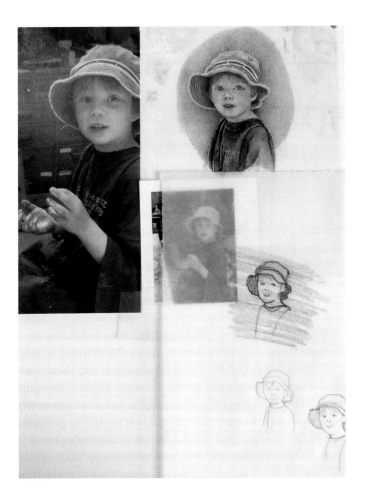

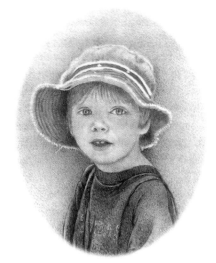

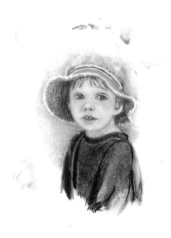

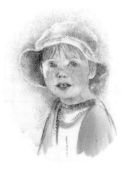

These drawings show how simple the image should be. Too much detail in the tracing will be lost. They are for proportions and position of the features only. All the hard work is done when painting.

Sometimes it all goes a bit wrong, and corrections have to be made.

The finished Mac in a Pink Hat.

This is the position of the eyes on the portrait, and everything else is drawn in relation to this line. Copy one of your drawings, putting in only the important lines. If you are using a lightbox, put one of your drawings onto the lightbox with the support on top, and outline the image underneath, in blue paint on the polymin.

Unfortunately things do not always go well, and in portraiture it is so easy to put the paint on unevenly, or make the skin tone too dark. This is the time to leave it till another day, and work on another piece.

The two paintings illustrated above need correcting. Although this is annoying, it is possible to rescue a portrait painted on a non-absorbent surface: you can lift off or blot off the excess paint, without losing the basic drawing. (The picture on the left has been traced (beginners); the one on the right was painted freehand.)

It is always a good idea to have more than one miniature work

Elizabeth Davys Wood (the founder of the Society of Limners), a silhouette self-portrait.

in progress, so that the one that has problems can be left for more than just overnight. You can then still keep working and learning, and when you return to the first it will be much easier for you to put right. When teaching, I always encouraged students to have two works on the go during a course. That way they sometimes avoided the problem of correction altogether.

I followed Elizabeth Davys Wood (familiarly known as EDW) into teaching miniature painting in the late 1980s, and continued until 2007. Aza Adlam took over from me after that; she now has a large following of students, and has kindly written a piece on her way of teaching miniature painting, developed over the years. It is slightly different, but there are always more ways than one to achieve the same end, and it would be quite interesting for you to try her methods for yourself.

Aza Adlam, teacher of miniature painting

I painted my first miniatures in 1989 (during a course with the author) and exhibited at the RMS and the Hilliard Society in 1990–1991, followed by a huge gap having just set up my own picture framing business. I rarely painted again until early 2000 and started to teach in 2005 – and from then on doing my own paintings rather took a back seat.

I have taught miniature painting almost exclusively to 'beginners and improvers' and I share with them the methods I have used myself and found to be the most successful. Although I have painted several miniatures using oils, I always teach using watercolour as I believe it to be the clearest way for those new to miniatures to understand the techniques of applying the paint to either an ivorine (sadly, very difficult to acquire now) or a polymin surface, both being completely non-absorbent. I have set out, as briefly as I can, the methods I personally use.

Firstly, I never use a 'palette' in its usual form – with wells – because no matter how small these are there is always the tendency to dip more than necessary of the brush into the well, thereby immediately creating a problem by using the paint too wet. I supply everyone with simple white tiles, on which I have put two tiny amounts of artists' watercolour (French Ultramarine and Burnt Sienna) straight from the tube to each side near the top of the tile. In the centre of these is a small circle in black waterproof pen.

I also use the egg exercise to get the students to practise stippling. The first thing they are asked to do is to water down the two pigments,

dragging the paint down the tile so as to spread the paint out and make sure that, by the time it reaches near the bottom of the tile, it is very pale and watery. Using a pen-drawn egg outline on tracing paper as a template, this is inserted underneath the polymin so that a very light outline of the egg shape can be applied over the line. Then, holding the pad at an angle, a very pale wash of the pale burnt sienna can then be applied in horizontal lines across the surface of the egg, always being careful not to lift the brush until the whole egg is covered – by drawing down the wet paint, a smooth surface can be acquired with practice. The last little wet drop left on the egg when lifting the brush off can be removed by touching the brush onto kitchen roll to remove any moisture, and then putting just the tip into this drop, thereby lifting it carefully out and leaving a smooth colour/surface on the painting.

A Portrait of my Grandmother *by Aza Adlam, watercolour on ivorine, 3 × 2.5 inches.*

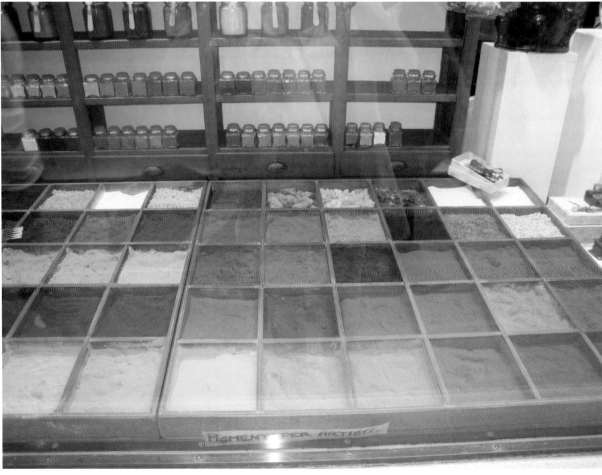

COLOUR MIXING

Watercolours

Before you start any miniatures, or even a larger painting, it will pay dividends if you spend some time practising mixing colours. A recommended basic palette for mixing the colours in the exercises is listed below:

I have divided them into two sections: warm and cool. In simple terms, warm colours bring things to the fore, whilst cool ones tend to recede. A red item in a mostly green landscape jumps forward, and if you think of the colour of distant hills on a summer's day, they are usually a blue grey.

Viridian
Light Red
Cerulean Blue
Raw Umber
Burnt Sienna
Rose Madder Genuine or
 Permanent Rose
Cobalt Blue
Yellow Ochre
Winsor Green (yellow
 shade)
Alizarin
Indigo
Cobalt Violet*
Ultramarine

Indian Red*
Perylene Maroon
Burnt Umber
Green Gold*
Cadmium Orange
Cadmium Red
Carmine*
Shell Pink*
Indian Yellow*
Davy's Gray*
Charcoal Grey*.

(Colours marked with * are
 optional.)

A basic palette of warm colours. Left column, from top: Yellow Ochre, Light Red, Burnt Umber, Indian Red, Sepia, Perylene Maroon; Centre: Green Gold*, Burnt Sienna.; Right: Lemon Yellow, Cadmium Orange, Indian Yellow, Cadmium Red, Carmine*, Rose Madder Genuine.*

OPPOSITE: *Pigments in an artshop in Italy and a watercolour grid.*

A basic palette of cool colours. Left column, from top: Shell Pink, Permanent Rose, Permanent Magenta, Cobalt Blue, Cerulean Blue, Indigo; Right column, from top: Viridian, Winsor Green, Davy's Gray, Ultramarine, Cobalt Violet*, Charcoal Grey*.*

If you are going to put a lot of time and hard work into learning how to paint miniatures in watercolour, it is a shame not to invest in the best quality paints; your efforts will be well rewarded. Artists' quality watercolours are well worth the extra expense, if you wish to succeed in learning about colour and blending. These paints are purer in colour, and their pigment is ground more finely, which is most important when you are painting small and in fine detail. Student watercolour paints tend to be milky and more grainy, and as a result the mixes will be duller.

Practise in daylight

Experimental work on colour should always be practised in daylight. Artificial light (even so-called 'daylight' bulbs) affects the true colour. Until you know your colours well enough to use them instinctively, practise using them in daylight. Even experienced artists have to do this.

Clean palettes, water pots and brushes

It is important when learning how to mix colours successfully to keep everything scrupulously clean. Have two water pots, and change the water frequently. If your preference is for tubes, invest in a metal enamelled palette, so that you can arrange your chosen colours in order; this makes working simpler. Cut an opening in the tubes when they get hard, to use them up.

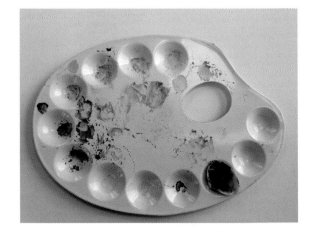

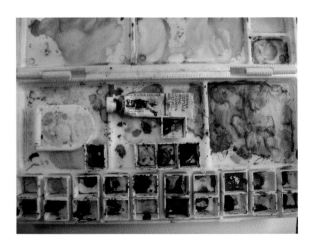

Enamel palettes are better than plastic.

Equipment

Palettes
Two water pots
An old tea towel (for wiping your brushes)
Some heavyweight watercolour paper, about A5 size
Plastic templates, with ovals or circles in different sizes (2cm is big enough)
Watercolour pencils, *not graphite*
Brushes

Synthetic fibre brushes are perfectly adequate for practising, and are better able to withstand the mixing up, painting and washing out better than sable brushes. Spotters are good to use, as they hold quite a lot of paint. Size 00 or 3 Pro Arte Series 107 will be suitable; try to use new ones though. Save the sables for later, for the stippling and hatching exercises.

Have everything on the work surface laid out before you begin. If you are right handed, have the water and paints and palette by your right side, and vice versa.

If you are using tubes, squeeze out a little of all those you will need. Put the others away, so you are not distracted by the colours you don't need now. If you are using a paintbox with pans, make sure the paints and the palettes are clean! As pointed out before, dirty colours will ruin the exercise.

It may well happen that whilst working on a project your mixed-up colours on your palette become very precious. So in these circumstances the palette may look dirty, but it is working one, and can be kept for the duration of the work. But do make

My teaching palette (dirty).

up a new palette of colours for each new work, and if you are working on more than one project at a time, then label each palette according to its contents. If it is for a portrait of Mac for instance, paint MAC on it somewhere, or WINE for a still life, so you don't mistakenly mess up a precious one for another subject.

How to mix skin tones

Keep your colours pale

Remember to mix your colours very pale: if the paints you mix are too strong you will not be able to see the subtle colours you make. This is vital when painting miniatures, because you will use many layers to build up the strength of colour.

Using your template, trace several small ovals with a sharp watercolour pencil (in lilac or pale blue) across the page. Blue or lilac will not alter the colours you paint inside them too much. Set up your table easel, and attach your paper to it with a large bulldog clip.

Colours for skin tones.

Now follow the exercise illustrated above. Starting with Light Red, mix up a puddle of colour in a palette well. Now mix some Permanent Rose in the next. By now the diluted paint on your palette is not so wet. Fill one oval with the Permanent Rose, and the one below with Light Red. Now mix the colours together, and paint the adjacent oval with the mix.

- Top left: Light Red + Permanent Rose makes the colour of lines on skin, nostrils lips, and the inner ear (mucous membrane colour).
- Bottom left: Cobalt Violet + Yellow Ochre makes the colour for older skin tones.
- Top centre: Permanent Rose + Yellow Ochre makes a north European skin tone (strengthen one or the other depending on the degree of yellow or pink in the skin). Use Rose Madder Genuine alone for young children.
- Bottom centre: Light Red + Utramarine + Raw Umber makes the colour for African or Asian skin tones; the blue is used for the shadows.
- Top right: Light Red makes the colour for tanned skin tones.

When practising the mixing up of these skin tones, place the filled-in ovals side by side, and then the next one to show what the mix looks like. If you have these charts to refer to when working, you will soon get used to recognizing the colour you need, and how to mix it. The colours of the paint in the pans can look very similar, especially the earth colours – the browns, siennas, yellows and reds – and also some of the blues – cobalt and ultramarine are very difficult to distinguish between, unless you try them out. This is why I recommend using pans when you are learning about colours, as putting them in order in a paintbox will help you to know where they are. I keep a chart of the arrangement of the colours in my box, because I forget which is which sometimes. At first keep to a minimum of colours, and as you get to know them, you can add more. Some of the colours available are unnecessary; for example, Naples Yellow can be made very easily with Yellow Ochre and Titanium White. Then there are others that cannot be mixed up, one of which is a relatively new one called Perylene Maroon. This is actually a deep blood-red, a particularly useful colour for all sorts of things, and especially for sharpening up the darks.

Black should always be mixed up (except for silhouettes) and there are many ways of getting black. Winsor Green and Alizarin are my choice, but you do have to get a very even mix or the green or red will dominate.

The last mix of three colours is for various different races' skin tones. For the darker skins of Nigerians, for instance, you would have to mix all three to get a dark skin tone, with the Ultramarine making the darkest shadows, whereas for a person from Mauritius you would mix only the Light Red and Raw Umber. These skin tones will need to be practised first if you are commissioned to paint people of different ethnicities.

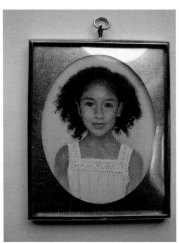
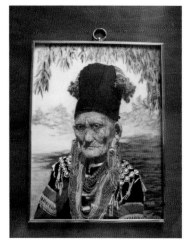
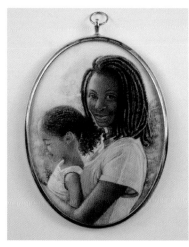
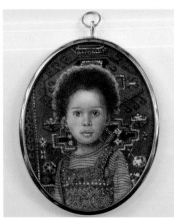
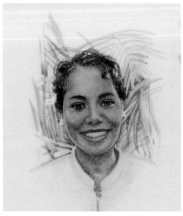
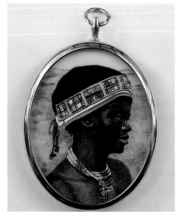

Skin tones of different ethnicities, using the lower group of colours. Portrait of Amy *(with gold leaf backed glass, verre eglomise), 3 × 2.5 inches, watercolour;* Woman with Many Beads, *by Coryn Taylor, watercolour on ivorine, 4 × 3 inches;* Amy and her Mother *3.75 × 3.25 inches, watercolour on ivorine;* Molly, *watercolour on ivorine 3 × 2.5 inches;* Maria *in progress, 3 × 2.5 inches, watercolour on ivorine;* Zulu Maiden, *2 × 2.5 inches, watercolour on ivorine.*

Colours for copper

This exercise is slightly different from the previous ones. The colours are not mixed here, but are used in layers when painting copper in your works. Depending on the state of the copper, the colours will be brighter and the reflections shinier if the copper is highly polished; if tarnished the colours will be darker.

Take a clean palette, brush and water pot, and mix up the following colours in separate wells:

Colours for copper.

Cadmium Orange
Permanent Rose or Rose Madder Genuine
Sepia
Burnt Sienna
Light Red
Titanium White

Finally, if you have a piece of copper (a small jug for instance), put it in front of you, and starting with the order the colours are listed in, try to paint the piece so that you blend the colours together as they are seen in the last oval below.

Leaving the shine unpainted is more effective than putting white on top, unless you are using oils or working on vellum.

Colours for brass and gold

As with the colours for copper in the previous exercise, the colours are used as layers. Again, if the brass is dirty the colours are different, duller and the reflections are not so bright. Take a clean palette, brush and water pot and mix up the colours in separate wells as before.

Colours for brass and gold.

For brass:

• Yellow Ochre
• Lemon Yellow
• Sepia
• Burnt Sienna
• Green Gold*
• Titanium White

* Whilst Green Gold is available to buy, you can mix Indian Yellow and Indigo.

For gold, add:

• Naples Yellow*

- Rose Doré (for rose gold) – not illustrated
- Titanium White

* Make Naples Yellow with Titanium White and Yellow Ochre.

Try to have a brass item to look at while you are working, because it does help you to see how the colours in the palette relate to the colours of the brass in front of you – that is, very tarnished (more sepia) or highly polished (more yellow and white reflections).

Gold is warmer than brass, hence the addition of Burnt Sienna. If the item is made of rose gold, then it should be pinker; Rose Doré is a gold pink and very useful for this, but you could make do with any other pinks in your palette.

As with copper, the unpainted support is very effective for reflections. Save the Titanium White for the brightest highlights.

Useful watercolour mixes (1)

Useful colour mixes – 1.

First, draw some ovals to match the pattern shown. Then take a clean palette and water pot, and mix up the following colours in separate wells.

- Mix up Cobalt Blue in a well.
- Mix up Light Red in the next.
- Mix the two together, and fill another well. (This is a very useful grey, and by strengthening the blue or the red you can make a cool grey and a warm grey.)
- Mix up Permanent Rose in a well.

- Mix up some Cobalt Blue in the next.
- Now mix the two together. (This makes a pure mauve or lilac, which is translucent, as both colours are transparent; it is therefore good for shadows.)
- Using Cerulean Blue, fill a well.
- Using Raw Umber, fill the next.
- Now mix the two together. (These two colours if laid side by side in miniature painting make a neutral background, which can be bluer or greener depending on the main colours in the picture.)
- Mix Indian Red, Ultramarine and Sepia in separate wells.
- Mix them together to make a soft dark or black; make it cooler with more blue and warmer with more red.
- Finally, mix Cobalt Blue in a well.
- In the next, mix Permanent Magenta.
- Mix them together to make a bluebell colour, or deep blue-violet.

NB: always mix pinks with blues to make violets or purples; red will not mix a true mauve.

Useful watercolour mixes (2)

Useful colour mixes – 2.

Using the instructions for mixing skin tones, take a clean palette, and mix up the following colours in separate wells, having drawn some ovals that match the pattern shown.

- Using Burnt Sienna, fill a well.
- Using Prussian Blue, fill another.
- Mix the two together, and fill the adjacent well. (This is a useful neutral dark green or shadow colour.)
- Using Aureolin, fill a well.
- Using Indigo, fill the next.
- Mix both together, fill in the adjacent well. (This is a bronze green.)
- Using Winsor Green, fill a well.
- Using Alizarin, fill the next.
- Mix the two together, very evenly, to get a useful dark, almost black.
- Using Cobalt Blue, fill a well.
- Using Indigo, fill the next.
- Using Sepia, fill the next.
- By using all three together or separately, you will be able to paint shiny objects of silver, pewter or steel; use Titanium White for the highlights.

Mixing greens

Green is a difficult colour to mix, and there has even been a book all about colours entitled Yellow and Blue do not make Green, by Michael Wilcox. The title is designed to get the artist's attention, and there is some truth in it, because there are many ways to make green, in all sorts of tones.

As with all colour-mixing exercises you have to practise a bit to get the subtle changes in the greens just right. This exercise uses two greens, Viridian and Winsor Green, which are both mixed with Aureolin, a bright acid yellow to which various reds are added. As red and green are opposites on the colour wheel, mixing them dulls them both down, and by way of it, produces several shades of green.

You will need the following:

A palette and a large white plate to mix up plenty of the basic green/yellow mix and with divisions in the palette, for the reds to keep separate.
Two water pots
Brushes, size 3 (synthetic will be fine)
A sheet of heavy watercolour paper with several ovals drawn in the pattern shown
Viridian
Winsor Green
Aureolin
Cadmium Red
Light Red
Alizarin

Mixing greens.

- Aureolin and Viridian make a very bright spring green.
- By adding Cadmium Red to the spring green, you get a dullish transparent green.
- Now add Light Red to the basic spring green to get a darker, more opaque olive green.
- Next add Alizarin to your basic green, to get a deep brownish green.
- Aureolin and Winsor Green make a bright emerald green.
- Again add Cadmium Red to this green to make a brighter, denser green.
- Then add Light Red to the green to get an opaque but lighter olive green.
- Finally, by adding Alizarin to the green you will make a deeper olive green.

Another mix for black

If you mix Winsor Green and Alizarin, in equal strengths, you will make a black that can be used in dark shadows, but will not kill the rest of the work (as one of the ready-made blacks would).

You will have to experiment with this green exercise, because the results do depend on the amounts of each colour mixed with its opposite, so be patient and try it out, when you have some time to spare.

It will be useful to have a range of greens at your fingertips, without paying for additional colours. In my experience there are so many different shades of green in nature that just one tube or pan of Hooker's Green, for instance, will never be enough. If you have the skills to mix up your own, you will feel more confident, especially when painting spring and summer landscapes.

Using complementary greys

The colours of subjects within a composition and their shadows cannot be painted at random. The results, if not understood and worked out carefully, will be dull and flat. On the other hand, if you study colours and their relationships with each other, you will be able to create a vibrant and lively painting, which will catch the observer's eye. Then they will be compelled to come closer to really perceive the work, although they may not realize why it is so enticing. The artist who understands colour is well aware of what he has done to make his work stand out from the rest.

Grey is a colour that can be mixed in many ways, in order to give a miniature some depth and dimension. Because of this, it is worth spending some time learning about mixing them up, so that you can use them in order to enhance your miniatures. You could say that they are especially important in miniature painting.

In the list of colours on page 112, just one useful grey is shown; it is made by using equal amounts of cobalt blue and light red. But if more blue is added, the resulting grey will be cool, and if more red is added, the grey will be warm.

There are two commercial greys that are manufactured by most art companies: Payne's Gray and Davy's Gray. These will vary quite considerably between the different manufacturers. For instance, Payne's Gray can be very a very strong, dull blue grey, or almost black. It has a tendency to stain and dominate, and should be used only sparingly. Some artists prefer not to use it at all, and I am one of

Complementary greys.

them. If a work needs a blue dark, indigo is preferable as it does not stain so much. Davy's Gray can vary too, from pumice grey to a green grey, depending on who makes it. It is made from pumice powder, and tends to be slightly gritty, but it does have one useful property: you cannot lay it on too thickly, and it will retain the same tonal value. Other colours can be built up in layers so that they are strong and deep, but it is easy to overwork them, and then you will have a lot of tedious lifting off to get back to the right tonal value.

So if you practise mixing the luminous greys listed here, you will have a whole range of greys at your fingertips when it comes to using them in a painting. The basic premise of these neutral greys is that you will use a complementary colour in the mixing of your basic grey, opposite on the colour wheel to the main colour in your picture. If you have a still life of clementines, for instance, the complementary colour in your basic grey mix will be blue, opposite on the colour wheel to orange, the colour of the clementines. This exercise takes some practice, and it is well worth spending time learning how to mix the greys properly.

You will need a bigger palette or a large white plate to mix up a lot of your basic grey. The following colours will create this basic grey:

Aureolin
Cobalt Blue

Rose Madder
Light Red

You will also need:

Viridian
Cadmium Red
Purple Lake

Keep them in separate containers. Individual pudding baking tins are very useful for keeping the colours away from each other as it is important that the colours are kept apart; the subtle changes in the greys will not work if they are dirty before you start. Keep changing your water pots too, and have a separate brush for each colour, then you will get the most out of this exercise.

Equipment

A4 sheets of thick white watercolour paper
Set square
Ruler
Plastic template
Scissors

Basic mix for complementary greys. Left: aureolin, rose madder and cobalt blue. Right: cool or warm grey mix, light red and cobalt blue.

Method

- Begin by drawing seven rectangles evenly spaced on the watercolour paper.
- Fill in the first three rectangles with Aureolin, Cobalt Blue and Rose Madder, keeping them very pure.
- Mix a basic grey using these three colours. Do this carefully so that no colour dominates. Fill in the rectangle next to the other three with this grey.
- Fill the next two with Cobalt Blue (by itself) and the next with Light Red. Make another grey with these two and with

it fill in the final rectangle. You will see that the greys are fairly similar, but the blue/red one is the one you will probably use the most, because it is easier to make it cool or warm.

On another sheet draw six rectangles, with a smaller one in the centre of each. Fill in the small centres with the following six pure colours: Aureolin, Purple Lake, Viridian, Rose Madder, Cobalt Blue and Orange (mixed from Aureolin and Cadmium Red).

LEFT AND OPPOSITE: Complementary greys, with their opposite in the centre boxes: yellow and purple; green and red; blue and orange.

Mix up a lot of the basic grey as before, on a plate. In a large palette put some of this basic grey. For the yellow square, you need to mix some of its opposite, which is purple, into the basic grey mix, tinting it subtly with purple. In the next square, the main colour is purple, so you will need to mix some yellow into the grey.

The list below explains what each colour needs as its complementary or opposite:

- If your main colour is GREEN, mix RED or PINK into the grey.
- If it is PINK, mix GREEN into the grey.
- If it is BLUE, mix ORANGE into the grey.
- If it is ORANGE, mix some BLUE into the grey.
- If it is YELLOW, mix some PURPLE into the grey.
- If it is PURPLE, mix some YELLOW into the grey.

If you want to see how well this works, you can take this exercise further by cutting out squares of all the main colours (yellow, purple, green, pink, blue, orange). Now mix each of their complementary greys in separate larger squares, and cut out a hole in the middle of each. Now you can mix and match the greys with their complementaries, and move them around to see for yourself how effective those special grey mixes can be.

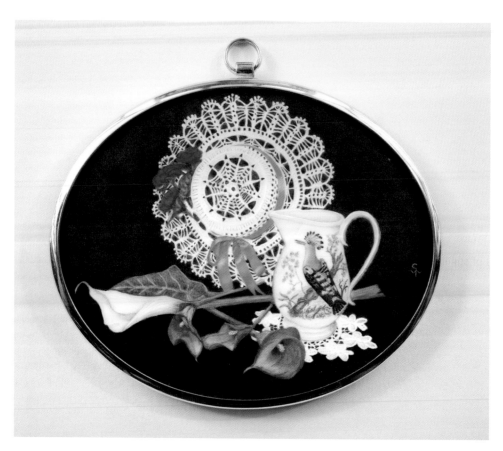

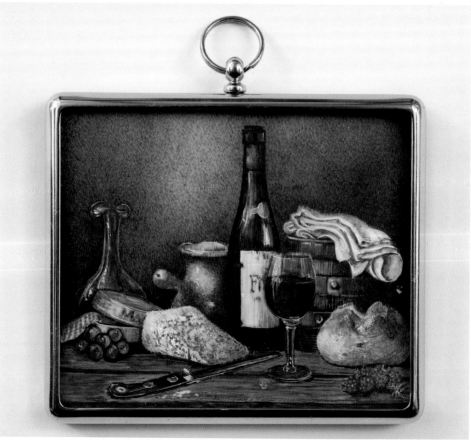

STILL LIFE

Ideas and inspiration

Miniature paintings of still life compositions are always popular at exhibitions, and there is so much subject matter at home, in the garden, kitchen, nursery, dressing room – even the potting shed!

All an artist needs is some imagination, and a constant awareness of interesting subjects. If this is not particularly easy for you, remember that many artists and craftsmen also find it hard to get that elusive element of inspiration going in their minds. 'What can I paint next?' is the plaintive request of many a student.

But a tutor cannot decide for the student what to paint. It is important to state here that whatever you paint, it must be something you will enjoy working on – something that you will want to get back to whenever you get a minute! It is good practice to have several ideas in your sketchbook, in the form of notes or sketches. An idea might pop into your head as you are doing a mundane chore or cleaning your teeth; these ideas have a habit of crossing your mind when you are nowhere near the studio! It is also a mistake to think, 'Oh, that's a good idea – I will remember that.' Next time you are bereft of inspiration and are all ready with your paints and brushes and have the time to spend on a new work, the chances are that you will not remember, and that is even more frustrating. So have a notebook (or mobile phone) handy, just to make a note of your ideas, which will jog your memory next time you are stuck. Keep a scrapbook of magazine and newspaper cuttings in a box file. When I was teaching miniature painting I was so often told, 'I haven't got any ideas', that I would direct the student to my huge file of cuttings. All sorts of subjects were kept there, in all shapes and sizes; because everything can be reduced electronically, material like this can be used to compose (not copy, necessarily) and inspire or spark off an idea. Some of the photos saved in the file were of my own collections of objects which I had used for a still life. The photographs were in different light conditions, with patterned backgrounds, or with dark and light ones. In this way, beginners on the courses could save time deciding what

A Potting Shed *by Brian Denyer Baker, etched plate (on zinc), 6 × 10 inches.*

OPPOSITE: Jug with Hoopoe, *3 × 3.75 inches, by Glenise Webb, watercolour on ivorine;* Wine, Cheese and Fruit, *2.5 × 3 inches, watercolour on ivorine.*

119

to paint, and work from these directly. Their learning process could then be concentrated on the techniques of getting the paint on to the support, learning about colours, and so on. As they progressed and became more confident they naturally moved on to choosing their own subjects to set up and paint from life.

Chesterfield, *gouache on vellum, 2.5 × 3 inches.*

Art books (on specific artists and genres) are of course are wonderful for delving into for ideas. Vermeer, although he painted only a limited number of works, crossed a wide spectrum of subjects. Arguably he was most famous for his portrait, *Girl with a Pearl Earring* (which alone has inspired a book and a film). His style of painting is highly individual, and it is interesting to see how that manifests itself in all his paintings. He liked to paint from domestic scenes of women making lace, or pouring milk, reading letters, or sitting at the piano.... I was inspired by the bonnets and costumes the women wore, and composed some sketches of Dutch girls in linen caps, which became the subjects for several miniatures. His work really inspired me to experiment in a way I had never done before.

During my training at the RCA, as a fashion designer, part of the curriculum involved studying other designers' works, in order to get inspiration for new ones of our own. Our tutor, Bernard Nevill, took each intake of first-year students into the reference library at the V&A to study old copies of fashion magazines, as well as the historical costumes on display. I can remember studying the old black-and-white copies of an

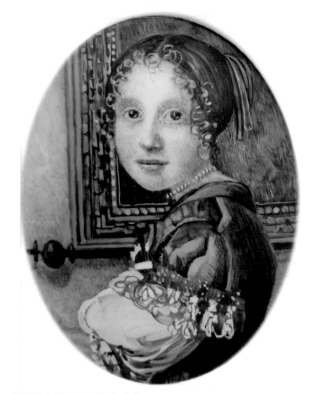

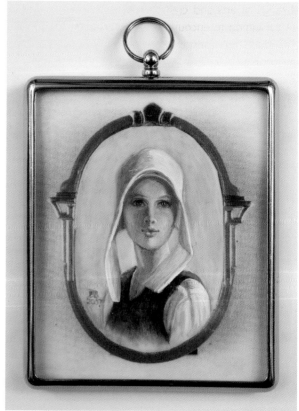

Portraits inspired by Vermeer. Dutch Girl – 1, 3 × 2.5 inches, watercolour on ivorine; Dutch Girl – 2, 3 × 2.5 inches, oil on ivorine.

Edwardian fashion magazine called *Femina*, in the reference library. It was fascinating and inspiring, and I used to look forward to the afternoons we spent there. Making notes of the shapes that clothes made on the figures, and the placement of fashion details like pockets, plackets and stitching, not to mention the shape of sleeves, the length of skirts and the various necklines. Any 'designer's block' I was experiencing at the time would be completely overcome.

I am still inspired to paint new subjects when looking at art books – not when I am looking for reference particularly, but just because I am interested in all types of painting. When I see a particularly good portrait, I immediately make a mental note of the pose, or the composition or the background, to try it out in my next work. But not exactly!

The fact that there is nothing really new for artists and designers is true; it is just that each new generation of designers and artists looks at the trends from a new perspective and comes up with their own interpretations of what was done before.

In this century we are all aware of changing fashion styles, which has become a commercial necessity not only in the fashion industry, but also in architecture, interior design, cooking/what we eat, and gardens/what we grow, and of course the whole range of arts and crafts. Even supermarkets constantly update packaging to encourage us to buy their products, and those products are constantly changing thier packaging and content to tempt us. So the old adage of 'what goes around comes around' is true: the re-emergence of old ideas is a continuing phenomenon.

Working from life

Working from life is so beneficial to an artist who is learning more about how to paint and draw. It is hard, though, to convince learners to do this, and until they are motivated they will not realize how important it is. If you just try a few drawings, of simple objects to begin with, you will at least learn how three dimensions work for you, in a sketch or painting. Simple shapes, such a cube, a ball, a cone, a tube and triangle are the best to start with, as they are not recognizable as 'articles' that you have to get right. Their simple outlines are uncomplicated, and by drawing them, you will be working at the shapes, lines, curves and shadows, which you can build up into a three-dimensional shape.

Oranges in a Blue Basket by Glenise Webb, 3 × 2.5 inches, watercolour on ivorine.

Exercise in setting up a still life

By now, having practised some sketches, you should be confident enough to set up a still life of your own, based on your own interests. Perhaps you like to sew, or cook, and so you could arrange a still life from these; or perhaps some favourite pieces of china, or toys, or some books with spectacles and a lamp. The list is endless, of course, but if you are devoid of inspiration get the art books out and look through the work of artists who have painted still life. If you are going to paint a domestic set up, for your first attempt, do not set up anything that is perishable, as the composition will change when the fruit, vegetables or flowers degrade. Glenise Webb, who painted the still life with vegetables shown on page 123, would carry on until the cabbage turned from green to yellow, by which time it was quite fragrant too!

Close-up of cut oranges.

Suggestions for inclusion

A bottle of wine, a wine glass, a plate, a knife, and some fruits, perhaps a lemon or orange. If you add fruits, as I have done, you can take a photograph of the set up, and print it out, then it doesn't matter if it dries up. This can be done with all food items, but not flowers – as they develop and change so much, they are always best when sketched from life.

Here are some points to consider:

- Is the meal assembled outside or inside? This will determine the background, and the lighting.
- What surface are the objects arranged upon? A board or a cloth? If the cloth is textured or patterned it will add to the composition. Its pattern may be checked or lace, or even a sumptuous damask.
- What is the background? With a still life composition, it is so important that the tonal value, as well as the colour, is in harmony with the rest of the items in the picture.

Still Life on a Side Table, *watercolour on ivorine, 5 × 6 inches.*

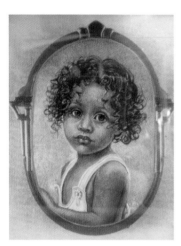
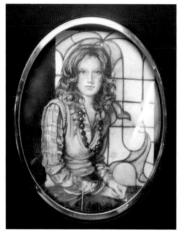
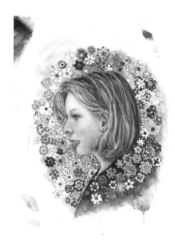

Different backgrounds add to the intricacy of a miniature painting. Patsy, *3 × 2.5 inches, watercolour on ivorine, with a transfer trompe l'oeil frame;* Girl by a Window, *3 × 2.5 inches, watercolour on ivorine (the stained glass pattern echoes her clothing); unfinished work, with the pattern of millefiori glass as background;* Maria *(completed) with leaves of sugar cane;* Francesca Resta, *with delicate rainbow-coloured background;* Clown *by Rosmar Booth, multi-media, acrylic on paper, 1.5 inches diameter.*

Arrange some vases, or jugs of different sizes, as if on a shelf, in a line. Then add another below, and maybe a third, and you will have created a composition of a display cabinet.

The reflected light of a lamp, or the sun coming through the window on glassware, is a challenging exercise. As you get more confident, the ideas will come flooding in, and you may well find yourself getting particularly observant in all sorts of situations: junk shops and markets can become a source of ideas.

Glenise Webb is very skilled in this genre, and when working on still life during a course, she would bring a large selection of bric a brac to set up in front of her, mixed with fresh vegetables. Perfect tomatoes and oranges are amongst her specialities.

Photo reference for the first demonstration of Shelf Display from Life.

Ideas and methods for painting a still life by Glenise Webb

Important elements of still life include:

1. Choice of subject
2. Arrangement of subject
3. Lighting
4. Transferring image
5. Painting
6. Background
7. Finishing

An excellent composition of vegetables arranged on lace with a willow pattern plate by Glenise Webb.

1. There is almost an infinite choice of subjects for a still life miniature. Blue and white china is a good contrast to fruit and vegetables. Also very good are brass, copper and pewter utensils, but it must be remembered that there will be reflections to contend with when painting metals. But this adds interest to the painting, especially when glass is included. I sometimes add extra lighting and include a lit candle. Lace mats under some items helps to give a three-dimensional effect.

2. Choosing a base for your composition is important: it may be wood or metal, or draped fabric. If this is carried up behind the subject it can provide the background as well. Start with taller items at the back, of various heights, and then add the smaller ones at the front, such as fruit and vegetables, peeling the citrus to add variety. Move things around until you are satisfied. I usually take a photograph to help with the perspective when making a drawing of the set up. If you need some staging to help vary the heights of some items, cubes of oasis or polystyrene underneath the drapery can help a composition.

3. Lighting, as previously pointed out, is most important when composing and working at a still life, so that the colours are bright. However, it is best if some light strikes the subjects at an angle, or the composition will appear flat. If you are right-handed the light should come from the left and slightly above the subject, and vice versa.

4. When drawing the still life, you can draw it at the size you prefer (or larger) and then reduce it on a photocopier. Transfer the outline to your support, using the Conté carbon method. I prefer to work with a well-used piece as I do not like the traced image to be too strong, as I find it difficult to hide.

5. I put on a thin wash over every element of the miniature as it is easier to stipple on this than directly onto the support. Start with the background wash, and let it dry, removing any paint from overlaps with a damp brush. The colours of the washes relate to the palest main colour of the subject. Leave all to dry, preferably overnight. Apply at least three layers of colour to each subject to achieve enough shading to give a three-dimensional appearance. Mix enough paint up in advance, and allow to dry. I mainly use Winsor and Newton artists' quality watercolours, but also include some Maimeri colours for fruit and flowers, as their pinks, blues and oranges are particularly strong and clear. I prefer to paint each subject to completion before moving on to the next, but most miniaturists like to work over the whole miniature in stages; choose whichever works best for you.

6. The background can be started when all the objects on the horizon are in place, or can be left until all the objects are painted. Usually the background should not be fussy; if velvet is used, or other fabrics, they can be draped in folds in the larger areas. Increase the number of folds in the foreground to give added interest. Interesting backgrounds can be made using wood, bricks and tiles. If a plain background is used, a dark colour will make the subjects stand out. I use Prussian Blue and Sepia, layered in stipples alternately, starting with the blue until the required depth of colour is reached. The combination of the stippled colours will give a more lively appearance than pre-mixing the two.

7. It is possible that the dark background will sometimes make the still life look washed out by comparison. If this happens, darken each element with another stippled layer. Neaten all the edges, and emphasize the shadows cast on the base, so that the still life appears to sit firmly and does not float.

Setting up a still life

To start learning to paint from life, perhaps backed up by a photograph, you could set up a still life on the table in front or to the side of your easel. The objects you choose need not be very small, as you will be miniaturizing them as you work. But try to get the pieces all of roughly the same size, to begin with, as it will make the exercise simpler.

It may also help you to contain your composition in an open box, as shown in the demonstration on page 36. It can be tall (portrait format) to take a bottle, or wider with just fruit (landscape format). This gives a shape to your composition, and eliminates the distraction of whatever is behind the set up. This helps to consolidate the design of the work, and can help with the lighting of the piece. If the box is dark, it can be lit dramatically from outside so that the shadows within create drama with cast shadows and reflections. If you can line the box with coloured paper, to complement the colours of the objects in your composition, there will not be anything to distract your eye. This way the shadows in the background will be easier to get right, if you are working in one colour.

As noted previously, it is important to get the lighting right for a still life. The advice on natural light given in Chapter 3 applies, but a still life set up in your studio in the winter can be lit by an electric light, and this can make the composition very dramatic. If your box is black with a velvet base, and you place reflective pieces of glass and metalware inside, the composition can become very interesting to paint. William Nicholson painted many simple but dramatic still life works this way – a pair of

Flowers

A word here about painting flowers: they do not stay the same once gathered and put in water. They are living things and will open and even go on growing (tulips do this) whilst you are painting your picture. So the digital camera can be used again here, just for the shapes of the buds or leaves, which you will have already put in at the drawing stage. Then you can refer to the photo for those, but work on the colours from the actual blooms.

white gloves and a coral necklace on a lace mat, for instance, and some flowers in a silver jug.

Setting up a still life needs time and care. Choose a simple composition to begin with, and do not put in too many objects. It is a good idea to use complementary colours, to make the picture more interesting (see Chapter 7 on colour for more advice on this). If you are really stuck, look at what famous still life painters have put in their works, and replace the composition with your own objects.

To paint from a three-dimensional image is very good practice, because it teaches you to look at (or *perceive*) your subject, and all the shadows, the colours and the perspective are constant. The lighting, however, will change, unless your set up is lit artificially, with a strong light.

In this chapter I have set up three different examples of still life compositions, all of which have been painted in natural light. The first is painted on polymin: a group of mostly glass

Still Life in the Dutch Style, *oil on ivorine, 4 × 3 inches.*

The second is a selection of autumn fruits, set on a plain white base. There are two examples of it, one on Kelmscott vellum, the other on polymin. This is the simplest, and it is shown stage by stage, from the first drawing in paint, directly onto the two different bases.

The third is a still life of a dresser display, with an assorted collection of found objects, some of which hang on the back of the shelf unit, which is made from aged pine wood. This time there are lots of patterns included, as well as a small portrait and a mirror. A tin has some lettering on the side, and again there are some reflective objects. A similar Bristol blue water bottle is used, to show how glass can still appear transparent on vellum. The ewer, with its bold zigzag pattern, is an exercise in itself, on how to paint in strong lines.

All were sketched from life and not traced; although there are instructions for tracing as in previous exercises, you are encouraged to try to draw straight onto the base.

If, however, you are not going to be able to paint the miniature before the fruits lose their fresh bloom, then it is necessary to take a photo in order to finish the work. Make sure the photograph you take is from exactly the same angle that you are working from.

Little Jugs, *watercolour on ivorine, 3 × 2.5 inches.*

items, in which the colour blue dominates. Some glass is clear, and the rest is opaque. The background is dark and light, because the composition was in a box with black sides and a white back (reflecting the blues). The foreground has some colour, a dullish red, to bring it forward; an extra item, the ginger jar, was added, as the first set up seemed unbalanced.

Flower Arrangement *by Coryn Taylor, oil on ivorine, 4.5 x 3.5 inches.*

Demonstration 1: *Rummer Still Life*

Part way through the work, a piece was added to the composition: a ginger jar on the left, which makes it more interesting. Added to this a silk fringe has been put across the foreground. The edge of the pale background has been strengthened, and a shadow of the bottle put in as well. More work has been done in the area of dark background. Then I have worked around and around the picture, gradually building up the colours, and adding some indigo to the fringe in the foreground.

Materials

For this exercise you will need:

Half a sheet of white polymin, stuck to white card backing, cleaned with talcum powder and silk
Paints (see below)
Two water pots
Linen rag
Kitchen paper
Brushes: sable 000 brush, synthetic spotters 2 and 0, and an old, worn brush for taking paint from the pan and mixing

The palette of colours used for the Rummer.

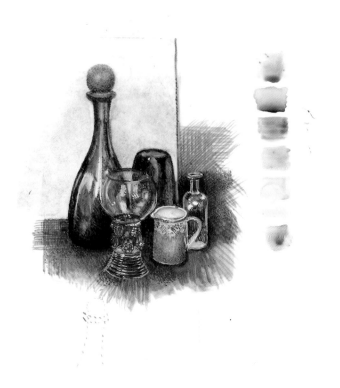

Rummer with Blue Glasses, *showing palette at the side, and the cross hatched background.*

The palette of colours used for Rummer Still Life (on white polymin) is as follows:

- First column (from top): Raw Umber, Cerulean Blue, Ultramarine, Cobalt Blue, Alizarin Crimson
- Second column (mixed): *Winsor Green (Yellow Shade) + *Alizarin, Black, Lemon Yellow, Sepia, Titanium White for highlights
- Third column: Indigo, Winsor Green (Yellow Shade), Raw Sienna, Yellow Ochre, Permanent Rose.

Mix up the colours in a palette now, so that they have time to dry whilst you transfer the drawing to the polymin. They are shown laid out alongside the painting, in the spare space.

Method

Take the photograph and reduce it to portrait format (upright), 3 × 2.5 inches. Make a tracing of the image and transfer it to the

polymin by placing Conté carbon face down on the polymin, held in place with tape. Use a hard pencil or a stylus to outline the images. Check that all have been transferred, and remove the carbon and the tracing.

Using a size 2 spotter, put a pale wash of the appropriate colour over all the items in the picture. Do not worry if the washes are a bit uneven: they will be built up and evened out later.

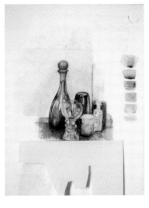
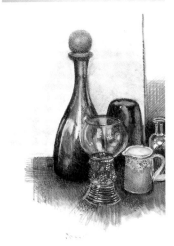

Clockwise from left: cutting the mask to sponge the background with pale blue; mask in place with sponging completed; background not strong enough behind the clear glass bottle, more dark background put in.

Cutting/masking/sponging

In the painting demonstration I have sponged the background. For beginners, this is a useful way of putting a light background in (notice the lilac shade behind the bottle). Compare this with the Alizarin/Winsor Green mix next to it (shown in the last picture, Stage 4), part of which has been laid on with a wash and in the foreground by cross-hatching. This mix is built up to a darker colour in the image below. Some pale white strokes have been placed where the highlights will be. The rummer (the green glass with a heavy stem) is drawn in with Winsor Green, and strengthened with the dark mix of Alizarin/Winsor Green.

Finally, the painting has been masked with an aperture of the finished size, and signed in white with my logo.

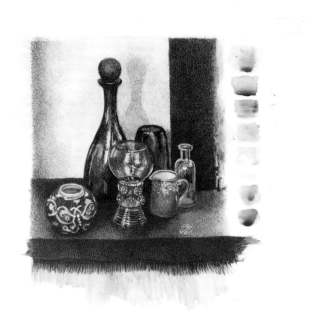

Rummer completed, with a ginger jar added to balance the composition.

Demonstration 2: *Still Life of Apples and Plums*

These two still life paintings were painted from life, both to fit within 2.5 × 3 inch rectangles (landscape format). The top one is painted on vellum, in watercolour, and the other is on white polymin, also in watercolour.

Take time to arrange the fruit. Choose a simple composition to begin with, and do not put in too many items. It is a good idea to use complementary colours to make the picture more interesting (see Chapter 7 on colour for more advice on this). If you are really stuck, look at what famous still life painters have put in their works, and replace the composition with your own objects.

For this demonstration, I have used just two apples (one green, one orange-red) and three plums, which have a particular bloom on their skins. The shadows the fruits cast are a cool blue grey, complementary to the overall warm, orangey yellow colours of the fruits. They are laid on a plain white base in this instance, but you could put them on a patterned tablecloth or a coloured plate, so that the composition is more interesting. I have added some extra colours to the palette, because the

subject needs some brighter colours to get the subtle shades of the fruits.

Notice the very quick watercolour sketch behind the setup, in my sketchbook. I have drawn them too, just to get my eye in and to loosen up a bit.

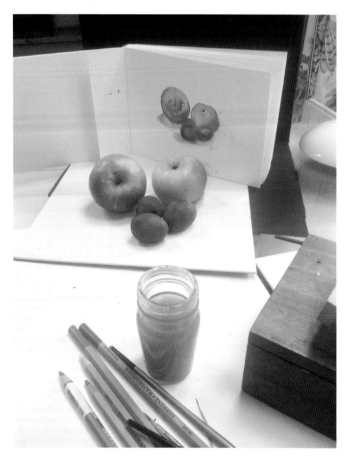

Apples and Plums, *set up for painting, with rough watercolour sketch behind.*

As with portraits the preliminary sketches help to start you off on the right track. You will have perceived their shapes and colours (and negative spaces) at least a couple of times, before finally transferring the set up, by whichever method suits you best. This time, if you copy this, do try to sketch straight onto your base, in a terracotta watercolour pencil. If the shapes are not quite right, they can be adjusted with your brush as you start to paint, and because you have used a water soluble pencil, you can alter the shapes very simply with a damp brush. (If you had used a graphite pencil, you would not be able to change anything.)

Remember the negative spaces behind and between the fruits as they nestle together. Noticing these curves, and their relationship to each other, is another way to get them right.

Check too, that the apples are larger than the plums, as you do not want them all the same size. Noticing this can also help to get the shapes in correctly.

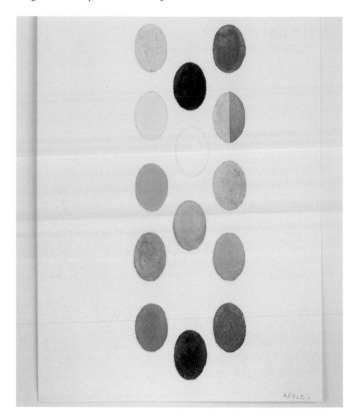

The palette of colours used for Apples and Plums.

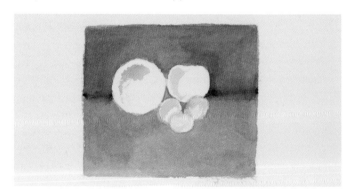

Negative spaces around the apples and plums in grey.

Colours used (additions are marked with an asterisk):

- First column, from top: *Cobalt Violet, *Lemon, *Cadmium Orange, Viridian, Cadmium Red
- Centre column, from top: Indigo, Titanium White, Winsor Lemon + Viridian = Bright Green, Sepia
- Third column, from top: Cobalt Blue, Rose Madder or Permanent Rose, Raw Umber, Light Red, Permanent Magenta

Transfer your image to the supports, using one of the methods below (I would urge you to have a go at the third method):

1. Reduced photocopy of your own photo, traced over the Conté, to show the image on the support.
2. Photocopy or tracing under polymin on the light box.
3. Drawing (with sharp watercolour pencil) or painting directly onto the vellum, using the dry brush technique.

Method

Mix up the colours separately as usual, and let them dry. Presuming that you have the images on the support, start by washing each fruit with its basic colour.

Cooking apple: Viridian + Winsor Lemon = green wash
Eating apple: Winsor Lemon wash
Plums (1): Permanent Rose or Rose Madder Genuine (for vellum)
Plums (2): Cadmium Orange (for polymin)

Let the rest dry as before, or do what I have done in the demonstration pictures, and paint blobs, quite big ones, of each colour on a separate piece of polymin (not vellum or paper); when they are dry, it is very easy to reconstitute them, whilst looking at the fruits.

In the first wash illustration, you can see which support is which, because the vellum is just a little bit creamier than the polymin, which is white.

I decided to try two different first washes for the demo, putting Rose Madder on the plums for the vellum support and Cadmium Orange on them for the polymin.

It is acceptable to experiment a little at this stage, because the colours are not too built up yet. The colours of the apples are quite obvious, but plums are a bit more complex, as they have a dusty bloom on them (put on at the end) and it tends to be slightly blue. I thought that putting blue bloom over orange might look dirty, so I would experiment. I have used the polymin as the tester, as it is easier to wash off.

Continue to build up the colours with pale layers of the next colour, which is Cadmium Red on the red apple, and more green on the cooker. The red apple has very distinctive stripes, and it is most important to keep them curved. It is easier to do this with a line of stipples, and when dry, join them all up with more pale colour. It is possible, however, if your brush is dry enough, to paint curved lines as is done on the polymin. It has to be done early on in the process or other colour underneath will be removed; the previous layer must be completely dry.

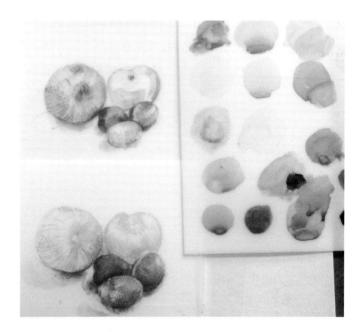

First washes for Apples and Plums – *top vellum, below polymin and a handy palette of colours to the side, ready mixed up pale.*

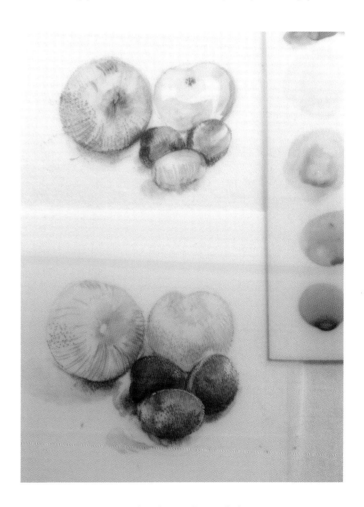

Close-up of the first washes for Apples and Plums.

Apples and Plums *completed (polymin left and vellum right).*

Drying times

With all non-absorbent bases, the paint can only dry from the outside in, because it sits on top, so it will take longer to set hard than if you are painting on paper or vellum. It takes a while to realize this, as a work can look completely dry when it is not, a bit like an underdone cake! To be absolutely sure, leave it overnight.

As you build the colours up, you can start to put in the darks. This is when things begin to come together – when teaching I called it 'sharpening up'. Use the lines of dots to do this sharpening at the edges of the fruits. Put in the stalk and the shadow in the centre of the red apple with Sepia and Raw Umber, and use just Sepia on the green one.

Now is also the time to paint in the shadows the fruit casts upon the white base, and suddenly the picture will begin to look like a still life. Until you get to this point, it looks as if the fruit is floating in mid-air. Mix Light Red and Cobalt Blue for this, making the blue dominate a bit, which will contrast with the warm colours of the fruit. Try to graduate the depth of shadows cast (see the vignetting technique mentioned in the self-portrait demo in Chapter 9). You could also sponge them, after masking out the rest.

(Notice the tiny triangles of the light base in between the apples and the plums. If you are sponging, don't worry about these tiny areas, because if they are light, you want them to stay light, and if they are darker, it is only a tiny area to stipple or hatch to fill in.)

In the final stages of this painting, the bloom can be put on to the plums by mixing some Cobalt Blue with a little diluted white, and stippling on the relevant areas. It may take several layers to get it to show, but putting too much white on will not work.

I have also put in a couple of water droplets on to the red apple. Everyone wants to know how to do this, so I have included it in this demonstration. It is done at the very end. Outline a tear-drop shape in the darkest red you have used. Camium Red + Magenta will make a good dark; when dry, take a clean damp brush and lift off a little of the colour underneath at the top of the drop. Then highlight it with a touch of white, inside, to complete the process. At the very end, strengthen the darks a little more as the watercolours fade when they dry.

I have darkened the contours of the plums with Magenta and the red apple with Cadmium Red plus a little Magenta, whilst the green apple has been strengthened with green on one side and Light Red and Cadmium Red on the other. If necessary, strengthen the shadows underneath with a tiny touch of indigo. Put your logo in a discreet position, then polish and frame it, remembering to put the details of the date, the support and who painted it, on the back.

Note: in the end I did not alter the washes on the plums, but decided that the initial wash on them should be orange, because the plums are slightly translucent, and the flesh beneath the skin is yellow/orange.

Demonstration 3: *Shelf Still Life* (drawn from life, painted from photo reference)

Materials

For this exercise you will need:

Paints (see below)
Two water pots
Linen rag
Kitchen paper
Brushes: sable 000 brush, synthetic spotters 2 and 0, and an old, worn brush for taking paint from the pan and mixing

The palette of colours used for the Shelf Still Life (on Kelmscott vellum) is as follows:

- First column, from top: Cadmium Yellow, Lemon Yellow, Cadmium Red, Burnt Sienna, Light Red
- Second column: Cobalt Blue, Sepia
- Third column: Ultramarine, Indigo, Cerulean Blue, Magenta, Titanium White for highlights

Mix up all your colours with water and keep each one separate on a palette with wells. This ensures that the colours keep pure

The palette of colours used for Shelf Still Life.

and clean. In order to mix any together, if you need to, use a separate palette.

Glenise Webb, who paints still life in miniature almost exclusively, recommends taking a photograph of the composition, and printing it out before starting, to make absolutely sure the composition and colours will make a really good still life.

The main colours in this composition are blues, against a brown wooden background, so yellow and red are good to use as they are primary colours (as is blue). This composition was drawn straight onto the vellum, using a very sharp blue watercolour pencil, freehand, shown here in black and white.

Sketch (from life) for Shelf Still Life.

Method

Set up your composition first of all, and take care to make it interesting. This means placing tall and short items side by side, and choosing objects with texture and shine. Shuffle things around, and then look at the arrangement through a rectangular aperture, to isolate it, and then you can view it and correct your composition if necessary.

Watercolour washes for Shelf Still Life.

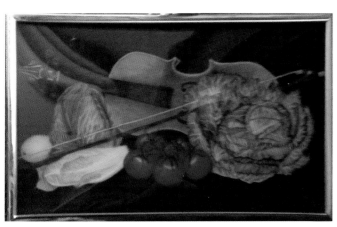

Violin and Vegetables *by Glenise Webb.*

However, it could be drawn in a sketchbook first, and then traced, and transferred by the Conté carbon method. But beginners may prefer to take a photograph, and reduce it to the desired size and make a tracing from that. However, try to draw from life at some stage to gain confidence in this method.

Use a new sable brush with a really good point, and start by painting a pale wash over the objects one by one, in the appropriate base colour. To get the greyish colour of the old pine shelf, mix Cobalt Blue and Light Red, but do not make it too cold, as there is a warmth in the wood. The blues are Cobalt, Ultramarine and Cerulean. Use Cobalt for the glass bottle as it is transparent; so is Cobalt Blue. Darken it in the opaque parts with Ultramarine, and finally Magenta. In the darkest parts of the bottle, there is a final layer of Magenta.

Creating dark backgrounds

If a background in a miniature needs to be very dense, it can be deepened to an inky dark by stippling or hatching Permanent Magenta as the last layer. To use black, whether mixed up by you or not, would kill the background, and that is not what it needs. A final layer of Magenta usually creates the depth needed.

Leave the work for a couple of days, covered up with acetate so that as you pass by, you will notice any little parts that could be improved. Watercolours usually dry duller than when they are wet, unlike oils, which are largely the same, dry or wet. Then you can just tweak the highs and lows, before you finally polish and frame it.

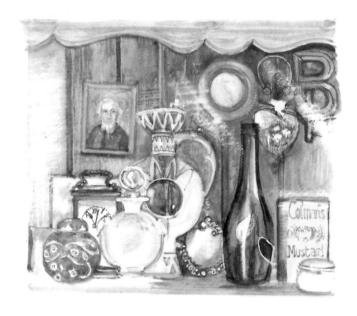

Shelf abraded with flour paper to show how to restore sharp edges more cleanly.

To make a colour for the brass and gold, look at the palettes for them in Chapter 7.

If you try painting on vellum, you will notice how much sharper your strokes and lines can be on its surface. The blue/grey ewer in this picture, with its zigzag decoration, would be much harder to get accurately and evenly on a non-absorbent surface. When setting up a still life, it is a good idea to bear this in mind. The shadows around the small mirror, the letter B and the key behind it can be strengthened with fine lines of Sepia, keeping the dark in the same tone as the wood.

The highlights in all the reflective surfaces are added in white towards the end, but pale washes of white in these areas should be indicated as you go; the final sparkle should be left, like the magenta darks, until the very end. Work around and around the painting, so that the layers are even. This is a good habit to get into, even when working on vellum, as working in this way gives the paint a chance to dry, before you go back with another layer on top. You can view your work as a whole, not in parts, and judge the lights and darks correctly.

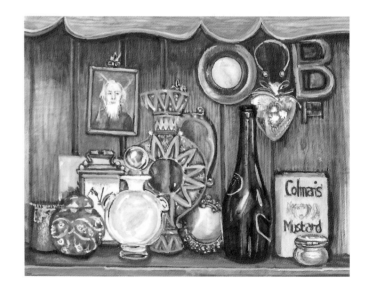

Shelf Still Life *in progress.*

Shelf Still Life *completed, 2.5 × 3 inches, gouache on vellum.*

Still life perspective

In order for a still life to look three-dimensional, the rules of perspective come into play. However, it is simpler with static objects than with faces, where the perspective changes with expression, pose and attitude.

As shown in this diagram, the horizon has to be established first (red horizontal line) and then the centre of vision (vertical red line). From the point where they cross one another, the vanishing points can be established too, along the edges of the lamp, boxes and other shapes in the composition.

If you start with a few simple shapes and practise by sketching them, putting in all the lines as shown, you should soon be able to recognize what needs correcting if the perspective looks wrong. Once again, practising in your sketchbook is the key to success.

Perspective of a Still Life *illustrated by Brian Denyer Baker.*

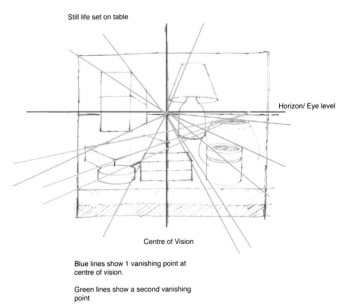

Still life set on table

Horizon/ Eye level

Centre of Vision

Blue lines show 1 vanishing point at centre of vision.

Green lines show a second vanishing point

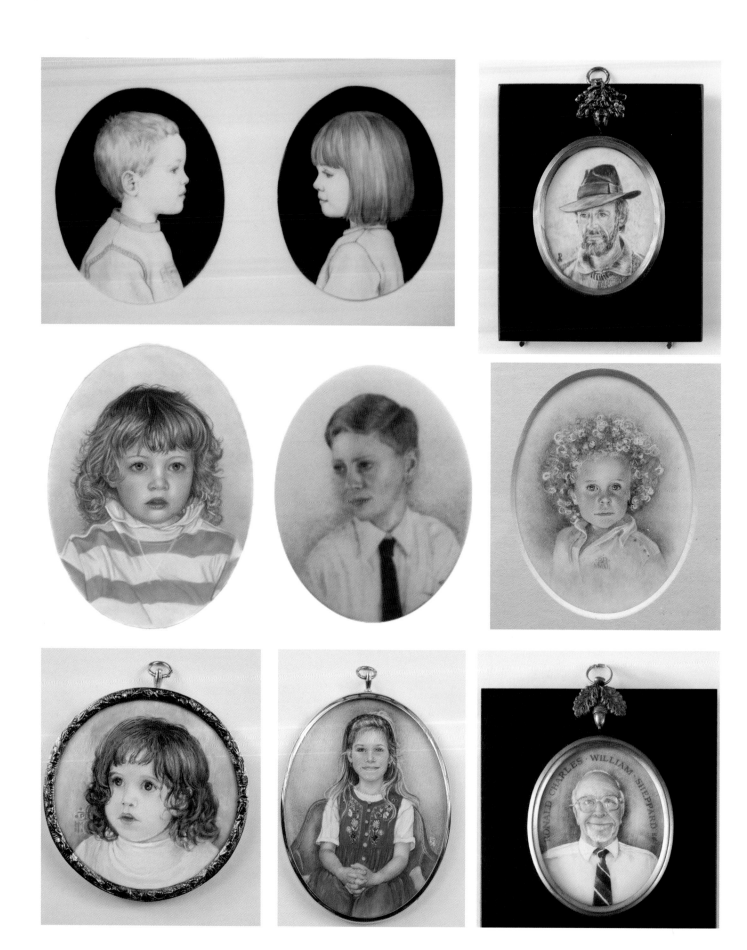

PORTRAITURE

An idea surfaced towards the end of the last century, and into this one, that learning to draw was not necessary in order to be an artist. Many Art Schools during the 1990s and 2000s decided to withdraw life drawing classes from the curriculum, and some of the up-and-coming conceptual artists of the day were influential in this new idea.

Consider the works of two highly acclaimed artists, Pablo Picasso and David Hockney, whose artistic careers overlapped: their paintings are highly stylized and innovative, and when studying their work you might not think about the drawing process particularly. However, both of them drew extremely well very early on in their lives; in fact Picasso could draw perfectly at the age of fourteen. (He is believed to have said it took him just nine years to draw like Raphael!) Similarly, David Hockney's early portraits (just line drawings) of his parents and friends are very accomplished. It should come as no surprise, then, that they both moved on to experiment with their talents. But you can be sure that their drawing skills were invaluable, and vital to enable them to produce such highly acclaimed works of art. Whatever you want to paint in miniature, it is important to try and learn some of the basic principles of drawing first.

Starting to draw the face

Drawing or painting portraits is a fascinating subject. If you consider the features that make up the human face – two eyes, a nose and a mouth – there are just four of them. Now consider

OPPOSITE: *Top: profile portraits en grisaille, both 2.5 × 2 inches, watercolour on ivorine, by Heather Catchpole; Brian, 2.5 × 2 inches watercolour on ivorine. Centre:* Carly, *3.25 × 3 inches, oil on ivorine, by Elizabeth Meek MBE;* Portrait of a Young Boy, *3 × 2.5 inches, watercolour on ivorine by Aza Adlam;* Michele Resta, *2.5 × 2 inches, watercolour on ivorine. Bottom. Oil sketch of a little girl, 2 × 2 inches, oil on ivorine; 5* Michelle Tilley, *3 × 2.5 inches watercolour on ivorine, RA Summer Exhibition 1995;* My Father, *3 × 2.5 inches, watercolour on ivorine, calligraphy by Michael Bartlett.*

Betty Edwards

Betty Edwards' book, *Drawing on the Right Side of the Brain*, is very informative if you are seriously learning how to draw. The basic premise of her teaching is that if you look at what is really in front of you, you will be able to draw, and to make this easier she suggests drawing objects upside down. For instance, when drawing a chair tipped over, so it is not recognizable as a chair, you will draw all the lines and shapes without thinking 'chair', and so you are more likely to get a more accurate drawing of it. The author writes: 'Everybody has artistic talent, and can be good at drawing.'

the millions of permutations of those four features across the world; it is just amazing that every one of those faces is different. It is therefore necessary to explore how to draw a face and, even more importantly, how to get the likeness right, and what to look for when drawing the face for the first time.

Look twice and draw once

Think about this for a moment. Maybe you have been present in an art class in which all the students were sitting around a still life, sketchbooks and pencils poised, and off they go. Have you ever looked at them more carefully? As a teacher I have often done so. You will notice that having glanced at the subject in front of them, they will soon fix their gaze on their drawing board and start drawing on the paper. Occasionally they look up at the model, but back they go to the drawing, and spend longer admiring what is on the paper, and making what are sometimes called 'arty marks', than really looking and concentrating on the subject before them. They are not looking long enough or carefully enough at the model, and so they will find it very hard to get it right.

An artist does not just look, he perceives.

Basics to start

Consider the following:

- The angle of the head in relation to the shoulders
- Looking up/looking down
- Three-quarter view/full on
- Direction of the light on the head
- The darkest areas in relation to the lighter ones

And some characteristics to look for:

- Hair: full or close to the head?
- Face shape: round, square, heart shaped, long or short?
- Eyes: close set or far apart?
- Eyebrows: strong or thin?
- Nose: long or retroussé?
- Nostrils: wide or narrow?

THINK – RUGBY BALLS ON TUBES

Heads – 1 to show simple (three-dimensional) perspective of a head looking up and down, and the division of the head into lines where the features will come. Think rugby balls!

Sketches of the Human Skull *looking at the skull from all angles, to further illustrate the perspective of the head.*

- Distance from base of nose to top lip?
- Lips: thin or full?
- Teeth: showing or not?
- Ears: showing or hidden?
- Cheeks: full or concave?
- Distance from brow to eyelid?
- Distance of chin from bottom lip?
- Shadows either side of the mouth/under the eyes?

All of these aspects are illustrated, and explained step by step, in the diagrams that follow. On the next few pages, there are some illustrations of very simplified heads, with guidelines to help you when you first attempt a portrait.

Following those, there are more heads worked up from those basic shapes into the elements that lead to a good likeness. It is a good idea to copy them; by so doing you may remember them when next drawing a portrait, and perhaps they will remind you to draw what is there in the model in front of you, and not what your brain is telling you he or she looks like.

The three ovals drawn in this illustration represent the shape

of the head. Think of 'rugby balls on transparent tubes'; this will help you to start thinking in a three-dimensional way.

The flat oval in *Heads – 1* at the bottom (C) is split by a vertical line and shows how the adult head is divided into sections by the features, shown by horizontal lines. The level of the eyes is just above the halfway point of the oval. The section below is divided into thirds, the nose on the next line, and the mouth on the final line. The two ovals at the top have the central line drawn as a curve, like the seams in a rugby ball.

In *Heads – 1A*, the feature lines are curved and drawn upwards. This is to show the model is looking up. In B the feature lines are drawn downwards. This is to show the model is looking downwards.

Notice how the sections of the features have now moved positions. In A (looking up), the section above the first line is reduced in size, while the section below the last line is larger. In B (looking down), the section above the first line is larger, while the section below the last line is smaller.

This is called perspective – a difficult concept to understand, but if you perceive, and draw what you see, you will get it right. Concepts of perspective will be explained in greater detail later, but an awareness of it early on in the drawing saves lots of corrections later on.

In C the head diagram is looking straight ahead, directly at you, but in A and B the heads go into what is called three-quarter view. This is because, whether looking up or down, they are looking more to the right or the left, and so all the features will appear differently shaped.

The two heads shown in *Heads – 2* and *Heads – 3* use the same simple diagrams used in the first selection of heads. Ovals D and E both have the same central line. Oval D is divided into the same sections as before, but with the proportions for the head of a child, with the first line positioned exactly halfway down the oval this time, and the next line and the last dividing the lower half exactly as before, into thirds.

Oval E, however, shows the proportions of an adult's head, and the first line is again slightly above the halfway point of the oval, the other two dividing the lower section into thirds again. You can see from these two diagrams exactly how the proportions differ between the adult head and those of the child.

When attempting a portrait of a child, knowing about this measurement will prevent you from making portraits of children look like little old men, which is a very common mistake made by beginners.

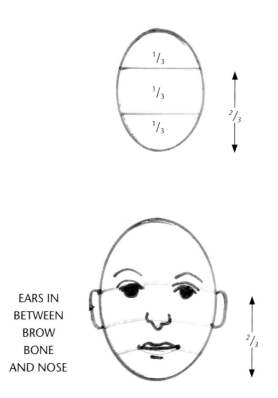

Heads – 2 to show where the lines for the features will be in an adult, compared with those of a child. If these are correct, you will be half way to getting a child looking realistic, and not like a small adult.

Heads – 3. Dividing the adult head into thirds, to illustrate where the eyes nose and mouth lie, and the position of the ears.

The two ovals shown in *Heads – 4* include more details, to help you to build up the adult portrait. The small oval is divided into thirds, in order to get the line of the eyes at the right level. In the large oval, the area below the line of the eyes is again divided into three. The nose is on the second line, and the mouth on the third. Notice that in both the diagrams of the head of the child and that of the adult, the ears are set between the eye level and the nose. Put your index finger on your brow, and your thumb on your nostril and move them around your head until you reach your ear, which will be between your finger and thumb. This position remains constant, as the head grows.

The ears and the nose are the only facial features that continue to grow through life. If you look at older men, their ears can be very large in their seventh and eighth decades. Their noses vary according to their lifestyle!

Oval F is another adult head, showing some hair and the ears

Heads – 4. *This illustration shows (above) the proportions of the features within the face, and in the face labelled [i] how to check the distances between X the brow and eyelid, U corner of the eye to the wing of the nose, Y distance between the eyes, V base of nose to top lip, Z from bottom lip to base of the chin.*

in the right position. Oval G is the head of an adolescent, and the position of the eyes is still nearly halfway down the oval, and indicates how to represent the correct age of your sitter. Placing the eyes at the right level makes getting the likeness so much easier.

I is a diagram marking some of the important measurements in the face to look for, in order to get the proportions in your drawing correct.

U is the distance between the corner of the eye and the top of the nostril. If the nose on your drawing looks too long, you can check it with this measurement.

V is the measurement between the base of the nose and the top lip – a very important characteristic to get right.

X is the distance between the top of the eyelid and the eyebrow, which varies so much from person to person.

Y is the distance between the eyes. It is said that this space is usually equivalent to another eye. (However, it is sometimes larger, especially in beautiful women.)

Z is the measurement from the edge of the bottom lip to the tip of the chin.

The drawing of a young woman's face in *Heads – 5* explains how to check the position of the mouth and nose within the face, and how to check and correct their length.

A: Measure from the corner of the eye, to check the length of the mouth.

B: Measure from the inner corner of the eye, to the top of the wing of the nostril, to check the length of the nose.

Noses simplified

Our noses are made up of bone and cartilage. This short nasal bone is part of the skull, and the cartilage joins to the end of the nasal bone.

The shape of the nose is defined by three balls of cartilage which form the tip of the nose and the wings of the nostrils. These are usually visible, whatever the shape of the individual's nose. If the cartilage tip of the nose is quite pronounced, it will hide the nostrils when the face is observed from the front at the artist's eye level. If the tip is smaller (and usually in the

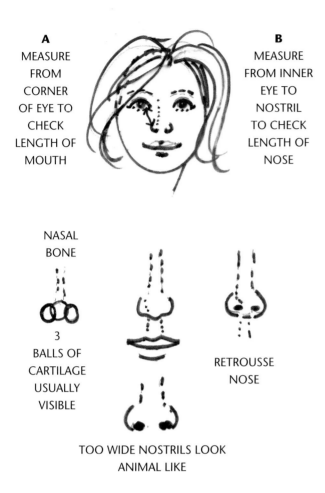

A
MEASURE FROM CORNER OF EYE TO CHECK LENGTH OF MOUTH

B
MEASURE FROM INNER EYE TO NOSTRIL TO CHECK LENGTH OF NOSE

NASAL BONE

3 BALLS OF CARTILAGE USUALLY VISIBLE

RETROUSSE NOSE

TOO WIDE NOSTRILS LOOK ANIMAL LIKE

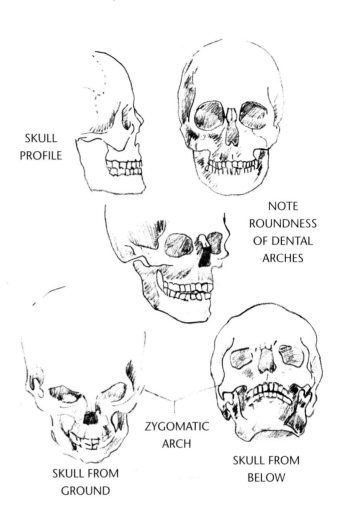

SKULL PROFILE

NOTE ROUNDNESS OF DENTAL ARCHES

ZYGOMATIC ARCH

SKULL FROM GROUND

SKULL FROM BELOW

Heads – 5. *Noses, and how to check the size and position to make an accurate drawing of the sitter's nose you see in front of you (or in a photograph). It is not a difficult measurement to check if the nose looks wrong.* **B** *is the measurement from the inner corner of the eye down to the top of the wing of the nose. It is often wrong and so the nose will appear too long as a result.* **A** *is a perpendicular line form the corner of the eye to check the length of the mouth. Below are sketches of different-shaped noses, which are comprised of cartilage from the nasal bone; three balls of it form the tip and wings of the nose. The shape of each individual's nose depends upon the size of these cartilages, whether pendulous or tip-tilted.*

young) the nostrils are visible; this is sometimes called a 'retroussé' nose.

When drawing the nostrils in a portrait, try to measure the septum between them accurately, because if the nostrils are spaced too widely apart, the nose will appear animal-like.

These drawings of the skull show the position of the eye sockets, the nasal bone, the jaw bone and the dental arch, and the zygomatic arch.

Lips simplified

Lip shapes vary a great deal, and again the artist has to observe the shape of the lips (which are characteristic to the sitter) very carefully to get them drawn accurately. Our lips do change shape slightly as we age, but usually only in their fullness. If your lips are thin, or wide, they will remain so but the curved dimension of them will lessen.

The four examples shown in *Heads – 6* illustrate several points to watch out for when drawing the mouth. A typical mouth shape is drawn at the top. Always start by drawing the line between the lips, whether they are closed or open. This line is always the darkest part. Then shade in the shape of the top lip,

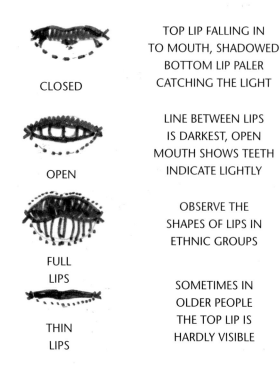

CLOSED — TOP LIP FALLING IN TO MOUTH, SHADOWED BOTTOM LIP PALER CATCHING THE LIGHT

OPEN — LINE BETWEEN LIPS IS DARKEST, OPEN MOUTH SHOWS TEETH INDICATE LIGHTLY

FULL LIPS — OBSERVE THE SHAPES OF LIPS IN ETHNIC GROUPS

THIN LIPS — SOMETIMES IN OLDER PEOPLE THE TOP LIP IS HARDLY VISIBLE

Heads – 6. *Here are simplified drawings of the shapes of lips, and how to recognize the differences, and the shapes and shadows to put in to make them correct.*

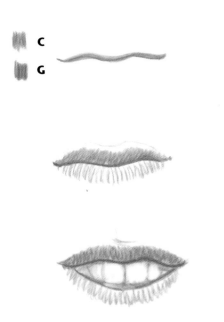

C

G

The painted mouth in two colours used for lips – light red and rose madder genuine. Open, with teeth, and closed.

which is nearly always falling into the mouth, away from the direction of the light, and is consequently darker in tone than the bottom lip, because that juts out slightly and catches the light.

This is the way to paint lips, whether the mouth is open or closed. The open mouth is of course more difficult to interpret in painting, because the teeth will be showing. (If at all possible, when learning, do not attempt to paint the teeth, until you are really confident enough when painting the closed mouth). However, the best way to paint a smiling mouth with a lot of teeth showing is by drawing in some of the teeth with the same tone/colour you have used for the lips. For a natural lip colour, use the mix of Light Red (C) and Rose Madder (G) recommended for 'mucous membranes' in the list of colours for skin tones (see Chapter 7).

The open mouth is started by painting in a fine dry line of the inside of the top and lower lip. Draw with the same colour to outline the teeth. In portrait miniatures, it is not always necessary to put in every single tooth! Remember the teeth are arranged in an arch on the jaw bone, which means that those in the corners of the mouth will often be in shadow. So indicate them with a line, and then fill those in with a lighter shade of the same colour you have used to draw them. The top lip casts a shadow over the top of the teeth, as the top eyelid does, over the top of the eyeball.

On no account should teeth ever be painted over with white. They will stand out, and will dominate the whole portrait. If the support is stained with the first colour wash, use diluted bleach on a synthetic brush to gently clean the colour off the area of teeth. Blot gently and they will regain the clean colour of your support. White, remember, is used for highlights and reflections only. In portraiture these highlights and reflections are only in the eyes and the hair.

Eyes simplified

Eyes are often described as the 'windows of the soul' and are undoubtedly the focal point of a portrait, which is why it is so important to get them right. There are numerous things to consider when drawing or painting the eyes; the illustrations and exercises below should help beginners to understand how best to interpret them in their portraits.

The eyeball is round and consists of the white, the iris and the pupil. Only one fifth of the eyeball is ever visible: the rest is contained within the eye socket in the skull, and covered by an upper and lower eyelid. However, the outline of the eyeball can be seen clearly, by the indentation above the top eyelid, and the curved shadow beneath the lower lid, which is accentuated by age, and is often called a bag.

EYES IN PROFILE
ONLY $^1/_5$ OF EYE BALL
IS SEEN SAME AS THE EYE FULL ON

ALLOW FOR THE
THICKNESS OF
THE LID

AS WE AGE, LESS OF THE IRIS IS VISIBLE. BUT IN
CHILDREN NEARLY ALL OF IT IS SEEN. WIDE OPENED EYES
SHOW THE WHITE ABOVE AND BELOW THE IRIS

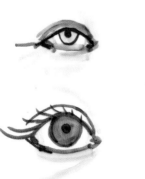

SHADOW
FROM LID

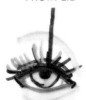

THE EYELID
(TOP)
CASTS A
SHADOW OVER
THE TOP OF THE
EYEBALL

Heads – 7. This shows simply how much of the actual eye is seen from the side, and how thick the eyelid usually is, to protect the eye. If this thickness is not put in, the profile of the eye will appear to stare.

The visible part of the eye, when viewed directly from the front, is almond-shaped. When the head is turned to a three-quarter view, the eye furthest from the viewer changes shape slightly, because of perspective.

Here the eye furthest away will be in perspective so consequently it gets slightly smaller. The drawings below show the pose of the head, when this must be looked out for.

See how the eye furthest from you is foreshortened, and although it appears to match the other, it is overall slightly smaller. It is easy to check this, because the shape of the whites of the eyes are changed. The white of the eye nearest to you is larger than the same white of the one further away from you.

Heads – 8. These illustrations show how the eye changes from childhood to old age, and roughly how to build up an accurate painting of an eye.

Hair

It is important to indicate the shape and tone of the hair quite early on when drawing a portrait. Students often ignore the hair, because they are so absorbed with getting the features in the right place. But if you think about it, our hair colour and shape are just as characteristic to us as our features, and indeed help the artist to build up an accurate likeness, right from the start. The texture of hair is important too, and actually should not necessarily be put in by the stippling or hatching technique.

My advice is always to paint the hair as if you were brushing it, so you can almost feel the texture. Smooth, long strokes for straight or wavy hair; tight curly circles in dry paint for fuzzy hair; fine, sparse strokes for thinning hair, when the skin tone will be showing through.

HAIR SHAPE, VOLUME
AND TONE SHOULD
BE PUT IN EARLY IN
THE COMPOSITION

Heads – 9. *When drawing portraits the student usually gets so involved with the features and likeness that they forget all about the hair! It is such an important characteristic, and must be indicated quite early on in the work. The tone of it, the shape and the texture are all equally important.*

Different attitudes and expressions

In the previous demonstrations of painting a portrait, the reference used has been fairly simple, with regard to the pose and position of the features. As the learning process on portraits progresses, you will need to learn how to draw and paint different attitudes and expressions, which give your work more interest to the viewer.

The three-quarter pose of the head, perhaps the most used in portraiture. Try to practise sketching it.

In this example, the face in the sitter is turning slightly away, so that the features change shape and go into perspective, which alters their shapes in a subtle way.

As noted previously, the eye furthest away from you appears smaller. This is shown in the first perspective illustration. The eye is foreshortened and you do not see the full length of the eyeball, as you do on the eye nearest to you. In the second illustration, a grid is drawn over both eyes, and the lines drawn along the top and bottom of the lid extend outwards to where they

meet at the vanishing point. These vanishing points are drawn in on the eye and mouth in this illustration, so you can see how the three-quarter view of a head needs to be carefully studied and measured to be correctly represented on your drawing.

It is the same with the mouth: if you draw a line down from the centre of the septum, (under the nose) through the upper and the bottom lip, the half of the lips nearest to you will be longer than the other half leading away to the cheek. If you imagine the teeth underneath the closed mouth, the lips follow the curve of the dental arch, which goes away from you, and is therefore shorter than the other. Think of the shape of rugby balls again: it will guide your perception to the three-dimensional.

Learning a little about the basic principles of perspective can only help you when you encounter it in your sketches. Having pointed out that the eye changes shape, notice too, that the eye is made up of several round parts – the eyeball, iris and pupil, as well as the lids, which cover these round parts. The eye in profile shows the thickness of the lid, which has to be taken into account when painting a portrait in profile.

All of these parts change shape too. In the small scale of miniature painting it is harder to paint these specific changes; nevertheless, you must learn how they change the overall look of the expression, in order to get it right on the smaller scale. For example, when the eye is looking to the side, the white of the eyeball shape is larger on one side of the iris than the other. The larger side will probably catch the light, and be much brighter than the tiny part of the white on the other side, which will be in the shadow of the eyelid.

The shape of the iris in the eye furthest away from you no longer appears round, but elliptical, because of perspective. So does the pupil. In this illustration, note these shapes, which have the effect of making one eye appear smaller than the other. As practising stippling and hatching helps you to get an even skin tone, practising different eye shapes will help you when you are actually painting a portrait.

Having gone through the basic steps of painting the eyes, illustrated earlier, you should be able to recognize the shape of the sitter's eyes, and understand why they are not both the same size. So many students when they are beginning to draw the features, draw the eyes as if they were on the same plane, but the mouth and the nose do not correspond with them – a sort of Picasso-esque distortion! It helps a lot, when you begin to draw the face, to remember the simple curves of the 'rugby ball' illustrated in this chapter.

As it is with the eyes, the lips also go into perspective in the three quarter pose. The half of the mouth furthest away will be shorter.

LEFT: The perspective of the head, above and below, by Brian Denyer Baker. The head in a box may help enable you to understand the changes and vanishing points more easily.

How to draw the features

To make it easier to learn, I have worked out a simplified formula of how to draw the eyes, nose, mouth and ears. If you look at the human skull diagrams as you follow this exercise, it will make sense of the formula.

Method of drawing the eye

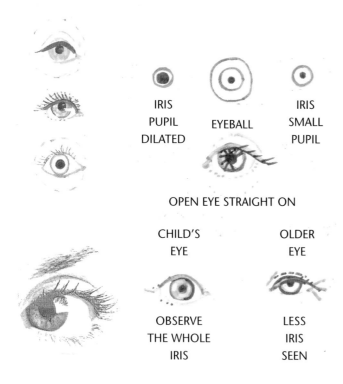

OPEN EYE STRAIGHT ON

If you copy these exercises of different eyes, you may learn how to construct them more readily in portraiture. The dotted lines indicate where the eyeball is, but not seen. The photo of an eye shows more clearly how the lid casts a shadow, and the white curves around into the socket.

You may do this exercise with a watercolour pencil, or graphite, or a paintbrush, on paper or polymin, but have a fairly large, clear picture of an eye in font of you. In the illustration watercolour pencils are used.

A: Cerulean Blue
B: Rose Madder
C: Light Red
D: Burnt Sienna
E: Indigo
F: Cobalt Violet
G: Permanent Rose

Start by drawing a small circle about .50 cm, which will be the iris; now start to draw a curved line from about .25 cm from the iris, starting at 9 o'clock, over and through the iris, slicing off about 10 mm, and curving back down about .25 cm from the iris at 3 o'clock. This is the top lid, and the visible whites of the eye.

How to draw eyes and ears, simplified and broken down into shapes to make it easier to see.

For the bottom lid, draw a mirror image of the top lid curve, with a line of dots, to represent the eyelashes.

Draw a small oval in the corner of the white of the eye on one side only. This is the tear duct. Strengthen the top lid line, and flick up a few top lashes. Above this line draw another curve, which is deeper, above the top lid, this is the crease in the eye socket of the eye lid.

Fill in a smaller circle in the centre of the iris for the pupil, and a little blue in both corners of the eye to indicate the curve of the white eyeball. If you are painting the eye, you can colour it as shown on pages 141–145 with all the shadows and highlights shown there.

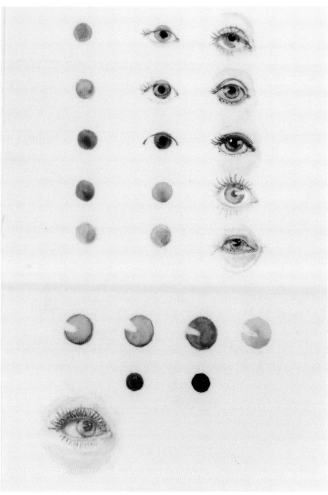

Lots of eyes, showing colours, ages, pupils, irises, and stages of construction.

The shape of the whites of the eye are so important for the expression, and direction of the sitter's gaze. They must be accurate, and match!

Method of drawing the ears

The ear is simplified into two C shapes, facing either to the left or right. The smaller of the two is inside the first, but it is not quite a replica of the first. Within the inner C shape (the small blue and indigo ear diagram) a Y shape at 1 o'clock is drawn across. The larger line drawing here shows the formula drawn, plus the small curve of cartilage that protects the ear hole. The complete ear is drawn underneath, incorporating all the points in the formula, with the appropriate shadows.

How to draw the ear (simplified):

C – Light Red
G – Permanent Rose
D – Burnt Sienna

Self-portrait exercise

We have learnt in earlier chapters the importance of working from life when painting portraits, and here is the perfect subject: yourself! No one will be able criticize or say the likeness is wrong, and because it is you, it will not matter; you can make mistakes, correct and even wash it off at the end if you want to!

However, it is best to keep all of your work – successful or not – because as you build up your body of miniatures, or portfolio, it will probably surprise you how much you have improved from when you started. (I still have my very first attempt at miniature painting from nearly twenty years ago, a pastel portrait of a dancer, which I had drawn from life.) It is very encouraging to see how your skills have progressed, however good you may have thought the drawing was at the time!

A summary of portrait elements

Noses can be large and bulbous, eyes small and heavy lidded, and lips thin and meaner. The eyes are wide open in the young, and less of the iris is visible in the older face, which can be very lined. You have to be aware of these differences, and then put all those characteristics into the face, where they are present, or your portrait will not be a very good likeness. (Remember Cromwell – 'warts and all' – and the 'too pretty' Anne of Cleves?)

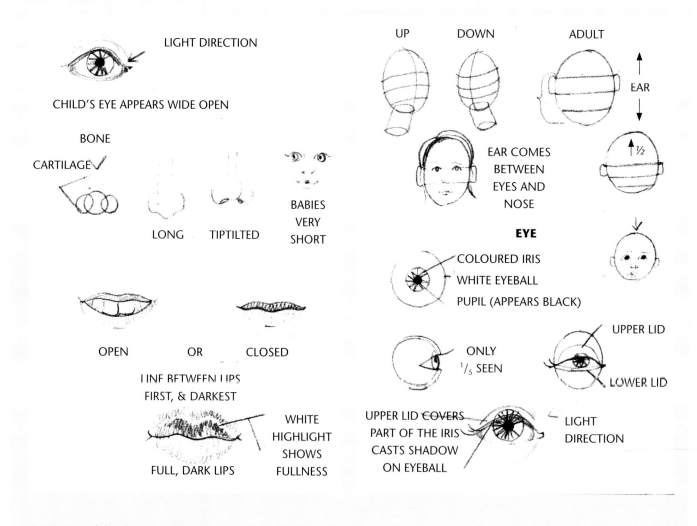

A summary of the elements of portraiture.

There are two opinions about painting a familiar face: one person will find it very difficult, while another will find it easier. Personally, I think that if you paint a face you know well, it is imprinted in your mind and this will inevitably help you get the likeness.

Assuming you have decided to try out a self-portrait, you will need a mirror, or preferably two – but one will be fine for beginners. For this exercise keep it simple. Make sure you are looking straight on, at yourself, at eye level, then you will not have any perspectives to worry about.

All your features will be central, and you can concentrate on the distances between them. Make a pencil sketch of yourself in your sketchbook (maybe several) with a fairly soft B pencil.

Self-portrait *demonstration, photo reference and initial sketch.*

Tracing the sketch for transfer.

Observe all the proportions and points laid out on page 146 (heads), and apply them to your sketch. Make sure you check all the following measurements:

- Corner of the eye to the top part of the wing of the nose
- Tip of the nose to the top of the lip
- Base of the eyebrow to the edge of the top eyelid
- Distance between the eyes, from right tear duct to left.
- Bottom lip to tip of chin

These will help you to get a likeness. Try not to use the eraser too much, and to press only lightly on the paper. As you build up the drawing, you will see more clearly the relationships of one feature to another, and the negative spaces between. If you put in several lines on top of each other, keep them light. If you have made heavy lines, you won't see the right ones!

Sometimes a black and white photocopy helps you to pinpoint vital features, and simplifies the shapes of fingers, spectacles hair and textures.

If you are a beginner and not sure of your drawing skills, for practice, take a photograph of yourself, and reduce it on your computer, in black and white, so that you can trace it. Or take the photo to a copy shop and get them to reduce it for you. (This is discussed on page 149.)

While you are looking, see what colour your skin tone and eyes are, and make a note. Look at the shadows on your face, and where the darkest and the lightest areas are. Fill them in

with light and darker pencil hatches. Make a note, too, of the tonal value of your hair, which is vital to get right, and will be either darker or lighter than your skin. So many students completely forget about this, and then wonder why the skin looks wrong, after they have painted the hair colour.

Which facial lines should I include?

Look at yourself again, and this time squint. Screw up your eyes, and look at your image, which will now appear blurry and out of focus. Whatever strong lines you can still see while squinting have to be put in; the ones that are out of focus should be left out. When you are drawing a portrait, to put in every line in the sitter's face can be very ageing and not at all flattering.

Beware of too many lines when painting children; by getting the proportions wrong and putting in all the lines, a young child can finish up looking like a little old gnome!

Now look at what is behind you in the mirror. This is the time to think about the background you will use. As this is just an exercise, use a single colour, but the tonal value of whatever is behind your head is very useful in terms of what looks right, and what does not.

In the photo, notice how the busy background detracts from the image, but the overall tone of the background is darker than the hair colour. This is called chiaroscuro, light against dark, but I will call it contrast. An understanding of contrast is very useful and important in painting – just by putting dark tones next to light, and light next to dark, your work can be much improved. In this photo, the background is dark next to the light hair and shoulders, but where the hair is darker on the top of the head, the background is lighter. Understanding this and putting it into your work, will give your portraits greater depth and dimension.

Notice how well it works in the final painting (page 151), and how well the bright colours of the clothing work against the skin tones: more contrasts.

In this demonstration, the subject is wearing spectacles. You must learn to be confident enough to paint anything in a portrait like hats and specs, which often crop up, and it is useful to know how to put them in without difficulty. In fact, spectacles or a hat can help you to get the likeness. This is because you have some extra points on the face to compare with each other, and these help you to get the specs in the right place.

It may help to think of the face as a road map. For instance, look at the nose piece on the glasses. It is in line with the bottom eyelid, and the top line of the lens is level with the top lid, and the lobes of the ears are in line with the mouth.

Self-portrait. *The first washes and Stage 2 with colour swatches on the white polymin.*

In this example, the sitter is holding a camera, so there is a hand to paint. Hands are notoriously difficult to get right, so if you are a beginner, leave them out, and learn about them later, but if you want to have a try, go ahead, and try using the negative spaces to help you.

The clothing is bright and colourful, without any patterns. The colours are primary, so the red, yellow and blue do not need mixing up, and can be used straight from the pan or tube.

Negative space

There is a way to look at difficult things within any painting (not just miniatures), which involves assessing the 'negative space'. This means that instead of seeing a complicated hand in front of you, if you just observe the shapes of lights and darks which make up the hand (use the squint again) and just draw or paint those shapes the hand will suddenly appear, much more easily than if you had thought 'fingers' – that is when sausages and bunches of bananas are produced. There are always negative spaces in compositions; learn to 'find' them and you will have a very useful tool to help get things right in drawing and painting any subject.

Palette of colours for my Self-portrait.

Notice how at the edges of the background, around the oval shape of the portrait, the colours fade and merge into nothing. This is called 'vignetting' and is a good way for beginners to finish off a portrait, for three reasons: firstly, there is less stippling to do; second, if you have not quite got the size correct to your template, it can be adjusted to fit a smaller or larger aperture; and finally, you can safely leave out difficult bits, like hands for instance. (For painting hands and fingers, see pages 148–150.)

Reducing a photographic image to the required size

There are several ways to get your image reduced to the required size: using computer technology, scaling down with a grid, or drawing with the naked eye.

Photocopy

Take your drawing to a shop with a photocopier, where they will be able to reduce your image to the size you want. Either take your photo, and get that made smaller, or trace the larger photo, and then take the tracing to be reduced. For beginners the last example is the best. Think about the size you want before you get there, take your template with you, and show them what size you want it to be. Reductions on photocopiers are measured in percentages. If you are in doubt, ask for 50 per cent to begin with, and then you will get an idea of the size reductions. They should be able to advise you.

Computer

If you have access to a computer and a scanner, you can scan your drawing and import it into Photoshop Elements or similar package. Crop the image, and from the drop-down menu choose Sketch, and then from that drop-down menu, choose Photocopy. You can then print it out at the size you need (in black and white), and it is ready for you to trace.

Lightbox

Put the photocopy on the lightbox, and put the translucent support, i.e. polymin or ivorine, on the top and stick both down firmly with sellotape. Switch the lightbox on, and the photocopied image will appear, although slightly diffused, through the polymin. There should be enough of the main outlines for you to trace directly onto the support. When you have done this, lift up the polymin to see if you have followed all the main lines; if not, put it back and draw in the lines you missed out. If you use a blue or light red watercolour pencil to trace the image, you can see what you have missed more easily, when you lift the polymin up.

Squaring down

This is another way of getting an image smaller. If you have

not got access to a computer or photocopier, and yet you do not feel confident enough to draw freehand, you can square a photograph down.

How to square down a picture from a grid of 1cm squares to ¼ centimetre squares, to get it to the desired size without tracing or using a photocopier.

Squared paper, as shown here, is widely available. If you buy an A4 pad of clear acetate, the leaves are separated by this type of paper, and this is what is used here. The photograph is 5 × 7 inches, the most popular size when having them printed. If you have a postcard-sized photograph of the face you want to paint, and do not have access to a copy shop or computer, you can square down your image by drawing a pattern of 1cm squares on tracing paper, over the face. Then to reduce that image, draw another grid, and this time divide the centimetre squares into four. By tracing your image through the tracing paper on the first grid, you can then follow the shape you have made on to the smaller grid, very carefully, and you will then have the same image on your second grid, which will be a quarter the size of the photograph. You can also buy these grids ready drawn on acetate, in stationery or art shops.

1. Using a fine black felt tip pen, draw up the centimetre squares to make a grid.
2. Trace the photo with tracing paper. It is not necessary to trace all the details – just the basic outline and important points, such as the shape of the head and hair, the features, neckline and outline of shoulders.
3. Now using a new piece of acetate, score the small squares on the acetate with a craft knife turned over (you do not want to cut the acetate) against a metal ruler.
4. Copy the tracing from the larger squares in the same way and in the same positions on the smaller square.
5. Now you can follow the steps in Chapter 8 to transfer your image to your support.

This is obviously a time-consuming way of getting your image on to your support. Personally I find that measuring the image so carefully in this way is counter-productive to getting the likeness right. After all, you are painting a picture, and however accurate your drawing, photocopy or grid may be, the skill and success comes when you are painting the portrait.

Drawing the image directly onto the support

If you feel confident enough to draw your image straight away, use a water-soluble colour pencil (in blue) with a sharp point and sketch your image directly onto the support. Remember to do some drawings in your sketchbook, and a quick colour one as well. It is surprising how this helps, although you might

Jonathan Chiswell Jones decorating his work. I painted this for him and he gave me a pair of his beautiful ceramic lamps.

The box

Eye level

Centre of vision

Drawings of the head by Brian Denyer Baker to illustrate dimensions of the head.

not realize it at the time. If you have a template of the size you want the portrait to be, then it will help to have an oval of that size drawn on squared or graph paper so that you can position the portrait within the oval more easily. Although the support is

never cut to the finished size before you start, it is important to get an idea of the composition inside the oval.

You may want to paint just the head and shoulders, but if the hands are going to be painted in (for instance, if your sitter is working at a potter's wheel or an easel) it will mean that the head will be smaller, in order to fit the rest of the interesting objects into your painting.

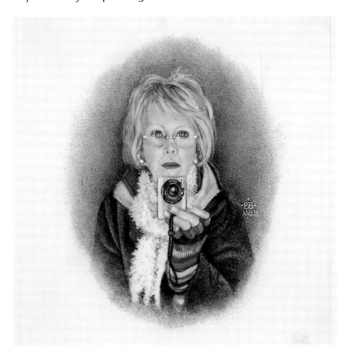

Self-portrait complete.

Make several templates in strong paper or card. Use the glass in miniature frames as a template. Alternatively, you can buy ready-made plastic templates (in craft shops) to trace around the various sizes; then you will always have a selection of templates in different shapes and dimensions to put around your works for checking how they sit within the shape. These templates can also be used to isolate areas in your own sketches or photographs, and help you to decide how your painting will be composed – a very useful tip that will save time later when you are completing the picture.

SILHOUETTES

It is a universal truth that a traditional silhouette must be totally accurate; otherwise it loses not only its purpose, but also its benefit.

(Michael Pierce)

As Michael has so eloquently explained, the silhouette is a true profile portrait, which is always painted monotone. However decorative the rest of the portrait may be, the features of the subject are painted in black, or occasionally sepia or dark red. The title 'Etruscan' usually means that the profile is red. Silhouettes may be embellished with colour as long as the profile is black: this Venetian silhouette takes the decoration almost to the limits.

Cutting silhouettes

Although silhouette cutters are rarely found these days, Charles Burns has pursued this art, and has made a successful career of entertaining clients at prestigious gatherings worldwide by cutting silhouettes of the guests. He has written a comprehensive book on his craft, *Mastering Silhouettes*. It is very informative, and even if painting is your preference, there is plenty to learn from his book.

If the silhouette was not cut, it would be painted on a thick paper, in a mixture of soot, and ink. This gave the black a dark velvety depth to the image. A very smooth tablet of plaster was the preferred surface for some of the better-known silhouette artists, such as John Miers.

They are, of course, very fragile, and not very many have survived. However, those illustrated in historical books on the subject are very fine. The plaster absorbs the paint readily, and a really skilled artist can manipulate the tones of the black gouache to indicate the softness of lace and hair with great delicacy. To experience painting on this surface is quite amazing, but you are advised to practise the art on paper before moving on to plaster.

Some silhouette artists took the genre even further, by painting the profiles on the back of the convex glass in the frames they used. These were often elaborately detailed, with the lace bonnets and ruffles worn during that time delicately picked out, making them look transparent.

A gold mourning brooch with a bronzed silhouette on plaster, attributed to John Miers, cracked across the left hand side, fortunately not across the face!

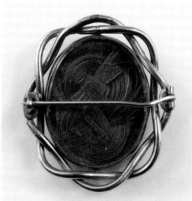

The hair of the sitter, plaited and set into the reverse. (1.5 × 1 inch.)

OPPOSITE: The Mayor *by Michael Pierce.*

Michael Pierce

When I am asked in what period the art of painting silhouettes first came into being, I usually refer the questioner to Egyptian tomb paintings or to Etruscan pottery, both of which employed depictions of the human form in profile. There is also the story in Greek mythology of a girl bidding farewell to her lover on the beach from which he was about to set sail for some distant land, perhaps they were never to meet again. The girl realized that the midday sun was causing her lover's shadow to be cast onto a rock, so she took a lump of chalk and drew around the shadow. She then returned to the rock every day to look at the outline of his shadow until he eventually sailed back to her.

More recently, the art of the silhouette became popular in Georgian times, when a method was discovered for mass-producing paper (until this time, paper making had been an expensive, labour-intensive process). Bearing in mind that artificial illumination in the average home was at table-top height, the light source being an oil lamp or candles, it takes little imagination to realize that in the evenings the familiar and recognizable shadows of family and friends would have peopled the walls, and in c.1750 a new parlour game came into being. Once the family had finished the evening meal, they would take several sheets of this new, inexpensive paper which could for the first time be used for frivolous purposes. They would pin the paper to the walls of the parlour and in turn, each member of the family would position themselves, sideways, against a sheet of paper with the light source casting a finely defined shadow of that person's head onto the paper. Another member of the family would be deputized to take a pencil and carefully draw around the outline of the shadow. When the outline had been successfully traced, the paper was taken down and one dextrous family member would meticulously cut along the pencil line with a pair of sharp scissors. The resulting sheet of paper, with a hole the shape of a person's face, could then be backed with soot blackened paper. Thus, the carefully rolled up paper could be stored as a permanent shadow reminder of each and every member of the family. It also catalogued the growth and gradual maturity of all surviving children.

By 1760, a few people with entrepreneurial spirits decided that this parlour game could be turned into a profitable business and studios sprang up across the country where, for a small sum of money, you could have your profile or 'shade' taken professionally. Someone then hit upon the idea of using a pantograph to reduce the size of the tracing to manageable dimensions; a size which when completed could be put into a picture frame. (Briefly, a pantograph was a mechanical device used by draftsmen and designers to accurately reduce the size of a plan or drawing.)

It was at this time that the art exploded. Every city and town had its 'professional' profile studio and the exponents could not keep up with the demand. Studios mushroomed everywhere; for example, the city of Bath in the early 1800s boasted of up to twelve shadow-taking studios, and their services were constantly in demand.

It was in the late 1760s that true portrait artists realized that they could dramatically increase their business by turning their painting skills to this new art form. A good portrait artist could produce a plain black likeness in a fraction of the time it took to produce a coloured portrait and this generated a heyday of about eighty years when the most exquisite silhouette images were created. The bubble burst with the invention of photography. Until then, a shade or profile had been the only means by which one could hold on to the likeness of a loved one: without this, the only tangible memory of a departing loved one would have been a luck of that person's hair or an expensive, painted portrait, but that required deep pockets. By contrast, a shadow portrait could be obtained for just a shilling or two.

There was of course, the cut paper silhouette as an even cheaper alternative. These days, most people think of the silhouette as being the preserve of 'end-of-pier' or 'fairground' characters, cutting black paper shape likenesses whilst the customer waits – a clever and old technique but not in the same league as the painted silhouette.

The eighteenth- and early nineteenth-century painters of profiles used a variety of surfaces upon which to paint their masterpieces. Card was a favoured surface but also fine plaster (pre-moulded to the shape of the intended frame), slivers of ivory, vellum and even the reverse of convex glass was used.

Some artists used a camera obscura with which to project the shadow, whilst others asked their clients to sit on a chair fitted with a wooden frame to one side; translucent paper was stretched across the frame and a candle on a pedestal was positioned so that

*Silhouettes by
Michael Pierce.*

the subject's face, in profile, was cast upon the paper. The artist would move to where he could see the shadow through the translucent paper and from there he would trace the outline. Once traced, the paper was removed and taken to the workshop where a pantograph could reduce the tracing to an appropriate size for the selected frame and transfer the tracing onto the chosen surface.

Unlike today, most artists mixed their own pigments, particularly if there was to be an element of colour in the clothing or even a touch of gold to highlight hair detail (think of a figure brushed by moonlight or even the flickering glow from a candle). Black pigment could sometimes be produced as soot, gathered from the chimney of an oil lamp, often mixed with a little beer to give viscosity.

My own technique was learned as a schoolboy, when I was tutored by an elderly lady who had herself once been a professional profilist in Victorian London.

All my work comes to me as a commission and has done since I first established myself with a high street studio; I therefore have no examples to display in exhibitions. Probably to the chagrin of my early predecessors, I employ a process that brought about their demise: photography! I take several profile photographs of my subjects. The printed photograph is placed in a vertical projector, which permits me to make an accurate pencil drawing of the features. My favoured surface is Arches 140 not or hot press watercolour card, but I also use plaster and, occasionally, convex glass. In the past, I have even used old ivory.

Using the faint pencilled outline as my guide, I confirm the features using an ink technical drawing pen (0.13 nib). The pencil line is then erased and the drawn outline image filled in with shellac-free black ink, diluted with a little water, using a size 1 and size 6 sable-hair paintbrush. Once the ink has completely dried (about four hours) I re-confirm the outline and add, with the pen, peripheral detail such as tendrils of hair.

The surface of the black image is then over-painted with high permanency gouache (Ivory Black). If the image is to be highlighted, I use shades of thinned white, gold or grey gouache using a flat brush. Gouache colour (for military dress uniforms) is used but only on the ink-painted surface, not on the black gouache, as this will cause the paint to become 'muddy'. To avoid the possible long term decaying effect of chemically treated tap water, I use only distilled water for thinning paint from the tube and for washing my brushes.

Once completed, the full name and date of birth of the subject is written, in pencil, on the reverse of the art work together with my signature and date of completion. Because I use high permanency paint and the watercolour card is acid-free, I fondly hope that the longevity of my work can be rated in centuries, especially if correct framing methods are used.

Finally, there is the question of the origin of the word *silhouette*. In eighteenth-century France, there was a pre-Revolutionary government finance minister, Etienne de Silhouette, who was widely known for his penny-pinching and parsimonious policies. Thus, in France, anything reduced to its most simple form for economic reasons was known as *à la silhouette*. If a gentlemen's tailor were to make an inexpensive coat with no pockets and a cheap lining, it was known as a *jaquette à la silhouette*. The word eventually came across the Channel to England and was soon applied to the black shadow art, previously known as 'shades' or 'the poor man's portrait'.

When finally put into the frame, with a cream coloured backing paper, and sealed up, the curved glass made the image reflect onto the paper behind, giving the silhouette another dimension. These particular images are keenly sought after by collectors.

Gilding

The glass was very often embellished by laying on gold leaf (on the back) to enrich the work, not only for silhouette portraits, but portrait miniatures too. If you look carefully at the Venetian silhouette on glass, you can see the outline of the masked profile which is painted with enamel paint, under the fine layer of gold leaf.

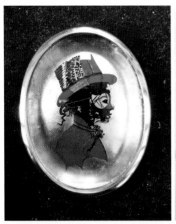
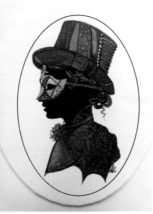
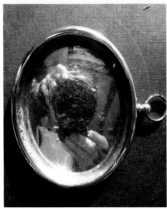

TOP LEFT: *Venetian silhouette in enamel paint on convex glass (reverse) sealed with gold leaf.* TOP RIGHT: *Venetian mask in (Humbrol) enamel paint, covered with gold leaf.* BOTTOM LEFT: *Note how 24 carat gold leaf shines on the back of the glass.* BOTTOM RIGHT: *Reverse of the gilded Venetian silhouette; note the indistinct outline of the Venetian.*

The technique of applying gold leaf to glass is called *verre églomisé*. It has to be applied by a skilled craftsman. Gold leaf is incredibly delicate, because it has been beaten to make it very thin. It flies off the gilder's cushion if the slightest breath of air passes over it.

It is sold in little booklets about 3 inches square; each sheet between leaves of red Conté on paper, to prevent the paper from sticking to the gold.

TOP LEFT: *gilding materials;* TOP RIGHT: *gold leaf from a supplier;* BOTTOM LEFT: *Shell gold paint;* BOTTOM RIGHT: *24 carat gold leaf.*

The gilder uses a special cushion that is covered with fine suede, and closed on three sides, by a strong vellum shield, which folds flat when not in use. The gold sheet is lifted out of the book with a gilder's tip (a wide brush with sparse hairs) and laid carefully on the cushion. It is then cut into pieces, with a gilder's knife. This is the hardest part because if the knife (or the craftsman) does not make a clean cut some bits of leaf are left. These are always gathered up and can be ground with gum arabic to make shell gold.

Transfer gold leaf is much easier to put onto the glass, as there is no need for the gelatine wash (which acts as glue), but it is not quite so lustrous. An artificial gold leaf is also available, but it will not last as long as the pure gold leaf or transfer gold leaf.

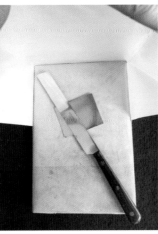

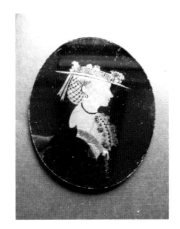
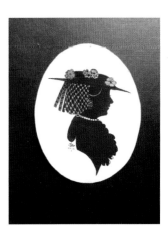

Gilder's cushion and knife. The shield is made of parchment, so that the leaf, which is extremely thin, and is apt to lift up and crease in the movement of air, is protected. The knife is specially made for cutting the leaf into pieces.

The piece of glass to be gilded is cleaned, and a gelatine wash laid over that area; then the gilder's tip is used again to pick up a piece of leaf, which is laid extremely carefully on the glazed area, and the tip is lifted up. This is a very delicate operation, for a steady hand. Then the glass, complete with the leaf, is steamed to make the gold stick firmly (the heat of the steam fusing the gelatine with the gold). Only small areas can be worked at a time, in a very sheltered and calm space. It can take a very long time!

A gold leaf border on the glass in a traditional frame makes the portrait or silhouette inside look extra special, and was predominantly used by the most accomplished portrait miniaturists, because it was very costly.

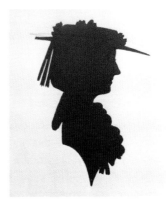

My trials of verre eglomise on flat glass, and black enamel paint. My design based on the image below from Dover Publications.

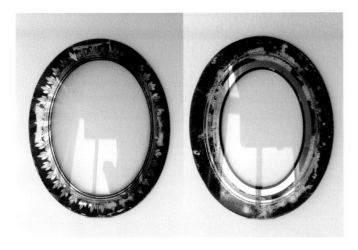

Two pieces of old verre eglomise on convex glass with a black border.

Not all silhouettes are of human profiles; historically, group silhouettes were painted, as a record of a wedding party or a special celebration, for example. These were called 'conversation pieces', and were of course larger than the single-image silhouette profile (see examples by Michael Pierce at the beginning of this chapter and on the frontispiece).

The framing too, was different, but traditional nevertheless. The frame was made of polished wood, sometimes maple, very often with an inset gold slip, to accentuate any gilding or 'bronzing' on the characters. 'Bronzing' was the term used for embellishing a silhouette profile with gold, yellow or white gouache. The shine on the hair, jewellery or clothing would be picked out, skilfully, by the artist to create another dimension. If shell gold is used to embellish rather than gouache, the brush has to be washed in a separate container, so that the residue that settles can be reconstituted and used again.

Different textures can be indicated, by using a dry paintbrush technique. Stray wisps of hair or curls for instance, can be used with this method. The loaded brush is wiped almost clean, and

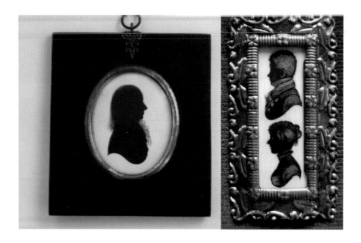

A copy of a John Miers silhouette on plaster, and an ivory piano key with two more copies, bronzed.

then scumbled around the hairline. The black, well diluted with water to a pale tone, is then used to paint delicate ruffles of fabrics and lace on the clothing.

The profile to be painted must always be drawn strictly from the side view. If the sitter's head is turned even slightly further to left or right, the profile will not be true and accurate. It must be at your eye level too, otherwise the likeness will be distorted by perspective.

If you are practising silhouettes for the first time, there are several copyright-free books of ready-made black profile images (such as Big Book of Silhouettes, Dover Publications). These are very comprehensive and contain all sorts of subjects: men, women and children, animals, flowers, seasonal scenes and plenty more. They provide excellent reference material for redesigning silhouettes for your own use.

It may surprise you what can be turned into a silhouette image. Keep your own scrapbook of profiles, saved from books and magazines, to use as a base for more designs. Tracings can be made, and enlarged or reduced to fit your requirements. Some of the images are quite large in these books, so it may best to trace them full size first, with a fine black rollerball pen, or very sharp hard pencil, putting in every detail. Then you can reduce the tracing to the size you want. This way the result will be far sharper to follow than if you were to reduce the silhouette in the book.

This process is really best when working on a silhouette from your own photographs, because it is always best to use a larger image to work from, as it is with portrait miniatures. Trace the large image first, carefully, making sure you keep strictly on the outline. Even the width of a blunt pencil line will make your traced image larger, and you will lose the accuracy of the profile.

Get this image reduced, and then you can use this, traced again at the correct size, and with as much care, to transfer by shading pencil over the back and then onto your support. When working from a larger image, it is easier for you to see the details of the features, and distances between them, which is one of he most important things to get right, so that you get a likeness.

Translucent supports, that is, polymin or ivorine, do not give such a sharp image as absorbent supports like paper and vellum. Remember that thick black paint on non-absorbent surfaces will certainly flake off over time. If you are painting on the back of glass, remember to use enamel paint.

June Blyth

June Blyth researches her subjects thoroughly, before she begins a silhouette. She chooses a particular character or period from history, and studies in detail the costume, hairstyles, hats etc, both male and female, before designing the silhouette to be painted. June's silhouettes are therefore authentic and correct. Both Michael Pierce and June design the bases of their silhouettes carefully. It is not worth spending a long time researching the historical details and getting areally good likeness without working out what the finishing shape at the base of the design will work best with thesilhouette

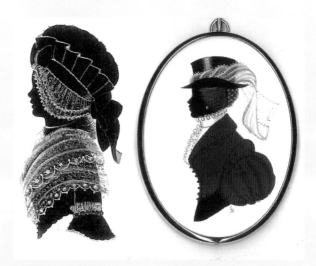

Traditional silhouettes, researched and designed by June Blyth. Left: To the Hunt, *black gouache and red, 3 × 2.5 inches, on paper. Right:* Lady in Lace, *Circa 1790, gouache on paper, 3 × 2.5 inches.*

Method for painting silhouettes

Materials you will need:

Tracing paper
Very sharp pencils – soft (2B), medium (HB) and hard pencil (2H or harder)
Stylus/old fine ballpoint or rollerball pen
Scissors
Eraser
Templates
Sellotape
A4 white card (as a base to work on)
Kelmscott vellum
Ivory Black gouache
Lamp Black gouache
Titanium White gouache
Gold, Silver and Bronze gouache

Illustrated for the purposes of this demonstration is a pen and ink tracing of a lady with a hand to her chin, and an interesting hairstyle. Many different designs may be worked out from this single image.

It has been traced from a larger image, so that all the details are clear. The parts at her elbow have been left, and these will be

Paints and techniques of bronzing and dry brushwork use to embellish silhouettes: lamp black and white gouache; opaque watercolours – cerulean blue, yellow ochre, silver and gold.

designed after the image has been reduced in size. Details such as the hairline and ear (that will not show) have been included, in order to keep the proportions correct and act as a guide to putting in any decoration at a later stage.

Presuming that you have already decided on the silhouette you are going to practise, and reduced or enlarged it to the size you need, you are ready to start. If you choose a profile, try not to copy someone you know to begin with: wait until you are more confident.

Stick the image to the A4 card base. Attach the tracing paper firmly over the image, so that it will not move (using removable tape). Take the 2H pencil and trace the outline of the image very

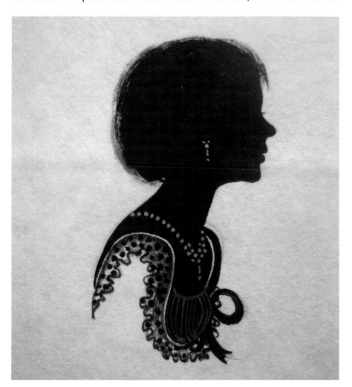

Lace and Pearls, enlarged to show the detail, dry brushwork on the hair, jewellery and lace.

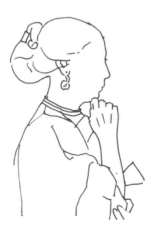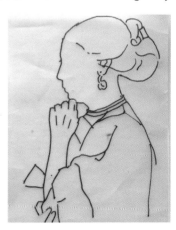

Silhouette demonstration, idea traced from a suitable image (eye level profile), then reversed.

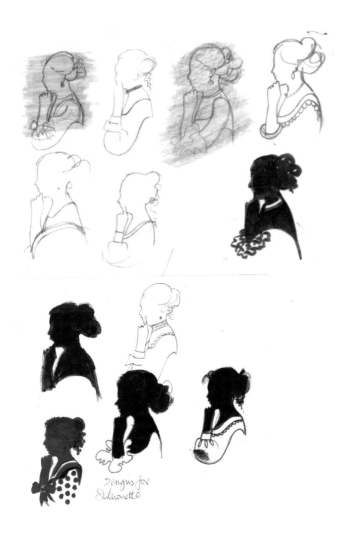

A page of rough designs based on the original idea.

carefully. (Lift up the tracing paper before taking it off, to check that you have traced everything you need.)

Remove the tracing and image from the card. Turn over the tracing and with the 2B pencil shade over the outline evenly with firm strokes.

Take the paper chosen for the final silhouette, or if you are practising first, some plain white cartridge paper will do. Attach the paper and the tracing (shading side down) again, firmly to your chosen support. Take the 2H pencil, or a stylus or ballpoint pen, and follow your first tracing, making sure you keep right on top of the first one, not slightly outside. It is better to trace slightly inside than out, because the silhouette will come out larger than you need if you do not take care.

Lift up the tracing again to check it's all there. If you have not used a sharp enough pencil or pen to trace with, your image outline will be thick, and you do not want this to happen – especially if there are some important thin design lines on your silhouette.

Your traced image must be sharp and clear. If some graphite has come off from the back of your tracing, it can easily be removed later, with white tack or an eraser. When you are satisfied with it, you may remove the tracing paper.

Now you can start to paint over the pencil outline with a fine brush line, keeping within the traced line. This is even more vital

Transferring the image to the tinted paper by laying graphite on the back of the tracing, then turning it over, drawing over the image again with a sharp pencil. Finally painting the outline of the design with a fine, dry brush

Palette, paint and brushes

Keep the black paint in a separate palette, as you can use it next time, unlike watercolours or oils for miniatures. Likewise, keep a separate set of brushes for silhouettes. Mix up some black gouache in your palette, to the consistency of thin cream. Use a small brush with a good point, moisten it and dip the paint. Blot off the excess, and practise some strokes in the corner of your paper. They should be thin and fine, and not too broad. If they are too thick then you have overloaded the brush with paint, or made it too wet.

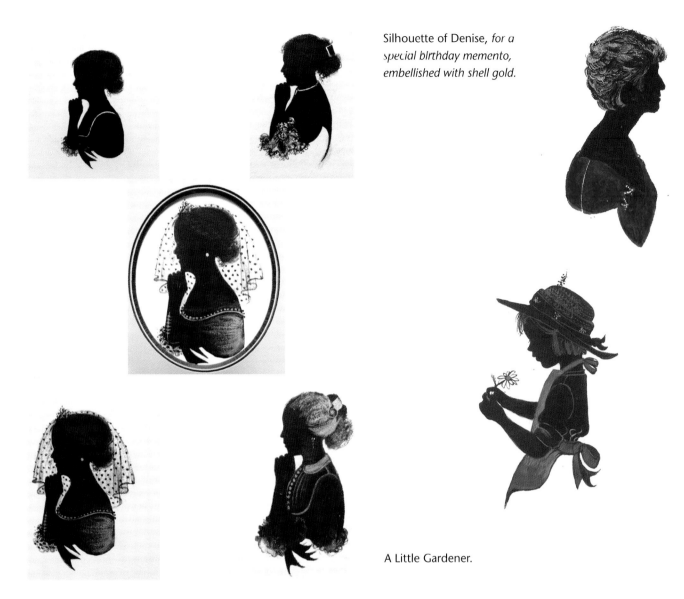

Silhouette of Denise, *for a special birthday memento, embellished with shell gold.*

A Little Gardener.

Selection of working drawings from the basic design, showing how different they can be!

now, as a mistake made with your brush around the nose or the lips can alter the likeness completely.

If you are painting the profile of a young woman, take special care when drawing in the line from the chin to the chest, because in the same way as too many lines on the portrait are ageing, so is a badly drawn neckline. The line of the neck to chest has to be very curved, to preserve a youthful look.

If you are happy with the outlines, you can now fill in the silhouette, using a bigger brush loaded with more paint. Try to keep the layer of paint even. It does not matter if the paper shows through at this stage, because it will need going over with more layers to achieve the velvety black of the silhouette. When it is dry (this is important), paint further even layers of

black, until you are satisfied with the results. Now you can embellish the silhouette, if it is appropriate, but a plain black, well-drawn silhouette can be just as effective.

Silhouettes are quite often used commercially, and if you get really skilled at this, you can make use of the technique, and produce your own Christmas cards, invitations and presents, which are very special because they are handmade and unique.

It is a really lovely idea to give a silhouette as a gift on a special occasion – to a bride and groom at their wedding, for example. I have taken photographs of the bride and groom, dancing or facing each other, and have used scumbling and thinned black paint to show the intricacies of the wedding gown, veil and flowers. The curves and profile of the bride have to be very carefully placed using all the techniques explained before. Then the design at the base of the silhouette must be carefully thought out, and the picture will hopefully become a very special memento. It is a most special gift, and outshines any photograph.

Nativity Scene, *based on reference from Dover Books, for a Christmas card.*

Silhouettes for special occasions and a typical 'Conversation Piece'.

Constance de Grandmaison: profiles carved in wax

My work is bas relief wax portraiture. It is usually an ivory colour and consists of a mixture of waxes, which can also be coloured. This is a mixture I adapted from various seventeenth and eighteenth century recipes I discovered when researching for a method of working in wax relief. There was no one who could advise me at the time, other than those who made copy portraits of known historical figures. The V&A had an impressive collection of these waxes, which I would study in the Conservation Department. They were very helpful with various tips. I also met the authority on old miniature waxes, Edward Pyke, who was most encouraging about my work, and made his formidable collection available for me to study. In 1996 he left his collections as bequest to the V&A and the Fitzwilliam Museum in Cambridge. Among these he included a portrait I had made of him, and also one of my son, which he had asked to have for his collection. Mr Pyke compiled and published The Biographical Dictionary of Wax Modellers, in which I was included as Constance Sykes.

My first portraits were life-sized and in clay, but I was soon inspired to try relief portraiture, and my four-year-old son and his friends were the perfect models. I model portraits to commission only or occasionally if I find a particularly intriguing face. The head is carved and modelled in Plasticine or modelling wax, using small wooden or dental tools. I like to have three to four sittings and then use photographs for further reference. When I am satisfied, I then make a mould of semi flexible rubber; this will take a heated wax mixture which is much harder. When cool, this is worked on to refine it to a finished state. Sizes very from 2.5 to 5cm. I like to use antique frames with convex glass when I can find them, which, sadly is not very often.

I became member of the RMS in 2007.

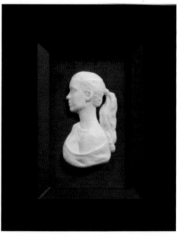

Wax relief portrait cameos by Constance de Grandmaison, all within size rules of the Royal Miniature Society.

Tracing from a photograph and shaded on the back with white pencil, so the lines will show on the black paper, cut out to assemble.

Double silhouette demonstration of two heads (1). Following the original tracing and reassembling the two side by side.

Designing a double silhouette 1: Lizzy and Christopher Rance, c.1961

Occasionally a double silhouette is required, and the best way to design this successfully is by tracing the two profiles separately, but with exactly the same dimensions. Instead of using the Conté carbon or shading soft graphite on the back, use a white Conté or watercolour pencil instead. The pencil must be very sharp.

In order to design how the images fit together, use a sheet of black paper to trace the two images on, using a fine stylus or very sharp 9H pencil, and you will have a white outline to follow. Cut them out separately, and then they can be arranged simply side by side, on top of a white piece of paper. You can change the top one for the one underneath, until you are happy with the way it looks. I usually put the female on the top, as the hair is often more interesting. Do not forget to design the shape of how the silhouette finishes at chest level, as before.

Practise this part several times as you will get more confident. Trace the underneath image, in this case Christopher first. Copy-

ing from your design, trace the second image, Lizzy, over the top. Now fill in as usual with a fine black paint outline first.

When the paint is completely dry, retrace the second image profile over the paint in exactly the right position. This is a critical bit, as this profile must be exactly right; doing it in pencil (9H) allows you to correct it until it is right. You do not need to rub the line out either, as you can paint over it with whatever colour you use to embellish it.

When you feel confident enough, take up your chosen white or cream paper and start again, on the real work this time, taking great care to correct the first profile before painting it in, as you have some leeway with the second.

Lizzy and Christopher, complete with gold paint embellishing.

Finally embellish the hair with gold or white gouache, when the black paint is quite dry. If you are not quite sure of yourself, pencil in the hair first, and then go over those lines, which you can rub out if they are wrong. However, you may have to go over that rubbed out area with more paint, as it sometimes makes the black paint greyish.

When doing any double portraits, there is the added challenge of getting them both right! My advice is to avoid them if at all possible, because one will always work better than the other, in my experience. Point out to the client that a double portrait may present a family with the decision of who has it; that way you may be asked to paint them separately, which is much better. But silhouettes are slightly different, and a little easier, and you can always make laser copies for relations. However, I did have to do two of these for Lizzy and Christopher as they are brother and sister, living in different countries.

Designing a double silhouette 2: Ben and Emma, 1999

This second example, of the silhouette of Emma and Brendan on holiday in the sun, takes the double image a stage further,

by leaving a small area un-painted in the design, to create more dimension. This area is between Brendan's neck in the front, and the back of Emma's neck behind. It is interesting to see how important this tiny area is to the whole composition.

More colour is added in this example, and it has been painted on a coloured and textured paper. It was designed and drawn up in the same way as the first double silhouette, except that

ABOVE: Trying out designs of the images, and (below) the final silhouette. Notice how the negative space between the necks is so vital to the success of the design.

LEFT: Double silhouette demonstration of two heads (2). Photo reference of Ben and Em, traced off singly and then cut out in black paper to arrange them in the best design.

this time I put Brendan on the front because I liked the details of his shiny sunglasses. I did try out the reverse option, roughly, just to make sure, but the final image on coloured paper works better.

Painting silhouettes is a another way of painting miniatures and involves just as much skill and attention to detail. It could be said that it is a little easier, and there is no doubt it may be quicker. As far as getting a likeness is concerned, it is just as important to take time to get the profile accurate, as it is to get the whole likeness in coloured portrait miniatures.

A silhouette painted on the back of flat glass, early twentieth century, American.

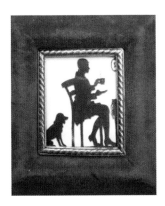

A selection of silhouettes on paper.

Mozart, Aged Seven, by June Blyth.

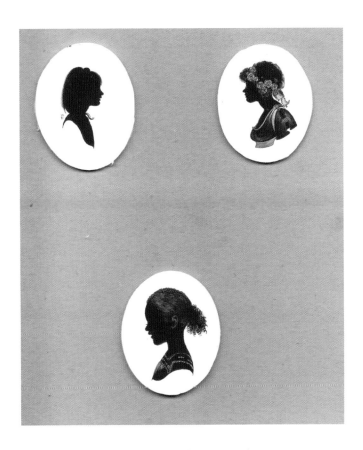

Silhouettes on tablets of plaster, all 3 × 2.5 inches.

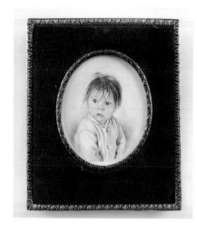
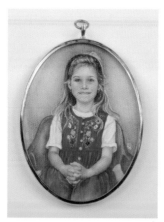
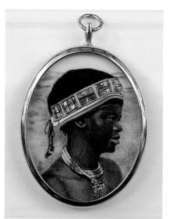

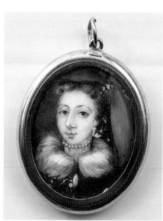

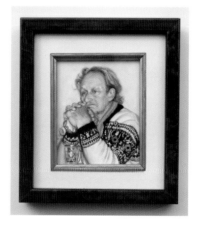

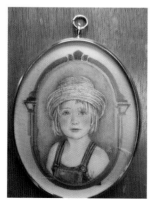

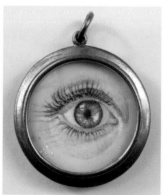

FRAMING

Of course the easiest way to frame is in the conventional way, with a mount set in an appropriately sized moulding, with flat glass. The mount between the painting and the glass is imperative, as the painting must not come into contact with the glass at any time (it might stick if it gets damp). Because watercolour has glycerine and gum arabic in its composition, it will be very susceptible to moisture.

When it comes to framing miniatures there are strict rules about size. For instance, sometimes small works are framed with much larger mounts, and frames, which does look quite effective, but is not permitted by most miniature societies in the UK.

*OPPOSITE: A selection of framed miniatures. Top row: *Baby India, vintage velvet frame with stand, 2.5 × 2 inches; *Michelle, traditional gold plated frame, 3 × 2.5 inches; *Zulu Maiden, traditional gold plated frame 2 × 2.5 inches; India, Art Deco enamelled frame, 4 x 3 inches overall. Second row: *Lady Archer traditional gold plated frame, 3 × 2.5 inches (portrait format); *gold plated locket frame, double sided, 1 × 1.25 inches; *rose gold antique, double sided frame with copy of Bernard Lens, 1 × 1.25 inches; vintage metal frame, with paste insets with photo, 1 × 1 inch. Third row: inexpensive Craft style frame with print, 1 × 1 inch; Sam Fanaroff, wooden frame with narrow moulding and gold slip inset mount, 6 × 5 inches overall; *traditional rectangular gold plated frame, 2.5 × 3 inches (landscape format). Bottom row: *Girl in a Straw Hat, traditional frame, with inset transfer mount on the support, 3.75 × 3.25 inches; *Monty in an 'ebony' turned frame (modern), 2.5 × 2.5 inches; *antique rose gold frame, single sided, with screw top hanger, 1 × 1 inch; Bronwen, in a wooden moulding, with verre eglomise, and a gold card mount, 5 × 4 inches. Frames with convex glass are marked *.*

Rules and regulations

UK societies

The overall size of the work must not be larger than 6.5 × 4.5 inches. Within that size the mount used should not exceed ¾ inch, and must never be pure white.

The size and profiles of the mouldings are restricted as well. This is really governed by the specially made display cases that miniatures are arranged in, where several works are arranged on velvet linings. These cases are glazed and locked for security, so thick mouldings and large frames will not fit within the format used universally.

There are rules too, restricting the size of subjects within a miniature painting, although these rules vary from country to country. In the UK the miniature societies do not use the $^1/_6$ rule they use in the US: instead, the sizes of individual subjects are restricted. For instance, when painting a portrait, the head must not be larger than 2 inches. This includes elaborate hats and hairstyles but not the neck. In landscapes or still life subjects, a church spire or bottle of wine must not be bigger than 2 inches.

However, there is always a point where something is borderline in its size. As a general rule, if a work is painted using the miniature technique, and is very carefully composed and correct in perspective and colour, and within the 6.5 × 4.5 inch measurements, the selection committee will then use their discretion about accepting or rejecting such a piece of work.

US societies

In the United States, miniature societies exhibits do use the $^1/_6$ rule: anything painted must be $^1/_6$ the size of the original. It is quite difficult to paint an insect when sticking to this, but not when painting an elephant! It does restrict your choice of subject matter to a certain extent, but in my experience the American Societies have a wider appreciation, and are not quite so strict as they are in the UK (although I submitted a miniature

of lychees piled in a bowl in the Miniature Art Society of Florida once, which was rejected, because the fruits were bigger than $\frac{1}{6}$ size).

Traditionally a miniature has been a painting of a whole subject, confined by the frame, which encloses the whole image or composition within the format chosen, i.e. oval or rectangular. This means that a head should not be cut off, or for a seascape the mast of a ship, and in a landscape the tops of buildings, except in particular views where perspective comes in.

Recently in exhibitions innovative artists have submitted partial works like those described above. Some of these have been highly detailed, so small and so carefully painted, that they have been accepted. However, reducing a subject on the computer, printing it off and painting over it, has been tried but is not deemed acceptable.

It is advisable then, if you wish to exhibit your miniatures in exhibitions worldwide, to abide by the rules laid down by the committees in that country. The rules are always explained in the prospectus and on the entry forms that are sent to you, or are available (more commonly these days) online.

Preliminaries

Right from the beginning when you start to paint a miniature, it is necessary to decide the size and the orientation you want your work to fit into and also the type of frame you will use. It is a good idea to have several oval and rectangular templates cut out in card, to the custom sizes of the frames, which will help you to decide which look best around your proposed image.

If you do not, and you start without doing this, you may not get your picture to fit comfortably into the ready made metal frames, which are available in a selection of sizes. To have a metal frame made up to order is almost impossible and would be very expensive. If you try out various sizes on your sketch or reference, before you start, you can check which style you prefer at any time during painting the work, as there is still time to change your mind. Another very valid reason for deciding this early on, is so that you do not have to do a lot of unnecessary stippling, which will be cut off at the end.

Plastic templates with rectangles and ovals cut ready for drawing around, are available in art or craft shops. Since craft making has become so popular, there are many tools available

Different sizes of paper templates cut from the glass in miniature frames.

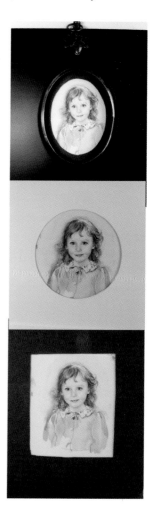

Trying out different shapes of frame for a portrait.

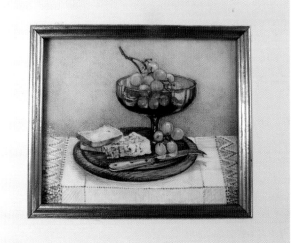

A traditional metal miniature frame and a gold slip mount – landscape orientation.

Plastic templates in all shapes and sizes.

to the miniaturist to use. Templates, burnishers and styluses can all be found quite easily.

Prior to this, oval or rectangular templates were only available to technical draughtsmen or architects. These came in many shapes and sizes, as ovals can be fat or thin, and the variety of them is almost endless.

How to frame your paintings

Another decision to be made early on is to decide first if your work is going to be framed traditionally in an oval frame with convex glass, or in a rectangular wooden frame with a mount inside, between the glass and the painting. Both methods can be completed at home.

A framer will make up wooden frames (with small mouldings) for you, so that you can have a selection at home, to choose

The basic parts of a traditional miniature frame: gold-plated metal, paper backing; curved glass, and velvet covered seal for the back. Pins (not shown) are supplied to secure them all together.

which is best, and then complete the process yourself. In the same way, framing a miniature in a traditional oval gilded frame can be done by the artist in the studio. It is easy enough, and the step-by-step guide that follows is simple to follow. However, there are pitfalls, and you have to be accurate and careful, otherwise mistakes made when cutting the miniature out to fit the frame properly can ruin everything.

So when you are sure your work is finished, and you have your client's approval, wait until you have a period of uninterrupted time. It is as important as having plenty of quiet and time to concentrate when you are painting. Everyone is fresh and has more patience first thing in the morning, so this is a good time to choose to do the framing.

Method

Get out all the tools you will need:

The frame, disassembled, and the glass put in a box, separately. (Stick the small brass pins supplied onto a piece of sellotape.)
Cutting mat
Sharp craft knife
Metal ruler
Microfibre lens cloth
Curved scissors
Blue watersoluble pencil. sharpened
HB pencil
Renaissance wax polish
Cotton buds
Small piece of clean, white habutai silk
Silver or gold foiled card (acid free) or gold foil from speciality chocolates.
Card or thin foam cut to the shape of the glass.

An acorn frame.

Before you cut out the miniature, and wax it, you must sign it. Traditionally miniaturists never signed their full name on their works, as it might have dominated too much. So instead they designed a monogram or logo of their initials and put it the painting, discreetly, so it was almost unnoticeable (see page 22). Yours will need to be designed first, and simplified, so that it is unobtrusive.

It is also usual to give the year it was painted as well, for historic purposes. I also indicate the support upon which it is painted, by drawing a box around the logo if it is on vellum. It is easy to forget this in time, and you cannot always distinguish between supports just by looking, even with the help of magnification.

Waxing

A miniature completed, totally dry and ready for waxing to protect it from damp.

Clear the table and damp dust it. (Having just spent a long time keeping the dust off the miniature, it would be foolish to wax it back on!) Make sure you have all your tools close to the work area.

Put the finished miniature face up, on a piece of clean white card, after making absolutely sure that it is completely dry.

Using Renaissance Wax, polish the surface of the painting by dipping your clean index finger into the wax, and taking

a little of it out. Put the wax on your finger onto the painting, starting outside the painted area, and using gentle circular movements, gradually spread the wax all over the surface, until there is an even layer on top of the painting. The warmth of your finger will melt the wax a little, so that it can spread more evenly.

Let the wax dry for a couple of minutes, before rubbing the waxed surface lightly with a clean piece of white habutai silk. It will begin to take on a soft sheen, and the colours will brighten considerably.

In order for the work to be identified in the future, as pointed out before it is best to write these details on the back of the actual painting, and not on a separate piece of paper, which

Write important details on the back, behind a dark part of the work, so it will not show through.

may get lost. It is easy to see the darkest part of the painting from the reverse, and you should write in fine lettering in blue: who the portrait is, their year of birth and death (if appropriate) and when it was painted and by whom.

For example: *Rose M Smith 1917–2001 Pauline Denyer Baker PINXIT 2005.* The Latin 'PINXIT' preceded by your name indicates that you are the artist.

Silhouette artists had specially designed trade labels, which they stuck on the back of their works, as a form of advertising. Marcelle D. Shears, who painted silhouettes exclusively, wrote all the details by hand in this style, and then put it inside the frame, with the silhouette.

Cutting your work to the size of the frame

Before you cut anything, it is vital to get the size exactly right. The best way to ensure the portrait is going to fit your chosen frame is to take the piece of convex glass from that frame and use it as a template. To make doubly sure that you are positioning your portrait correctly in the oval, having taken the glass out of the frame and put it in a small box, take the main part of the

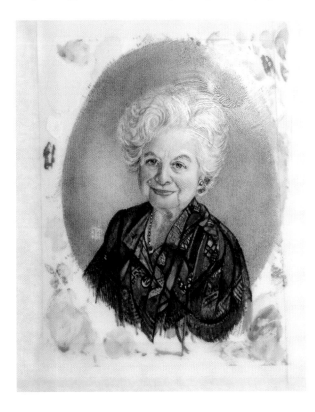

Putting on the wax with a finger – note the fingerprint top right. Work it in well and polish with clean jap silk.

Renaissance Wax

Renaissance Wax is a very fine micro-crystalline polish. It is used by museums to care for precious objects, and because it is pure it will not discolour any surface. In fact it enhances colours, as you will notice as soon as you put it on your work. It will not damage watercolour, as it is not wet but spirit based, and it will not remove any colour. But the painting must be completely dry, before polishing. If not, your finger pressure on top of the wax will wipe off the wet paint.

Since non-absorbent surfaces, when painted on, only dry from the outside, it is important to leave the painting on polymin, ivorine or vellum to dry for at least two days, or longer if possible, to ensure the paint has dried completely, before waxing and framing.

frame, and turn it over, and place the bezel (gold oval) over the painting. (Notice a little rim all around the bezel on the inside: this is called the rebate, and it is where the glass will be held in place, stopping it from falling out.) What you can see of your painting is called the sight size; now is the time to decide how you will place the portrait in the frame.

Because you painted a little bit bigger than this measurement, you have a little leeway to move the painting up or down or from side to side. You do not want the top of the head to touch the edge of the bezel, but leave a little space above it. Try to centre the head in the middle of the oval, with the eyes a little above the halfway point. The rest of the work (the dress) will fall into place.

If you are satisfied with your image in the frame (this is what you will see when it is closed up and pinned in), make tiny marks with a blue pencil, slightly under the rebate if you can, at 12 o'clock, 3, 6, and 9 on the work.

Take the frame off the painting and put the glass on it to line up with your marks, which should be under the glass, and slightly inside it. Hold the glass in place, lightly, and draw around it with your blue pencil. Now take the glass away and put it back in its box.

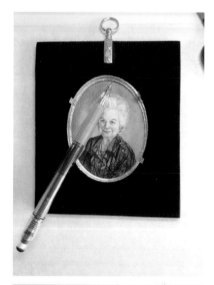

Checking the size is right by using the glass, not the frame, or the miniature will not tuck in behind the rebate.

Check to see if the blue outline is visible all the way round the painting; this is the line you follow, to cut it out with your curved scissors, keeping exactly or slightly outside the blue line.

If you cut it a little too big, you will be able to trim the work down, which is preferable to finding it is too loose inside the frame. If that happens the painting will move about inside the frame when closed and pinned. Clean the glass with a microfibre lens cloth, and wipe around the frame so it is clean. (NB: do not use the Renaissance Wax to polish the gilded parts, as it will remove the plating. I discovered this the hard way!)

A typical handwritten backing paper, traditionally used for silhouettes.

Assembly

Assemble the elements in the following order:

1. Frame
2. Glass
3. Artwork
4. Gold foil wrapped around acid-free paper (cut the same size as the painting)
5. Backing with velvet cover
6. Three or four brass pins, depending on whether the frame is rectangular or oval.

With the frame rebate side up, slip the glass into it, followed by the painting face down (making sure that the painting is not crooked) and then the gold foiled paper. Now put the velvet back on top, and gently press it in, until it is flush with the

Having checked the size carefully, draw around the glass with a blue pencil and cut with curved scissors, right on the blue line.

The final miniature, framed and boxed ready for presentation.

frame. Using an old needle or stylus, push it into each of the pinholes that are on the sides of the frame. This makes it easier to push the pins in, because they must go in straight, not up or down at all or they will show in the front or poke through the backing plate.

If the artwork buckles, it just needs more trimming. Cut slivers with nail scissors until it fits securely. If by any chance it has been over-cut so that it moves around, it will be necessary to stick it to a piece of acid-free card, or polymin, which is thin, and cut to the right size, so that it will stay in place securely. There's nothing worse than making all the effort of framing, only to find that the head or bottle is at three o'clock!

Finally, having completed the framing process, and if it is an acorn frame, stick the plastic backing supplied over the back to seal it from dust. Then put the frame in its box and it is ready for presentation.

One of the simplest and best miniatures in my collection of old and new works is a simply framed text of Psalm 46, by George Simpson. It measures 95mm × 80mm, inclusive of the frame, and the mount, and the base is cream paper. Embellished with gold leaf punctuation marks and borders, the actual piece measures a mere 55mm × 45mm.

Historically it was this type of calligraphy from which miniatures originated, and it seems appropriate to add it here, in the final chapter.

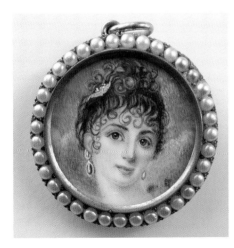

Make sure the picture is correctly positioned in the frame! Note here that when hung this little miniature will be crooked.

Psalm 46. *A fine piece of calligraphy by George Simpson, in coloured inks and gold leaf on paper, 2 × 2.5 inches.*

BIBLIOGRAPHY

During my time teaching miniatures, I carried lots of reference books to and from the venues. Most of them were rarely looked at because the students were much more anxious to get on with the actual painting, than reading them. This was quite understandable as time was limited; however, there are a few books that personally have been a great source of help to me. I recommend that anyone who is really keen to learn to draw and paint in the broader sense, would benefit from studying the following books. Then there are just three I have found good for more information on the history of miniatures.

General

Burns, Charles, *Mastering Silhouettes*, Fil Rouge Press

Dunstan, Bernard (RA), *Starting to Paint Portraits*, Studio Vista

Edwards, Betty, *Drawing on the Right Side of the Brain*, Souvenir Press

Grafton, Carol Belanger, *Silhouettes*, Dover Publications (copyright free images)

Wilcox, Michael, *Blue and Yellow Don't Make Green*, Collins

History of Miniatures

Coombs, Katherine, *The Portrait Miniature in England*, V&A Publications

Davenport, Cyril Miniatures, *Ancient and Modern*, Methuen

Hilliard, Nicholas, *The Arte of Limning*, Carcanet

SUPPLIERS

Paints

www.artsupplies.co.uk
www.daler-rowney.com
www.jacksonsart.com
www.lawrence.co.uk
www.winsorandnewton.com

Miniature frames and materials

stuartstevenson.co.uk
www.art-in-miniature.org
www.derwentshop.co.uk
www.hobby.uk.com
www.polymersplus.co.uk
www.rosemaryandco.com
www.tiranti.co.uk
www.williamcowley.co.uk

Finally…
My favourite art shop is Heaton Cooper Studio www.heatoncooper.co.uk

INDEX